THE
WEEKEND PHOTOGRAPHER

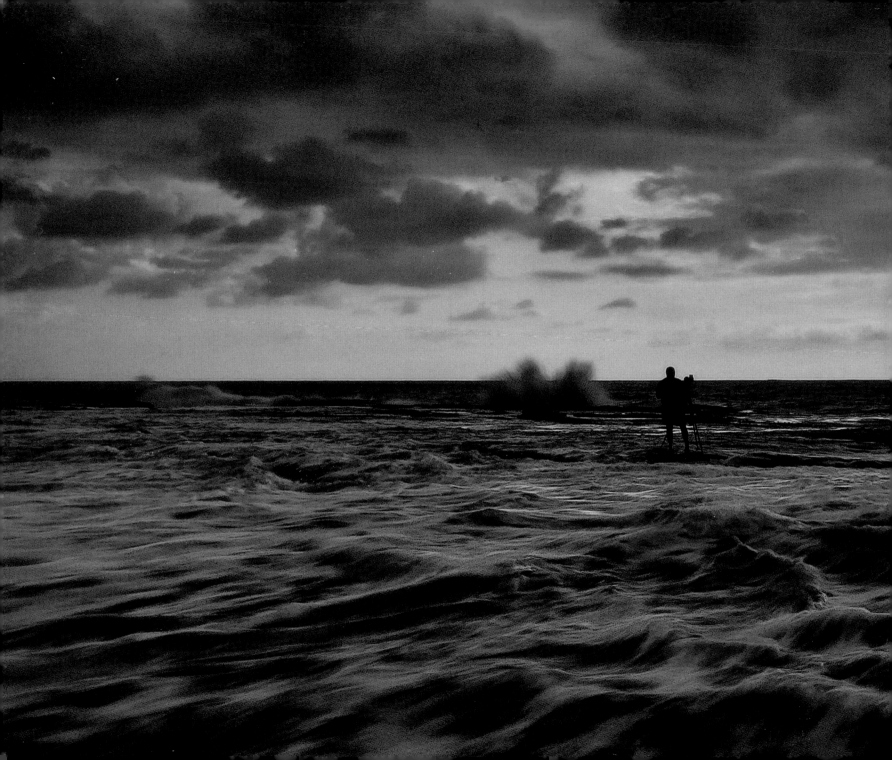

THE
WEEKEND PHOTOGRAPHER

John Van Pul

NEW HOLLAND

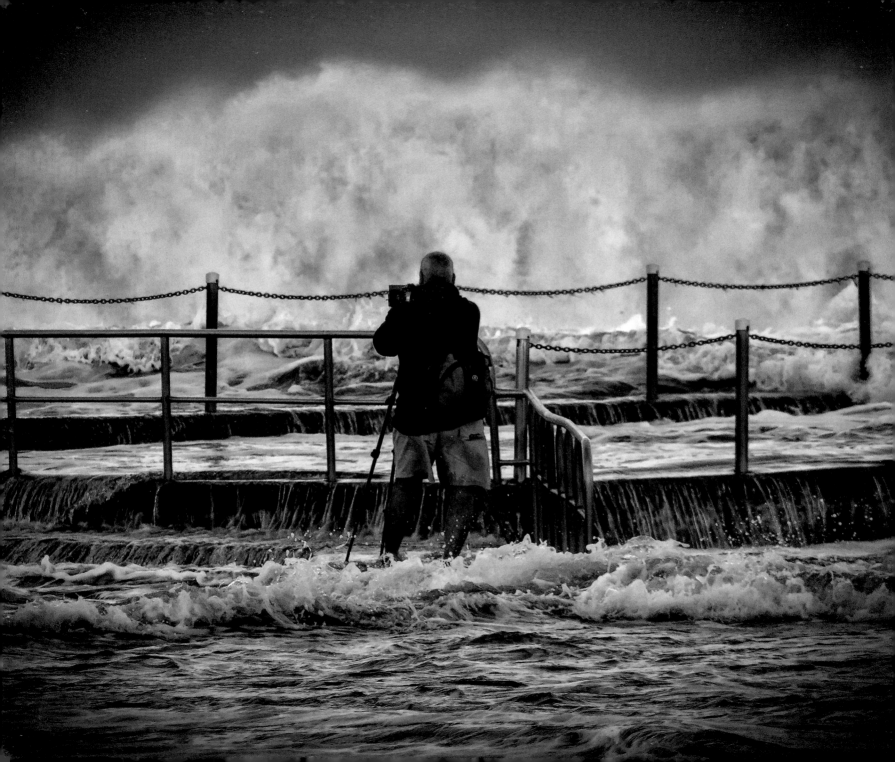

CONTENTS

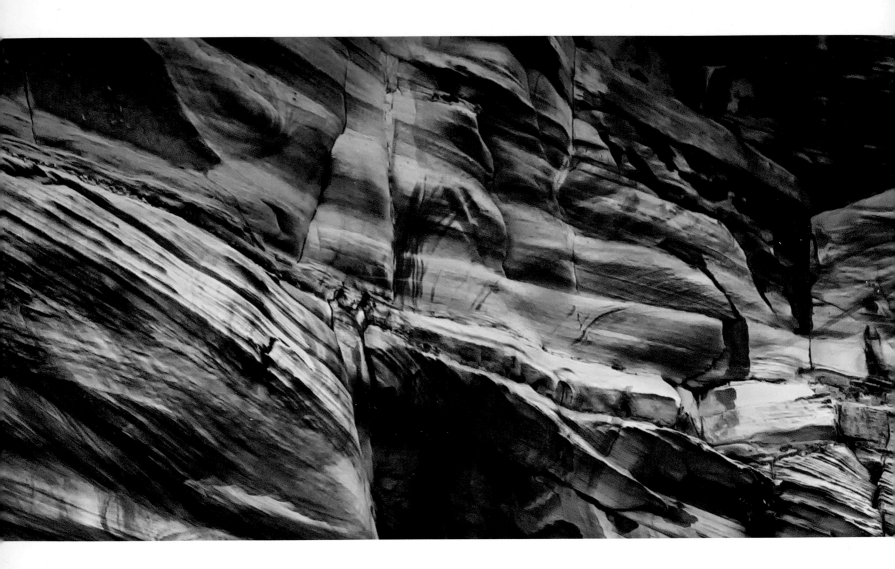

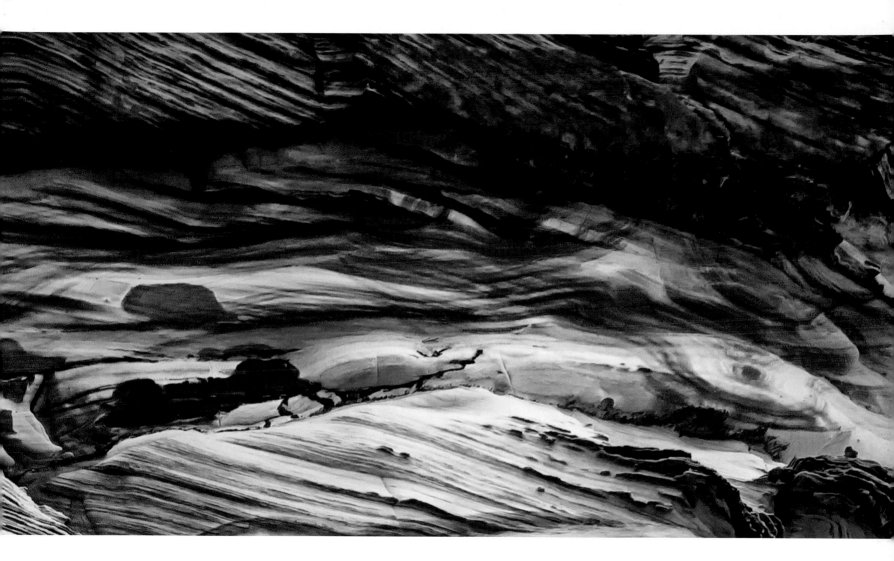

INTRODUCTION

Photography plays an important role in my life yet it's only been something I have indulged in over the last eight or nine years.

Initially, my photography focused on capturing or recording snapshots of events with little or no thought behind them—a shot of the house being renovated, the new car that's just been purchased and the occasional family event such as birthdays and celebrations.

Some would argue that these photos could be the basis of an emotional trigger but I think such photos are simply a record or a timestamp of an event. Is it photography? Every person will answer this differently.

The focus of my photography is now a more rewarding one—I hope each photo can now trigger an emotion every time you see it. The underlying DNA of that photo should be able to continually register something within you to like the photo. For all us, what that trigger will always be different.

The simple test that applies to every shot I now take is:
- Why am I taking this picture?
- Do I like my photograph?
- Why do I like it?

If you can honestly answer these questions and be a critic of your own work, then you will have found the reasons behind what gets me out bed to take photos at all hours of the day and night. For me, a photo must stir an emotion, which will resonate with me long after the shot was taken. If, by chance, someone else experiences a similar feeling or sensation, then the photo has exceeded my expectations—a very rewarding thing.

THE WEEKEND PHOTOGRAPHER

From the outset, I should make it clear that I am not a professional photographer nor is it a profession I should wish to pursue on a full-time basis. As the name of the book suggests, I only do photography on the weekend unless I am on holidays over a prolonged period of time.

But photography has become an important part of my life. It helps me maintain a sense of balance and, more importantly, is a great form of escapism from the day-to-day grind of my everyday job.

So how do you escape the rat race and create a sense of Zen?

For me, landscape/seascape and travel photography has become my release mechanism. It's something that I have only taken up in recent years, more by accident than by detailed planning.

SO WHY PHOTOGRAPHY?

It's simple—it's one of the purest forms of being able to capture a moment in your life's timeline that truly embraces the very essence of the moment.

Elliott Erwitt, an advertising and documentary photographer known for his black and white candid shots of ironic and absurd situations within everyday settings, summarised photography as follows:

To me photography is an art of observation. It's about finding something interesting in an ordinary place. I've found it has little to do with the things you see and everything with the way you see them.

As a weekend photographer, I am my own critic and the manner by which it is done is not considered or commanded by anyone else. I sense that if it became a major source of income or a deliverable item for someone else's expectation, then I would lose the very basic principle and fabric for what I currently do and enjoy.

I have found that the hardest part of photography is not the depth of the subject and technique that has to be learnt, it's having the available time to immerse yourself in it. The demands of raising a family no longer demand a huge amount of time so this precious commodity is now channelled into various photographic landscape assignments.

At first it was something that I did by myself but more recently a small group of us escape on the weekends to share in this passion. All of us have very different lives, ages, commitments and pressures yet our photographic escapes exalt the identical pleasures in each of us.

While photographing friends and family members is still important to me, the ideal escapism is an immersion with nature. The one thing that nature offers is that it changes continuously. It also has the ability to remain timeless in the face of relentless change.

In breaking down the concept of photography, the basic meaning of the word photography is 'writing with light', amalgamating the ancient Greek words of 'writing' (graphy) and 'light' (photo). The very essence of most of my photos in this book is in interpreting, pursuing and capturing the various light tones that emanate from various natural sources. Within this scope there is so much to work with that at no time does the subject become stale or overdone.

For those who have not experienced this, there is something very special about standing alone on an isolated beach or perched upon a mountain top, waiting for the light to change from dark and subdued to a rich gold glow as is spreads over a landscape. That's exactly where photography takes me.

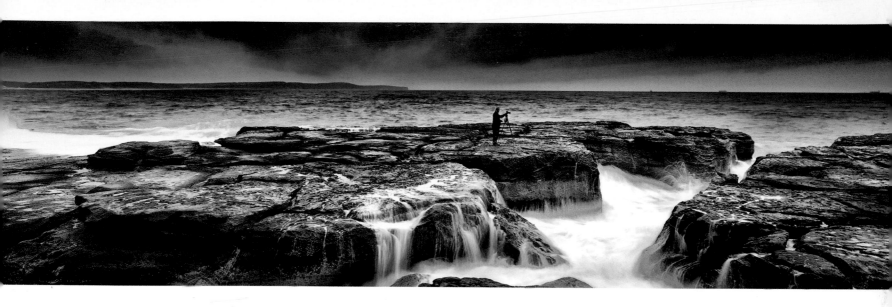

WHAT DOES IT TAKE?

One could argue that it's just a matter of going out and finding a spot bang in the middle of nature, then start shooting. While this could be done, the results may not be what you expected. To obtain decent results, you do need to focus on some basic principles and levels of commitment. There is some homework that needs to be done for you to have the best chance of good photos.

There are thousands of books out there that will teach you how to take photos. I have received no formal training nor taken any professional courses. I'm just self-taught, with lots of trials and errors.

The advent of digital photography allows a huge degree of forgiveness as you can probably take a couple of hundred shots and the feedback is immediate. A big plus also is that you won't burn through film.

But once the photographic bug bites you, you may well have an empty wallet as there is some wonderful equipment out there that will take your photography to new levels. Althought the basic elements of taking a photo remain the same irrespective of the cost of the gear you possess.

Having said that most of the shots in this book can be taken with a basic camera kit. The kit would comprise of a camera body, a wide angle lens, a sturdy tripod and a filter or two. The biggest expense would be your own personal time and level of commitment to get out there and shoot (and learning from your mistakes).

My first digital camera was a Kodak DC4800 model. It could capture 3.1 megapixel shots and at most the memory card could store around 50 shots. Certainly a far cry from what is available now. And the shots that came of it were pretty average.

SO WHERE DO I SHOOT?

Over recent years, I have been fortunate to travel overseas a fair bit. I've photographed various places in Hong Kong, extensive parts and regions in France, iconic locations in Italy—Venice, Rome, Florence, Tuscany and Chianti Hills, Switzerland, Austria, Germany, Holland, Belgium, Monaco, Dubai, New York, Providence, Boston, Newport Rhode Island, Washington, Rochester NY, Finger Lakes district in North America, Toronto, Niagara Falls and Montreal.

Expeditions do take me to a large range of coastal locations—some 35 beaches to choose from and experience. Other snippets include the numerous national parks i and of course the city area and wonderful harbour foreshores. Given that I am keen to capture most sunrises anywhere, it's usually a very early start. It's not unusual to be out of bed at 4.00am, be on the road by 4:30am and travel 31–37 miles (50–60km) to get to a coastal location on the northern beaches by 5:30am, a good half hour before the first light appears on the horizon.

From there, natures' show begins and you are in a position to see it unfold in front of our very eyes. I've consistently found that these pre-dawn sessions produce

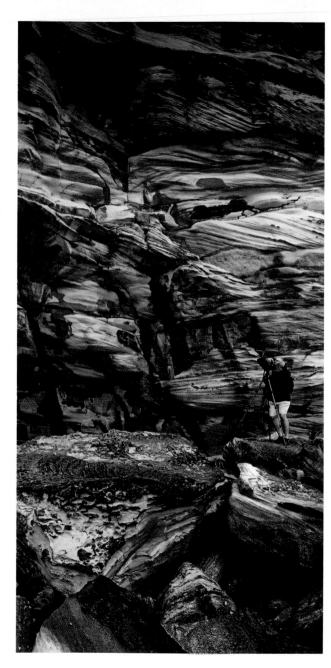

some of the best results ever. The period known as the 'golden hour' is renowned for some of the best photography results. These early hours are great for landscapes for a number of reasons, but the 'golden' light is the main reason.

The other reason that I love these times is the angle of the light and how it can impact a scene—creating interesting patterns, dimensions and textures. This phenomenon disappears during the day in most parts. The other advantage of these early starts is that there is no one around to get in your way (except other keen photographers).

If I am heading out to a coastal location, I always do some homework before the shoot. There are numerous resources available free of charge on the internet that will provide you with the following information:

- Weather forecast
- First light and sunrise times
- Tidal information (high, medium and low tide times)
- Swell height
- Wind and direction
- Moon phases and tidal patterns
- Chance of rain
- UV information
- Weather condition warnings

Each aspect can make a huge difference to the type of shots you are likely to take, the result and certainly the safety factor should not be overlooked.

Some would think that a low tide, clear sky, low strength wind and zero chance of rain might provide the ideal conditions. But the photos with the best results have been taken with the opposite of all of these conditions. Photography might take you outside your own comfort zone but the results are truly worth it. The drama that usually unfolds with a partly overcast morning is worth capturing and mid to high tides give you the chance to capture some great movement of water at slower shutter speeds.

SO WHAT IS IN MY KIT BAG?

Over the last five years, I have started to invest in some quality equipment and have realised that there are specific pieces of camera gear that will produce some exceptional results.

The style of photography I have developed dictates the type of lenses and accessories that I now carry. If you are serious about photography either as a strong hobby or as a profession, quality equipment is essential. My array of lenses and equipment has been slowly accumulating over the last seven years and technically the gear will last me for many years to come.

SEASCAPE/LANDSCAPE PHOTOGRAPHY BASE KIT INCLUDES:
- Canon 5DMkII body (full frame camera)
- Spare Battery (x2) and Compact Flash Card (x2)
- Canon EF 16-35mm f2.8 IS USM
- Canon EF 24-105mm f4.0
- Canon EF 70-200mm f2.8 IS USM
- Manfrotto carbon fibre tripod and ball head
- Polarising filter
- Lee Filter kit—ND8 Filter, ND Graduated 2 and 3 stop filter
- Cokin XPro Filter kit
- Remote shutter release
- Numerous cleaning clothes (to keep lens dry and clean from sea spray/moisture)
- Weather proof backpack to carry all the kit items

TRAVEL PHOTOGRAPHY BASE KIT INCLUDES:
- Canon 5DMkII body (full frame camera)
- Spare Battery (x2) and Compact Flash Card (x2)
- Canon EF 16-35mm f2.8 IS USM
- Canon EF 24-70mm f2.8 IS USM
- Canon EF 24-105mm f4.0
- Canon EF 70-200mm f2.8 IS USM II
- Manfrotto carbon fibre tripod and ball head
- Polarising filter
- Lee Filter kit—ND8 Filter, ND Graduated 2 and 3 stop filter
- Cokin XPro Filter kit
- Numerous cleaning clothes (to keep lenses clean)
- Weather proof back pack to carry all the kit items

PORTRAIT PHOTOGRAPHY BASE KIT INCLUDES:
- Canon 5DMkII body (full frame camera)
- Spare Battery (x2) and Compact Flash Card (x2)

- Canon EF 24-70mm f2.8 IS USM
- Canon EF 85mm f1.2
- Canon EF 70-200mm f2.8 IS USM II
- Canon Speedlite 580EX Flash
- Various reflector panels to assist with lighting
- Manfrotto carbon fibre tripod and ball head
- Numerous cleaning clothes (to keep lenses clean)

SPORTS PHOTOGRAPHY KIT SHOULD INCLUDE:
- Canon 5DMkII body (full frame camera)
- Canon 1DsMkII body (1.3 crop factor)
- Spare Battery (x3) and Compact Flash Card (x2)
- Canon EF 16-35mm f2.8 IS USM
- Canon 24-70mm f2.8 IS USM
- Canon EF 70-200mm f2.8 IS USM II
- Canon EF 300mm f/2.8 L IS USM
- Canon EF 100-400mm F4.5–5.6
- Canon 2.0 Extender
- Manfrotto Monopod
- Manfrotto tripod and three-way head
- Polarising filter
- Numerous clean clothes (to keep lens dry from Seaspray/moisture)
- Weather proof backpack to carry all the kit items

WHAT HAPPENS AFTER THE SHOOT?

Whatever the quality of the kit, post processing of all photos will still occur. I have a good PC with a decent amount of RAM memory (16mb) and numerous internal and external backup drives to store all the photos. I am a stickler for post production and ensure a rigorous workflow takes place after each shoot.

- Unpack all equipment, check for any marks/damage and clean all of it.
- Recharge and swap batteries.
- Download and check that all shots (RAW format) have been successfully downloaded onto a hard drive.
- Sort all photos into 'keepers' and 'rejects'.
- Keep the rejects for a while to learn why the shots are not what you hoped for—i.e.: learn from the mistakes (compositions, exposure, shutter speeds, etc.).
- Edit the shots as you require—I use Adobe CS6 software (Bridge and Photoshop) and also plug-in applications such as NIK software and OnOne software.
- Back up the shots once editing is finished (on an external hard drive).
- Store away or pack the camera gear for the next shoot.

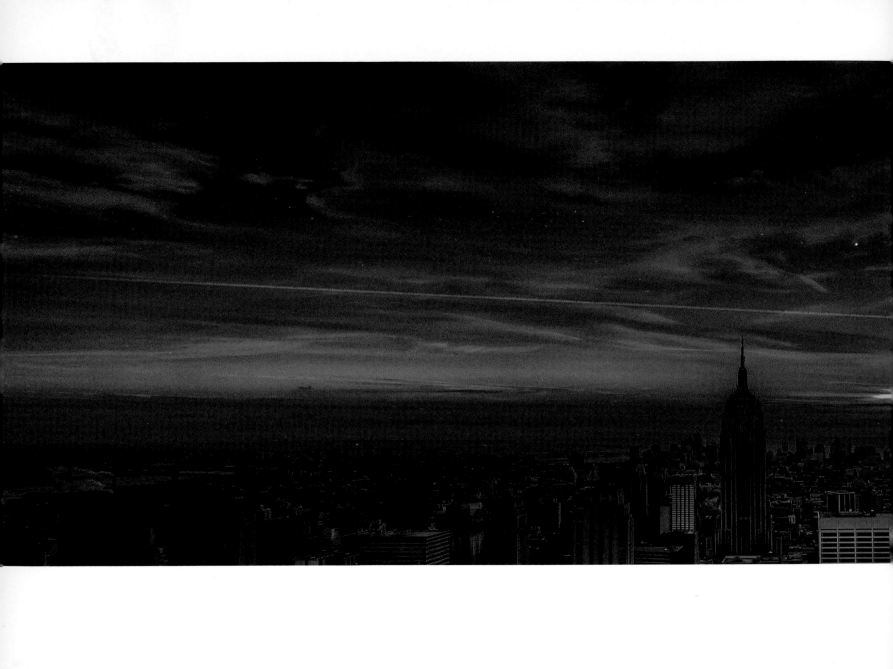

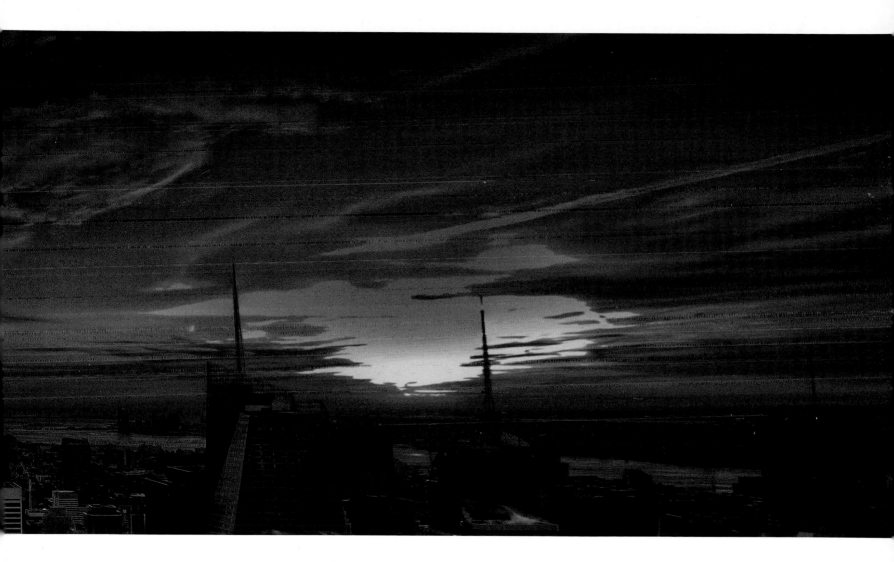

1.CITY

1.1 ARCHITECTURE

The Arc de Triomphe monument stands in the centre of the 'Place Charles de Gaulle' (formerly named Place de l'Étoile), at the western end of the Champs-Élysées.

The shot was taken directly underneath the arc itself in late June 2009 leading up to the celebrations in France for Bastille Day on the 14th July. This monument is always crowded, especially on sunny days, so the angle of the shot was deliberate, to avoid the throng of people mingling underneath.

A polarising filter was used to obtain the rich blue colour of the sky. No flash was used and the photo was taken handheld with no tripod. The spot directly above the flag was the main focal point used in order to obtain a good exposed detail range in the sculptured area.

The focal length of 10mm shows some form of dark vignetting in the upper corners. The concept of vignetting occurs in photography when there is a reduction of the brightness and/or saturation at the corners of the photo, as compared to the centre of the captured shot. The effect usually adds to the overall tonal presentation of the photo. Shooting at the base of this monument is highly recommended as there are numerous photo opportunities in every direction.

1.1A
CAMERA: Canon EOS 1D Mark II
LENS: Sigma AF 10-20mm f/4-5.6 EX DC HSM
SETTINGS: f/10, ISO 100, 1/60th second
 exposure manual mode
FLASH: no flash
FOCAL LENGTH: 10mm

1.1B f10, 1/250 sec, ISO 100

1.1C f10, 1/250 sec, ISO 100

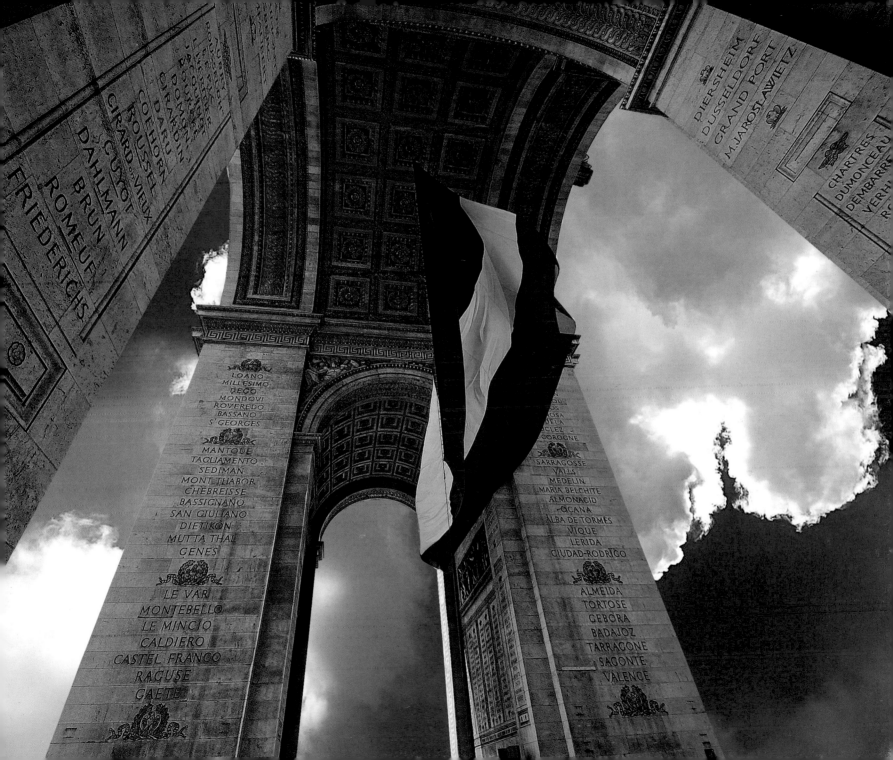

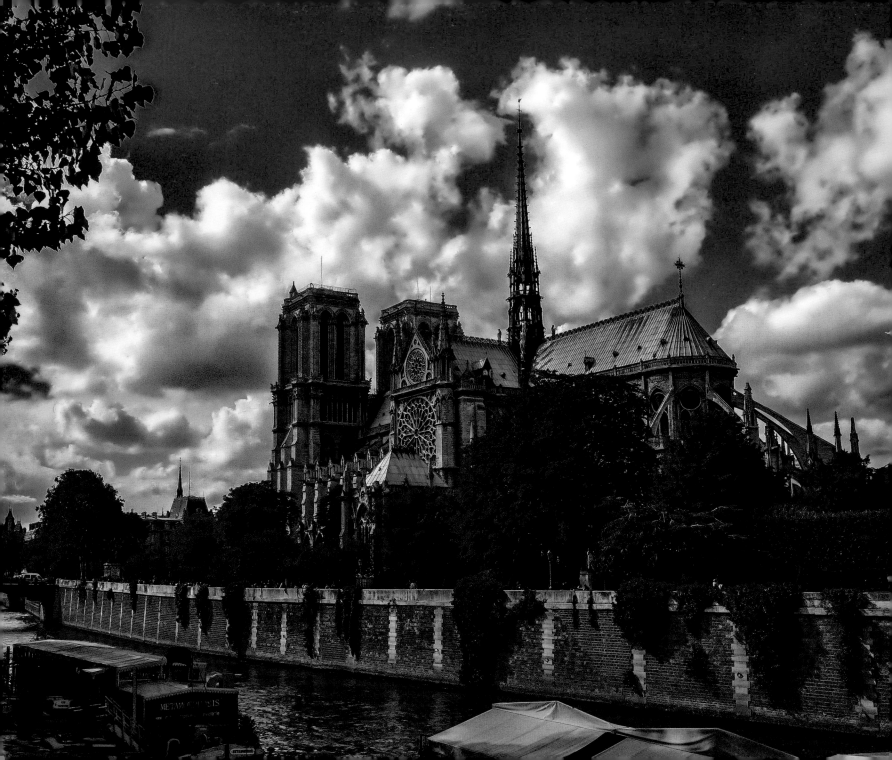

1.2A
CAMERA: Canon EOS 5D MkII
LENS: Canon EF 17-40mm f/4.0 L USM
SETTINGS: f/13, ISO 400, 1/320th second
 exposure manual mode
FLASH: no flash
FOCAL LENGTH: 33mm

Notre Dame Cathedral is probably one of the most photographed locations in Paris. I took this shot under a shady area of an overhanging tree near the bank that adjoins the Latin Quarter district. The shot angle was used to avoid the huge masses of people that tend to congregate around the front of this famous building. In fact, every time I look back at this photo I often think that this is the better angle to shoot this from as the adjoining area of the bank, the Seine River and the boats offer a better landscape scene.

 The shot was taken with my favourite camera—the Canon EOS 5D MkII. No flash was used and the photo was taken handheld with no tripod. The focal point used was the building on the left-hand part side of the Cathedral. A polarising filter was used to obtain the rich colours. The photo was subsequently cropped in Photoshop to provide a wide-angle feel to the presentation.

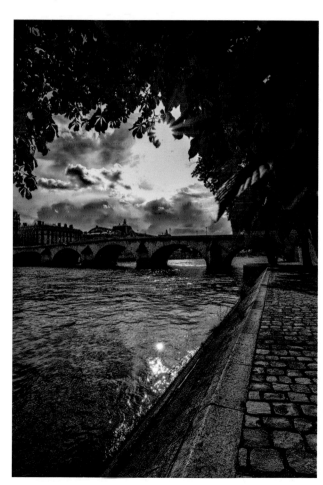

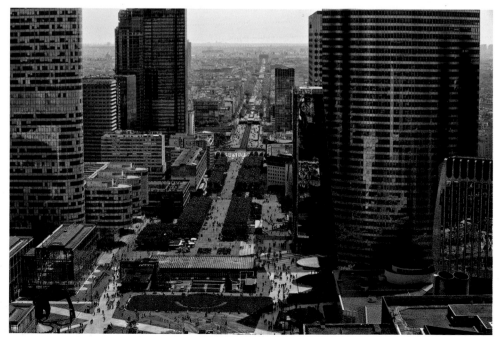

1.2B — f14, 1/400 sec, ISO 400

1.2C — f8, 1/250 sec, ISO 100

1.3 MEMORIALS

These photos were taken in September 2011, one week after the 10th anniversary of the attack in New York. The effect I was trying to capture was the sheer scale of the area at ground level that was impacted. Architect Michael Arad who created the remembrance pools first imagined the twin reflecting pools with cascading waterfalls—he calls them voids. The main shot is just one of the pools and the difficulty in capturing this area is that the shear width of the affected area is almost impossible to capture at ground level. I was surprised that we were able to photograph all parts of the memorial although to get access to the site requires a pre-booked reservation, with a reserved entrance time, to experience the Ground Zero memorial.

The shot was taken with the Canon EOS 5D MkII camera. No flash was used and the photo was taken with no tripod however the camera was rested on the side of the pool wall structure to avoid camera shake. The focal point used was the pool pit area at the centre of the structure. A UV filter was also used however the sky conditions were cloudy and totally void of colour.

1.3A
CAMERA: Canon EOS 5D MkII
LENS: Canon EF 16-35mm f/2.8 L II USM
SETTINGS: f/3.2, ISO 100, 1/40th second exposure manual mode
FLASH: no flash
FOCAL LENGTH: 19mm

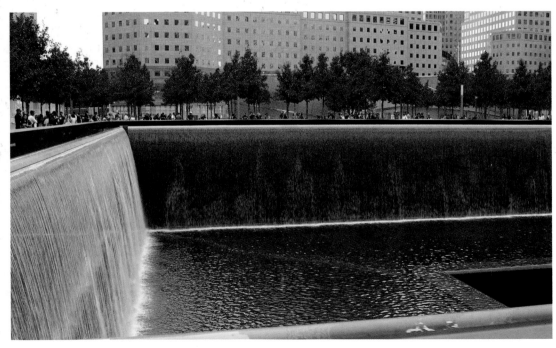

1.3B – f4.5, 1/40 sec, ISO 100

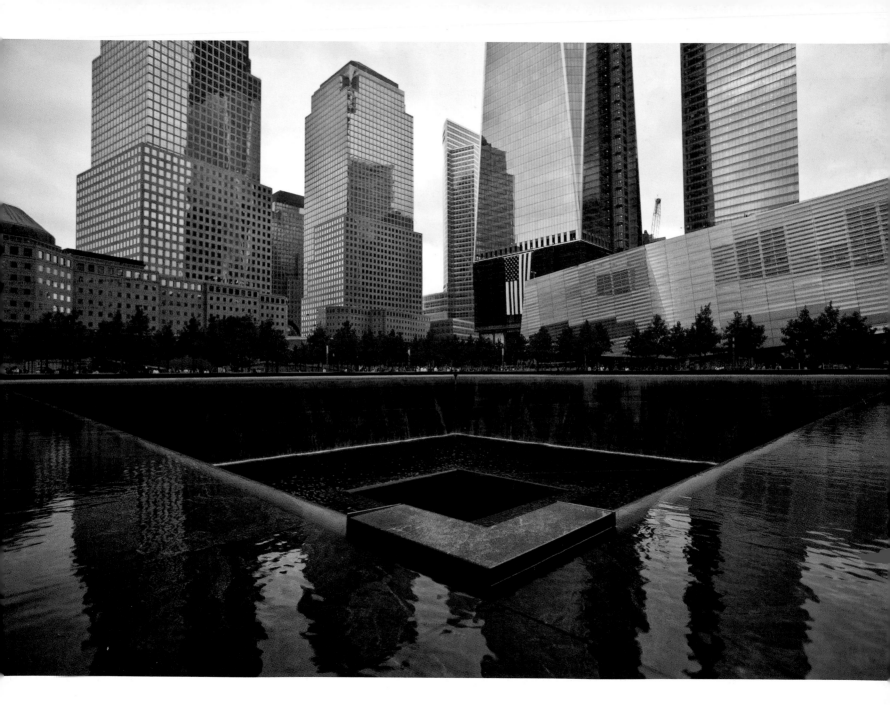

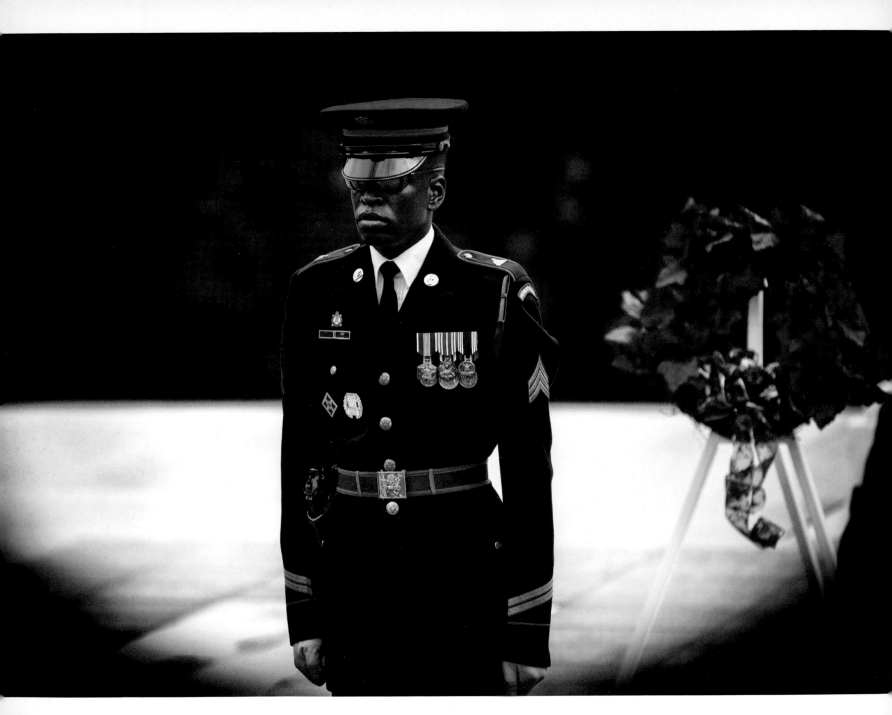

1.4 VIGNETTING

The Tomb of the Unknowns at Arlington Cemetery has been perpetually guarded by the US Army since July 1937. This photo captures the changing of the guard that takes place daily. Given the large number of people around me at the time, no flash was used. These are the times that test you as an amateur photographer—there is no prep work and a limited amount of time to get into a position where you can actually fire in several shots to freeze frame a special event.

I tried to capture the solemness and importance of the ceremony and wanted the entire focus on the guard himself who was positioned about 10 metres (32 feet) away. The colours were vibrant as we had a soft light day with only a little sunshine hidden in low clouds. At the time of capturing the shot, I quickly looked through the back of the camera and thought I had captured something good. The black edge vignetting effects around the photo was added with Photoshop software.

1.4A
CAMERA: Canon EOS 5D MkII
LENS: Canon EF 70-200mm f/2.8L IS USM
SETTINGS: f/2.8, ISO 100, 1/400th second exposure manual mode
FLASH: no flash
FOCAL LENGTH: 200mm

1.4B – f6.3, 1/60 sec, ISO 100

1.5 LARGE-SCALE LANDMARKS

Visiting New York for the first time in 2011, the Statue of Liberty was always going to be on my hit list, but we weren't quite ready for the long, snaking queues. While we had several days to spend in the big apple, a helicopter flight over the city and Hudson River offered a better experience and photo opportunity. Shooting from up high does throw you several challenges: vibrating cockpit, spinning blades above getting in the focal view of your scenes, reflections of the flight instruments on the windows and potential high glare from above. I borrowed my wife's camera. The 1.6x crop factor of the 550D body with this lens extended the reach for shots to be taken. I also took my Canon EOS 5D MkII camera with the Canon EF 16-35mm f/2.8 L II USM lens. In total some 100 shots were taken with both cameras covering the entire skyline length of New York and a large chunk of the Hudson River with sections of New Jersey and Brooklyn—the results being better than expected. The advantage of such a venture being that you will have photos that most travellers rarely get a chance to see yet alone take.

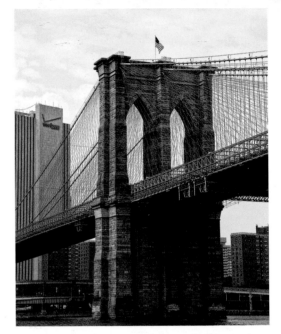

1.5A - CAMERA: Canon 550D
LENS: Canon 24-105mm f/4 L IS USM
SETTINGS: f6.3 ISO 200 shutter speed of 1/500th second manual mode
FLASH: no flash
FOCAL LENGTH: 200mm

1.5B – f8, 1/250 sec, ISO 100

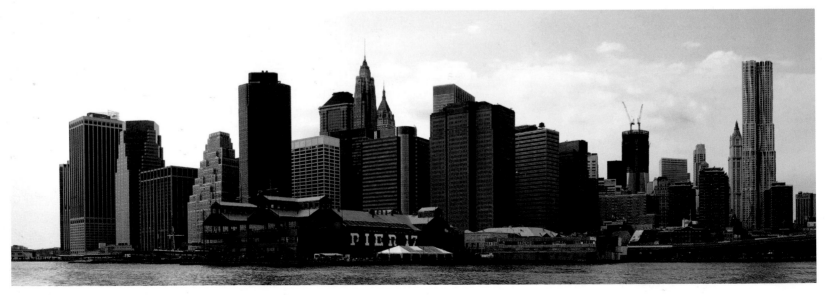

1.5C – f10, 1/200 sec, ISO 100

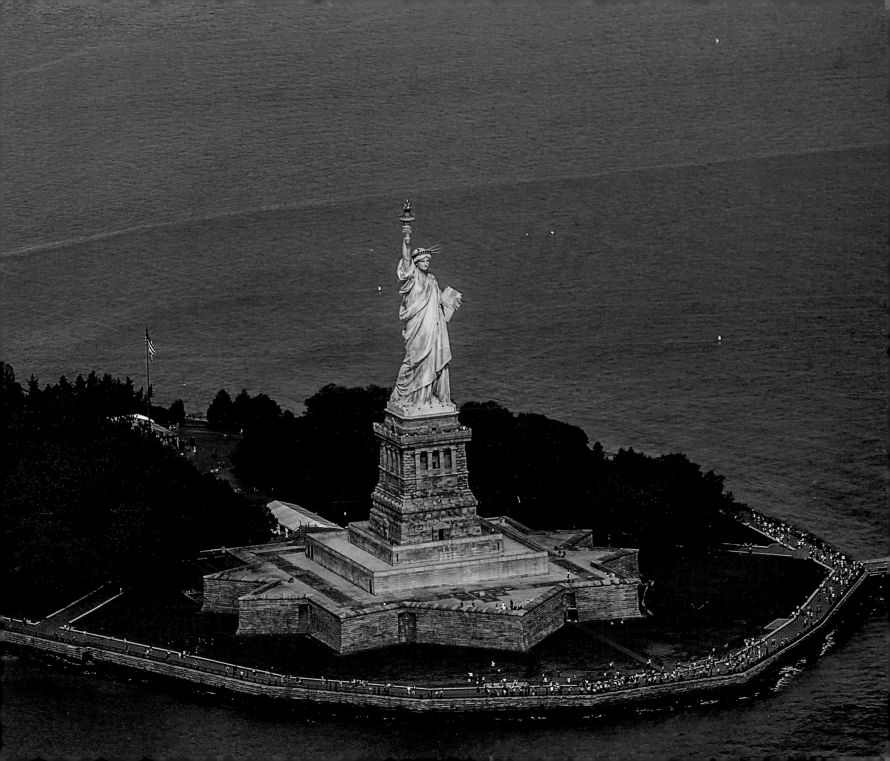

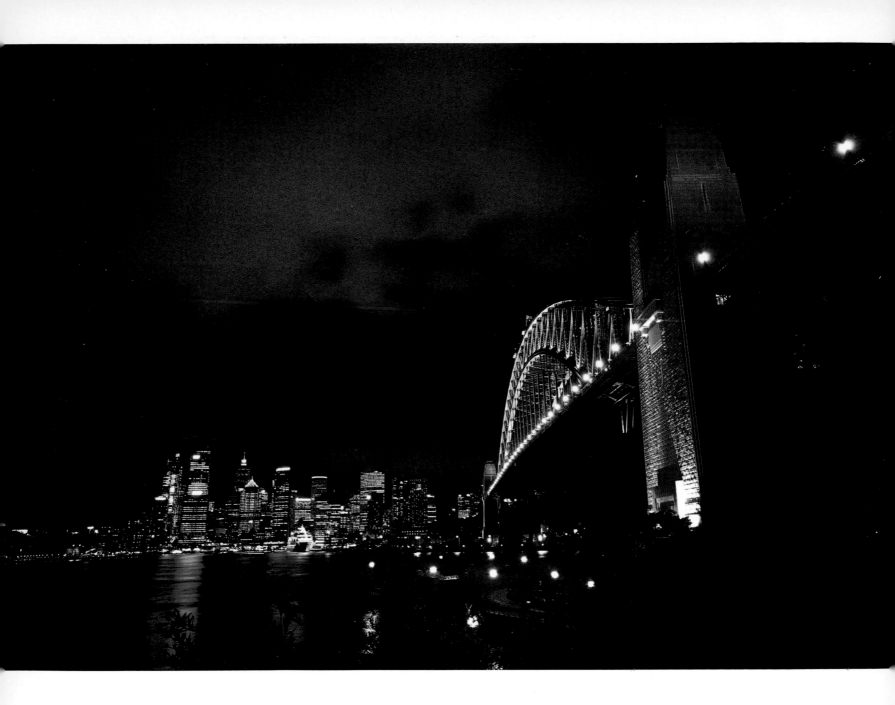

1.6 CITY AT NIGHT

The challenging aspect of this photo is to ensure that the focus point is manually aimed at non-moving objects. Make sure passing boats and ferries are not in the focal view of the shot during the exposure as their movement would have caused unrecognisable blurring segments on the scene itself. A must for this type of shot is a sturdy tripod to mount your camera on. To avoid any camera shake whatsoever, I also used a remote shutter. Without these two components, it is virtually impossible to shoot handheld and hope to get a clear shot.

This iconic shot of Sydney Harbour Bridge was taken back in March 2006 about two years after I first took up photography. It would have been one of my first outings doing night photography. The beauty of this location spot is that it is accessible to everyone who wants to capture it. The area is on the foreshore of the harbour on the north side of the city near Milsons Point.

1.6A
CAMERA: Canon EOS 1D Mark II
LENS: Sigma AF 10-20mm f/4-5.6 EX DC HSM
SETTINGS: f/5.6, ISO 100, 8 second exposure
 manual mode
FLASH: no flash

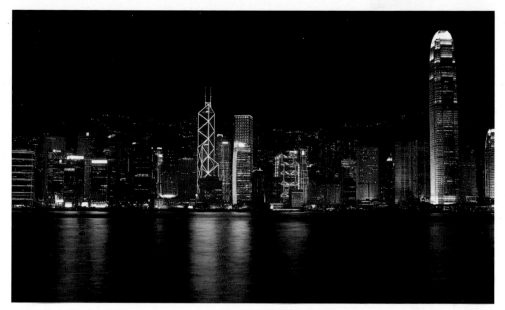

1.6B – f9, 10 sec, ISO 100

1.6C – f11, 4 sec, ISO 100

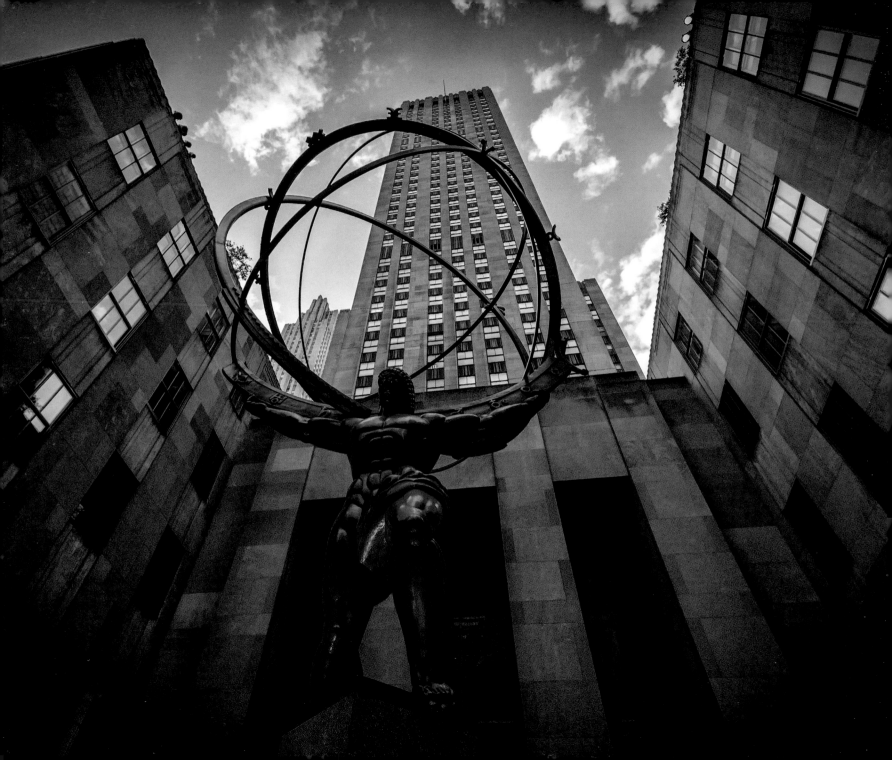

1.7 CITY SKYLINES

Rockefeller Centre is a National Historic Landmark in New York City comprising of a complex of 19 commercial buildings covering almost 22 acres (9 hectares) between 48th and 51st streets and spanning the area between Fifth Avenue and Sixth Avenue.

Rockefeller Centre represented a turning point in the history of architectural sculpture: it is among the last major building projects in the United States to incorporate a program of integrated public art. Sculptor Lee Lawrie contributed the largest number of individual pieces (12) including the 'Statue of Atlas' facing Fifth Avenue. The challenge in taking the photo of 'Atlas' was ensuring that all parts of the shot were well-balanced with light, avoiding shaded areas, nor have areas that were overexposed. The shot was taken late in the afternoon to avoid stong high light in the skies. The focal point was just above Atlas' head and with one extra 'exposure metered' stop providing the right balance.

The lighting on the statue's legs emanated from in-built flood lights at the base of the statue flaring up and no flash was used.

1.7A
CAMERA: Canon EOS 5D MkII
LENS: Canon EF 16-35mm f/2.8 L II USM
SETTINGS: f/2.8, ISO 800, 1/800th second exposure manual mode
FLASH: no flash
METERING FOCAL MODE: centreweighted average
FOCAL LENGTH: 16mm

1.7B – f10, 1/200 sec, ISO 100

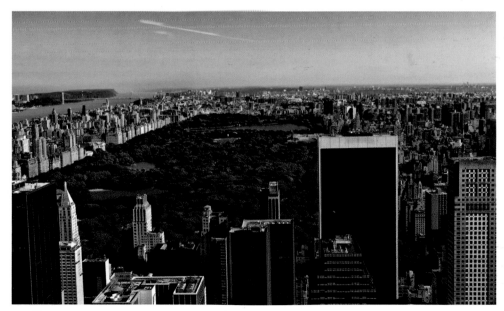

1.7C – f22, 1/40 sec, ISO 100

1.8 PARKS

Central Park, New York City, is a must for the sheer amount of activities that take place within, making it a photographer's paradise. The park stretches over 843 acres. It is 4 kilometres long between 59th Street (Central Park South) and 110th Street (Central Park North), and is 0.8 kilometres wide.

The purpose of the shot was simply to record the very relaxed nature of such surroundings in the midst of such a large capital.

1.8A
CAMERA: Canon EOS 5D MkII
LENS: Canon 24-105mm f/4 L IS USM
SETTINGS: f/4, ISO 100, 1/400th second exposure manual mode
FLASH: no flash
METERING FOCAL MODE: centreweighted average
FOCAL LENGTH: 32mm

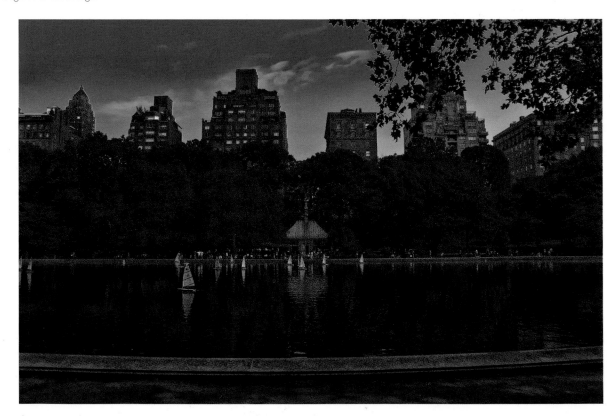

1.8B – f4, ISO 100, 1/640th sec
Following pages: 1.8C – f4, 1/125 sec, ISO 100

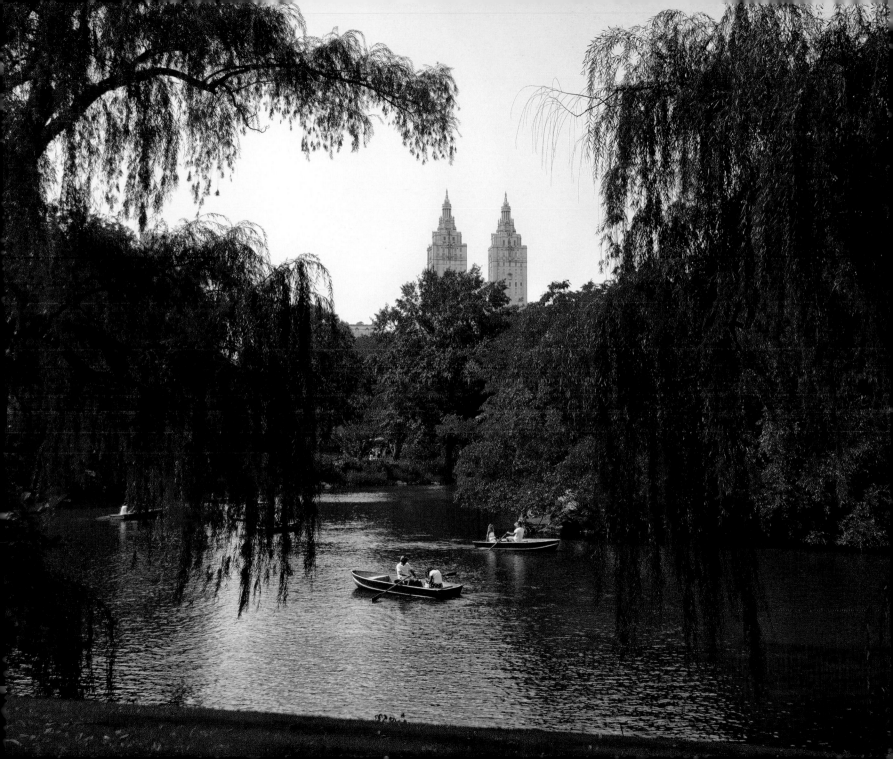

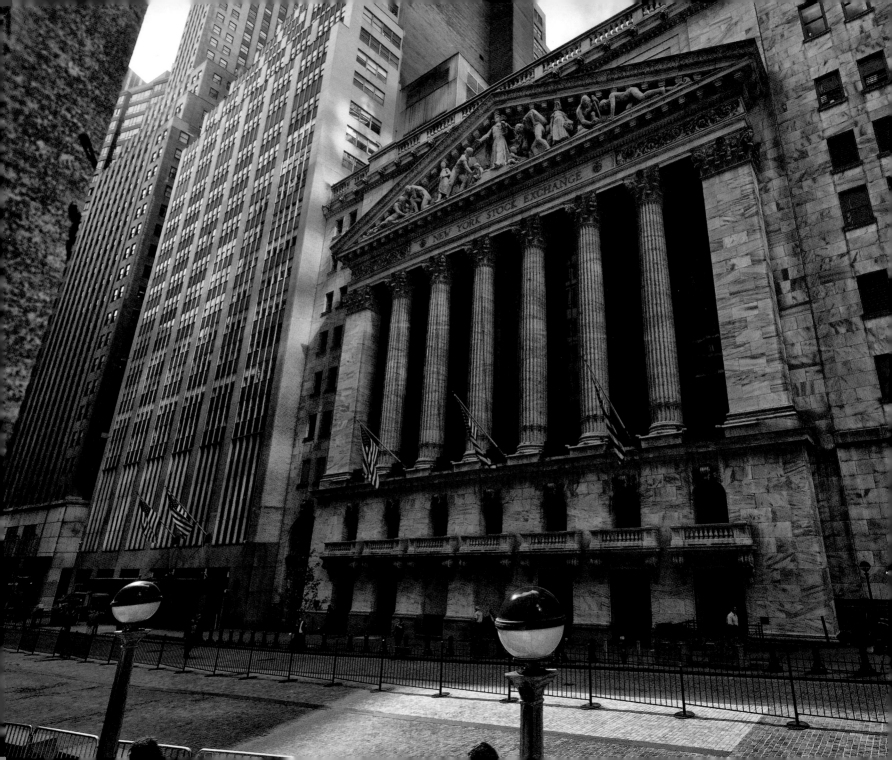

1.9 BUILDINGS

The New York Stock Exchange is located at 11 Wall Street, Lower Manhattan. This iconic building was photographed in all its glory but was guarded to a point where one could only take a photo behind barricaded, restricted walkways guarded by police. Nonetheless, the architecture of the building along with various other styled adjacent buildings makes for a worthwhile shot.

1.9A
CAMERA: Canon EOS 5D MkII
LENS: Canon EF 16-35mm f/2.8 L II USM
SETTINGS: f/6.3, ISO 100, 1/50th second
 exposure manual mode
FLASH: no flash
METERING FOCAL MODE: centreweighted average
FOCAL LENGTH: 16mm

1.9B – f16, 1/25 sec, ISO 100

1.9C – f22, 1/20 sec, ISO 100

1.10 STATUES

While visiting Bordeaux some years ago, I was struck by the amazing balance of old and new within the city and old buildings have been preserved beautifully. A passing storm on the outskirts of the city provided a great backdrop to the *Place de la Bourse*, presenting a great photo opportunity. The threat of storms caused most people to seek cover, which provided a clear shot at a usually busy landmark. These weather conditions are my favourite to shoot in—low light towards the end of the day with lots of stormy clouds providing natural drama. This was a handheld shot.

1.10A
CAMERA: Canon EOS 1D MkII
LENS: Sigma AF 10-20mm f/4-5.6 EX DC HSM
SETTINGS: f/11, ISO 100, 1/40th second
manual mode
FLASH: no flash
METERING FOCAL MODE: centreweighted average
FOCAL LENGTH: 10mm

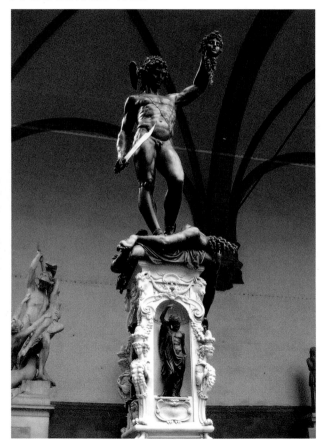

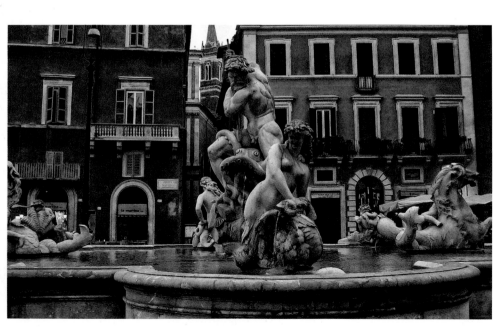

1.10B – f2, 1/30 sec, ISO 160

1.10C – f2.8, 1/80 sec, ISO 100

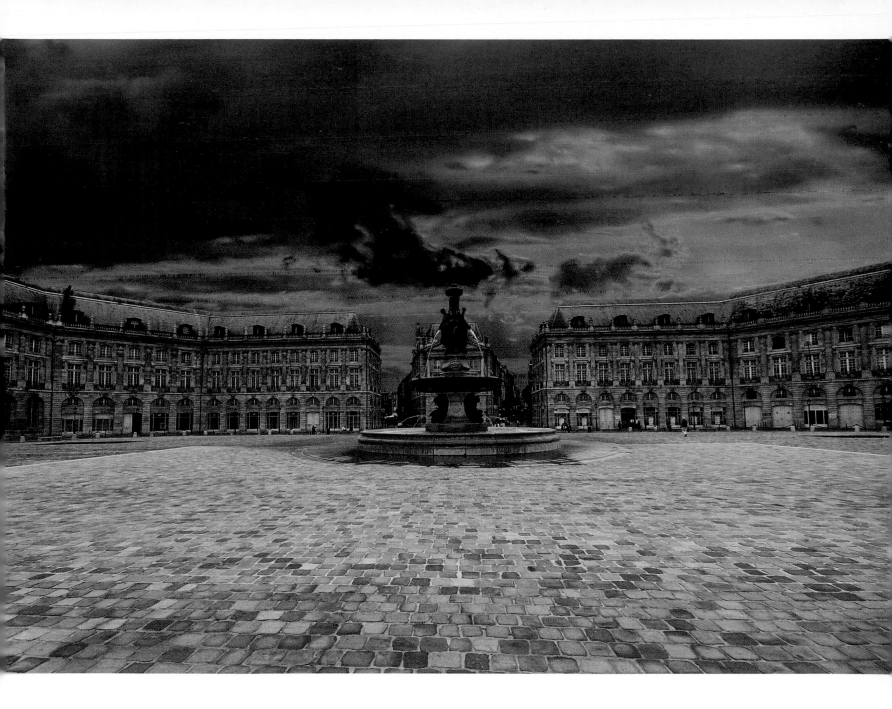

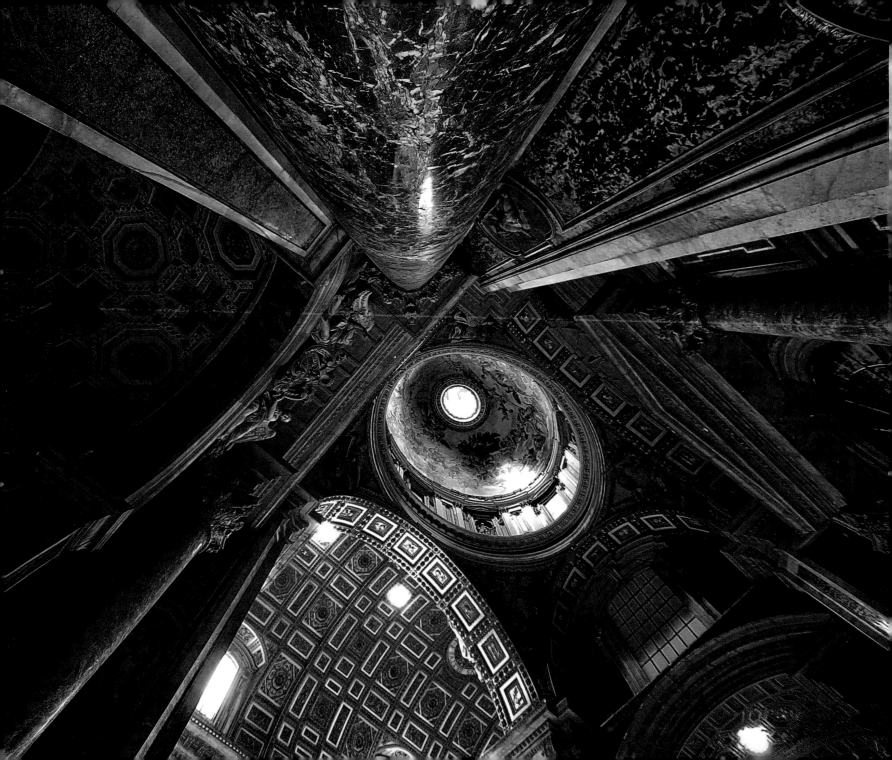

1.11A
CAMERA: Canon EOS 1D MkII
LENS: Sigma AF 10-20mm f/4-5.6 EX DC HSM
SETTINGS: f/5, ISO 100, 1.6 seconds manual
 mode
FLASH: no flash
METERING FOCAL MODE: centreweighted average
FOCAL LENGTH: 10mm

Vatican City the smallest independent state in the world, by both area and population, spreads over an area of 110 acres (45 hectares). Saint Peter's Basilica has the largest interior of any Christian church in the world and I was pleasantly surprised that you can take photos throughout the large walkways and side sections (no tripods though). Be prepared to spend extensive periods of time in queues.

The key challenge of photographing the spectacular inside sections is that large number of tourists block most of your shooting angles and vistas. Light conditions will also cause some issues, requiring longer than normal exposure techniques to be adopted. To obtain a still photo, I positioned the camera body on the floor with the lens facing straight up and took a series of shots until the desired effect was achieved.

The shot was captured with the Canon EOS 1D MkII camera. I took some 200-odd photos that day in the Basilica, but this is one of my favourites because of the different angle.

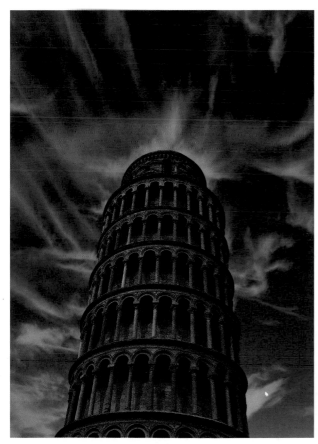

1.11B – f8, 1/320 sec, ISO 100

1.11C – f2.8, 1/125 sec, ISO 100

1.12 WATER CITY

A second visit to Venice, and the neighbouring island of Murano, provided many opportunities for taking great photos. There is simply no shortage of places and subjects to shoot here and each turn along canals and walkways provides new levels of inspiration.

I would highly recommend taking the time to visit the neighbouring islands to avoid the crowds and tourists. The biggest challenge one faces is what to focus on and a wide range of photography styles can all be accommodated. My photography was still very much in its embryonic stages yet the results were quite rewarding.

1.12A
CAMERA: Canon EOS 1D MkII
LENS: Sigma AF 10-20mm f/4-5.6 EX DC HSM
SETTINGS: f/10, ISO 100, 1/200th second
manual mode
FLASH: no flash
METERING FOCAL MODE: centreweighted average
FOCAL LENGTH: 20mm

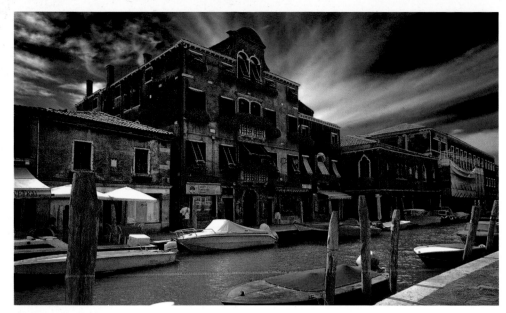

1.12B – f8, 1/125 sec, ISO 100

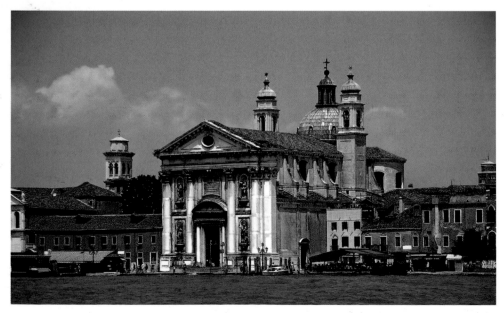

1.12C – f5.6, 1/1250 sec, ISO 100

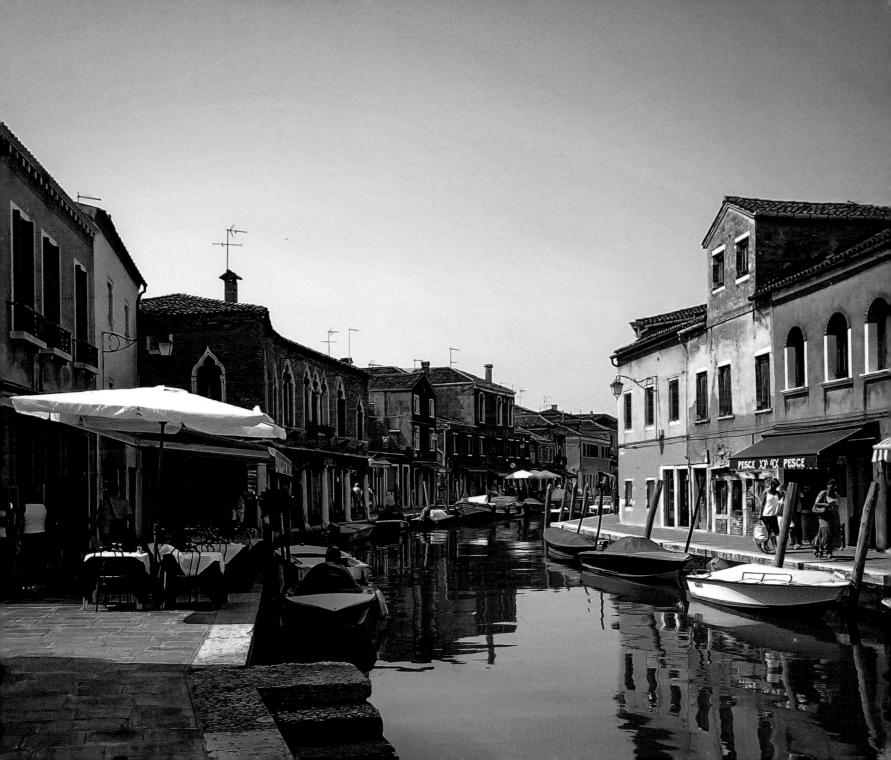

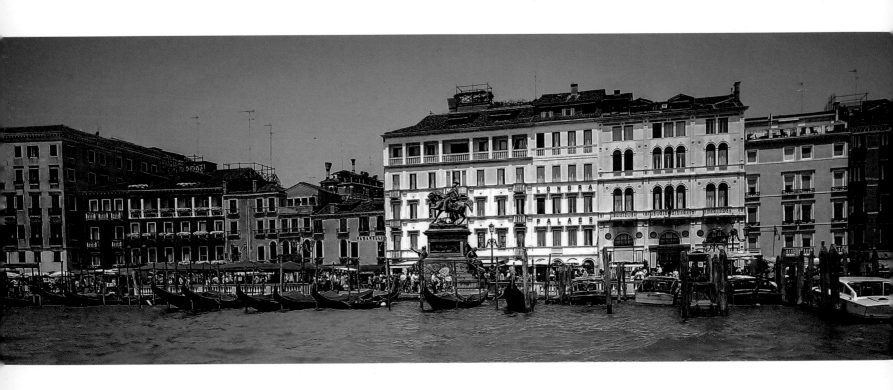

1.13A
CAMERA: Canon EOS 1D MkII
LENS: Sigma AF 10-20mm f/4-5.6 EX DC HSM
SETTINGS: f/6.3, ISO 100, 1/500th second
 manual mode
FLASH: no flash
METERING FOCAL MODE: centreweighted average
FOCAL LENGTH: 20mm

A trip along the Grand Canal by *Vaporetto* (water ferry) is a must, not only for transport from one place to another, but to provide opportunities where different viewpoints for shots can be achieved. The *Vaporettos* travel across about 19 scheduled lines that serve locales within Venice and nearby Islands. As these transport vessels run pretty well all day, it is a great way to learn where some of the best features of Venice can be photographed. I would highly recommend several trips along the Grand Canal for the many wonderful sites to be captured.

This shot was taken coming back from Burano island, just before the Grand Canal commences. Use a very fast shutter speed when travelling on any ferries/boats to avoid blurred shots.

1.13B – f5, 1.125 sec, ISO 100

1.14B- f11, 1/50 sec, ISO 100

1.14 INTERESTING FEATURES

This photo focuses on the Doge's Palace's façade towards St Mark's Square. The photo was taken at the top of the St Mark's bell tower (*Campanile di San Marco* in Italian), which is located directly across the square.

Access to the top of the bell tower is easy—just take a lift to a viewing balcony that offers 360-degree views. You can expect some queues however I would strongly recommend the wait.

Once up there, you have some majestic views across all parts of Venice and its waterways.

In taking this shot, I purposely focused and framed my shot tightly to show the various patterns both on the plaza itself and the architectural design on the façade of the Doge's Palace. The mix of the old building and the adjoining café area provided a nice balance and an interesting shot. I was pleased, also, with the angle of the shot as it was not something that most people would photograph and yet there were sufficient details to provide a sense of relaxed activity.

Basic post editing of the photo was done in Photoshop to give the image a sepia tone, which gives the image a somewhat antique look and feel.

1.14A
CAMERA: Canon EOS 1D MkII
LENS: Canon 24-70mm f/2.8 IS USM
SETTINGS: f/8, ISO 100, 1/640th second
 manual mode
FLASH: no flash
METERING FOCAL MODE: centreweighted average
FOCAL LENGTH: 30mm

1.14C – f5.6, 1/500 sec, ISO 100

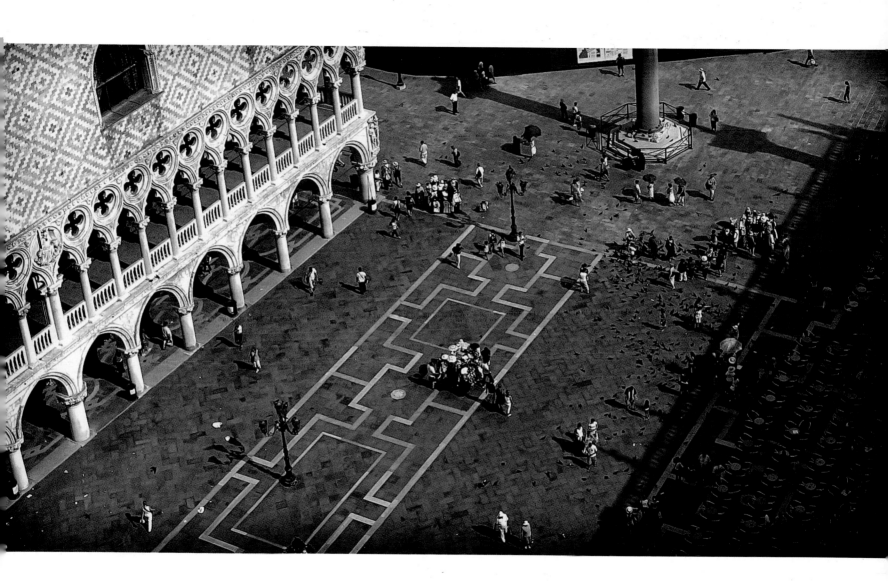

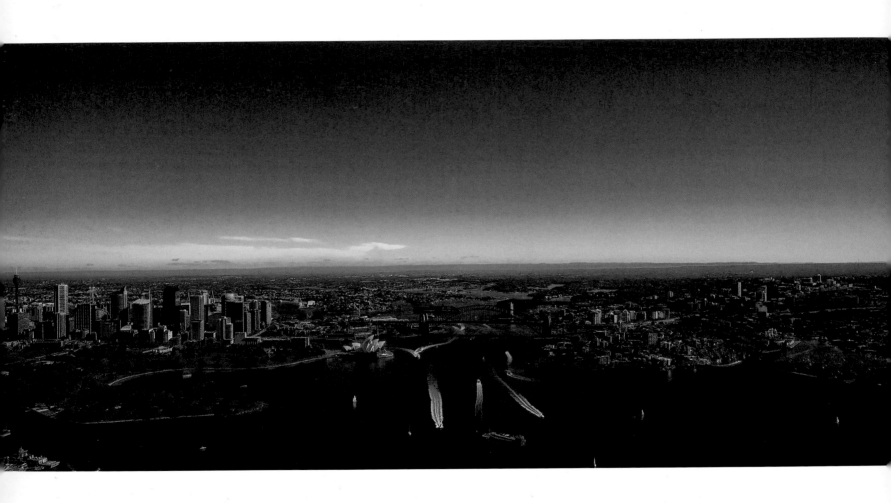

1.15 AERIAL VIEWS

If you are wanting to take some aerial shots, ask the flight company if their service provides flights specifically for photographers.

There is a difference between a joy flight and one for photographers. When booking, I asked numerous questions about the flight itself and exactly which part of the habour we would be flying over. I also expressed my need to take a large number of photos with some great scenery and panoramic angles. I found out that the pilot had previously been a professional photographer and I was assured that the flight would be extremely accommodating.

Once up in the air, the helicopter was positioned away from sun glare and would 'hover' in selective spots, in lieu of continuous flying, allowing me the best opportunity to capture special shots. In 30 minutes, I took about 120 photos. To avoid constantly changing lenses on the camera, I used two cameras each with separate lenses—a Canon 550D camera with a 24-105mm f/4 L IS USM lens on it, as the 1.6x crop factor of the 550D body with this lens extended the reach for shots and the Canon EOS 5D MkII camera with the EF 16-35mm f/2.8 L II USM lens. This lens offers exceptional coverage over a very large wide framed area and is one of the best landscape lenses available.

The helicopter had side windows that could be opened, giving me direct, uninterrupted views without the fear of glare or reflections occurring. The only form of post editing done was to crop the photo at the top and bottom in Photoshop to create a more panoramic result.

1.15A CAMERA: Canon EOS 5D MkII
LENS: Canon 24-105mm f/4 L IS USM
SETTINGS: f14 ISO 400 shutter speed of 1/400th second—manual mode
FLASH: no flash

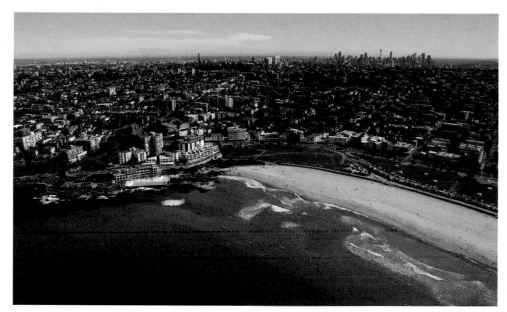

1.15B – f9, 1/200 sec, ISO 100

1.15C – f9, 1/160 sec, ISO 100

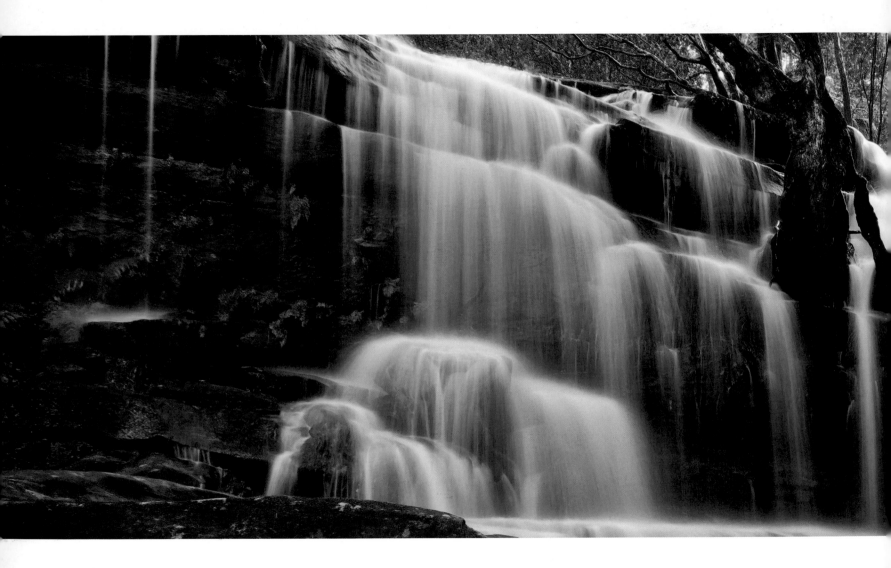

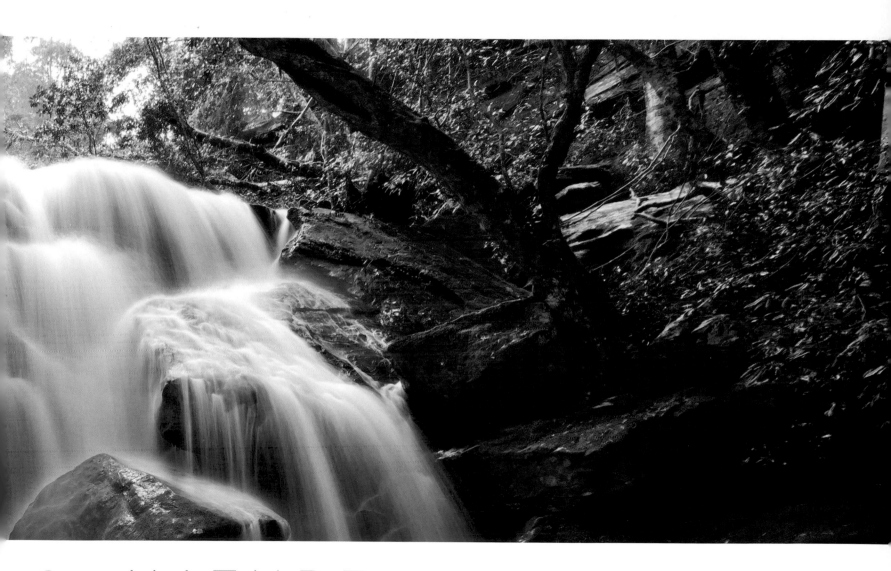

2. NATURE

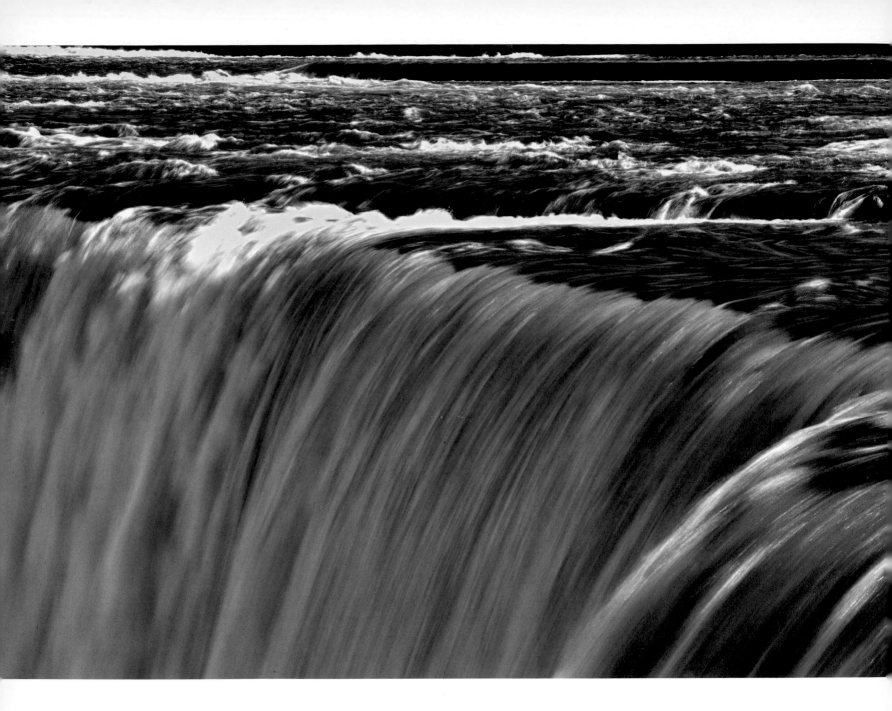

2.1 RUSHING WATER

A recent visit to Canada in September 2011 gave us the wonderful opportunity to visit Niagara Falls. The Horseshoe Falls, located on the Canadian side, were at their peak at the time of our visit and the opportunity to photograph them was not wasted. The sheer expense of water coming from Lake Erie is something to behold. The verdant-green colour of the water flowing over the Niagara Falls is a by-product of the estimated 60 tonnes per minute of dissolved salts and 'rock flour' (very finely ground rock) generated by the erosive force of the Niagara River itself. The photos have not been enhanced to reflect the tonal colour. The range of photographic scope is limitless.

Given the huge amount and force of the flow of water, I would highly recommend that you use some protective material to cover your gear. The spray gusts that arise at random will get you soaked very quickly and without much warning. A series of dry cloths to keep your lens dry are a must.

2.1A
CAMERA: Canon EOS 5D MkII
LENS: Canon EF 70-200 f/2.8 L IS II USM
SETTINGS: f/32, ISO 100, 1/8th of a second
 manual mode
FLASH: no flash
METERING FOCAL MODE: centreweighted average
FOCAL LENGTH: 200mm
tripod used

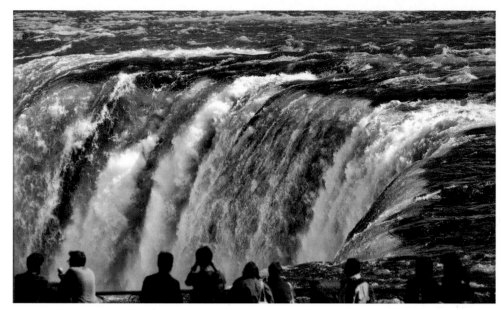

2.1B – f5.6, 1/800 sec, ISO 100

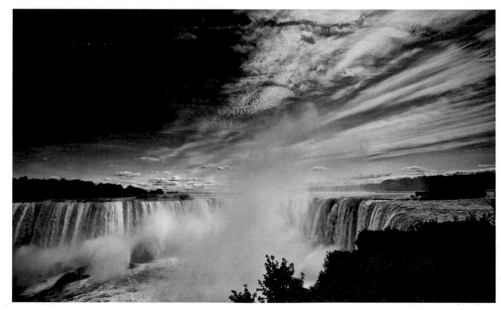

2.1C – f4.5, 1/320 sec, ISO 100

2.2 RULE OF THIRDS

This dramatic handheld shot of the Niagara Falls was taken further along the edge of the precipice.

I chose to frame the photo during the shoot using the concept of the 'rule of thirds'. The rule of thirds is often used by photographers to better position and frame the content of the photo.

The basic principle of this rule is to imagine the image you are taking is divided into thirds (both horizontally and vertically). As you're taking an image you would have done this in your mind through your viewfinder or in the LCD display that you use to frame your shot. The theory is that if you place the key points of interest in the intersections or along the lines that your photo becomes more balanced and will enable the viewer of the image to be better drawn to the the shot as a whol.

So in this photo, the side of the rocky outcrop makes up one-third of the shot vertically and also the bottom green section is also roughly one-third of the photo at a horizontal level.

The shot is engaging because of the sheer power of the falls and the tiny group of individuals adjacent to this natural force.

2.2A
CAMERA: Canon EOS 550D
LENS: Canon EF 70-200 f/4 USM
SETTINGS: f/6.3, ISO 100, 1/320th of a second
 manual mode
FLASH: no flash
METERING FOCAL MODE: centreweighted average
FOCAL LENGTH: 75mm

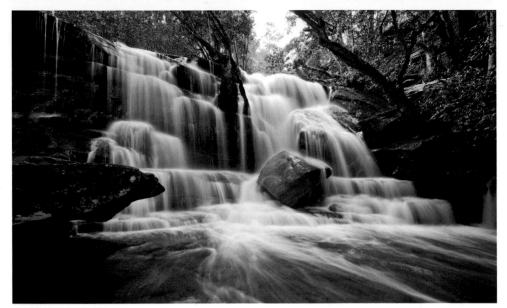

2.2B – f11, 1.3 sec, ISO 100

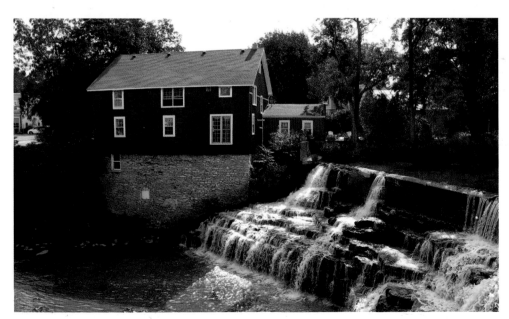

2.2C – f7.1, 1/100 sec, ISO 100

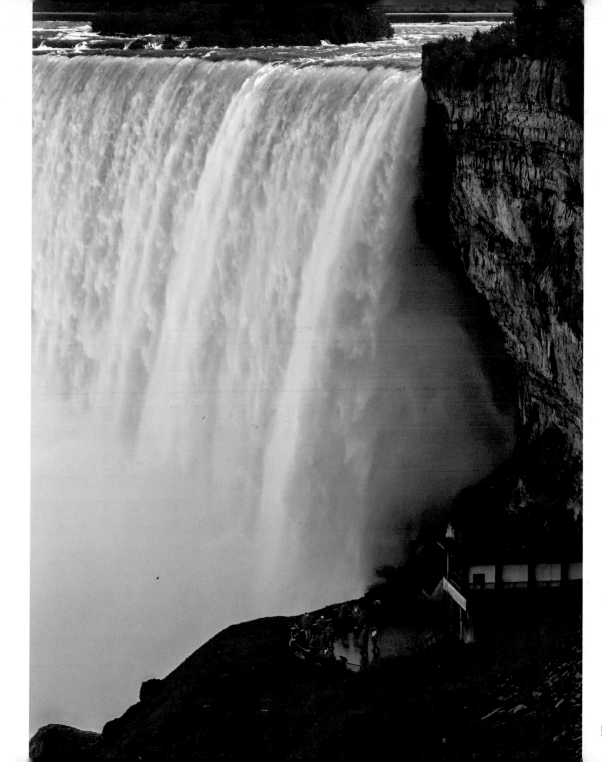

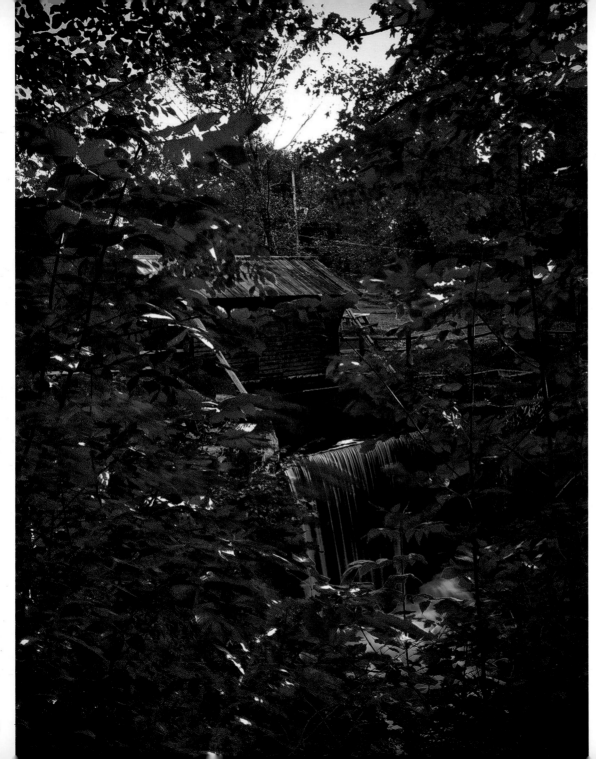

2.3 FOLIAGE

I have always been fascinated by water mills that are spread over other parts of the world. Having landed in Syracuse in New York State, we would then travel via numerous hills, valleys, lakes and streams that nestle in the beautiful Finger Lakes region.

We visited 'New Hope Mills' near New Hope Falls. The visit was not quite on the cusp of the Fall season, which would have made the shot more attractive with all the seasonal colours. Nonetheless, the location of this old mill in total wilderness was indeed a sight to behold. The challenge I had when taking this shot was to capture the ambience of the forest and, at the same time, smooth out the water as it poured over the edge of falls. The light was still fairly bright from above so that aspect had to be counteracted.

This photo was captured with the Canon EOS 5D MkII camera. A tripod was used to ensure a long exposure shot was taken to smooth out the flow of water. A neutral density graduated filter was also used to block out incoming light from the top of the frame. Using the filter ensured no over exposure occurred from the bright sky. The shot could have been taken with less exposure time (eg: 2–3 seconds) but trial and error provided the best results in trying to balance the overall effect.

2.3A
CAMERA: Canon EOS 5D MkII
LENS: Canon EF 16-35mm f/2.8 L II USM
SETTINGS: f/20, ISO 100, 8 seconds exposure
 manual mode
FLASH: no flash
METERING FOCAL MODE: centreweighted average
FOCAL LENGTH: 33mm
tripod used

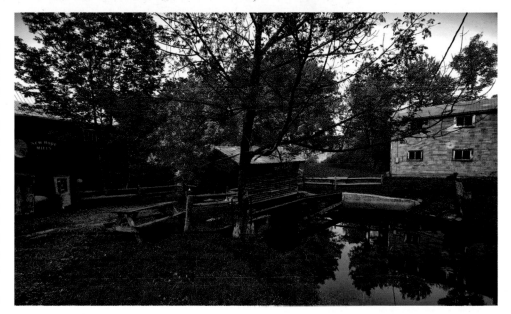

2.3B– f14, 1/3 sec, ISO 100

2.3C – f16, 1/10 sec, ISO 100

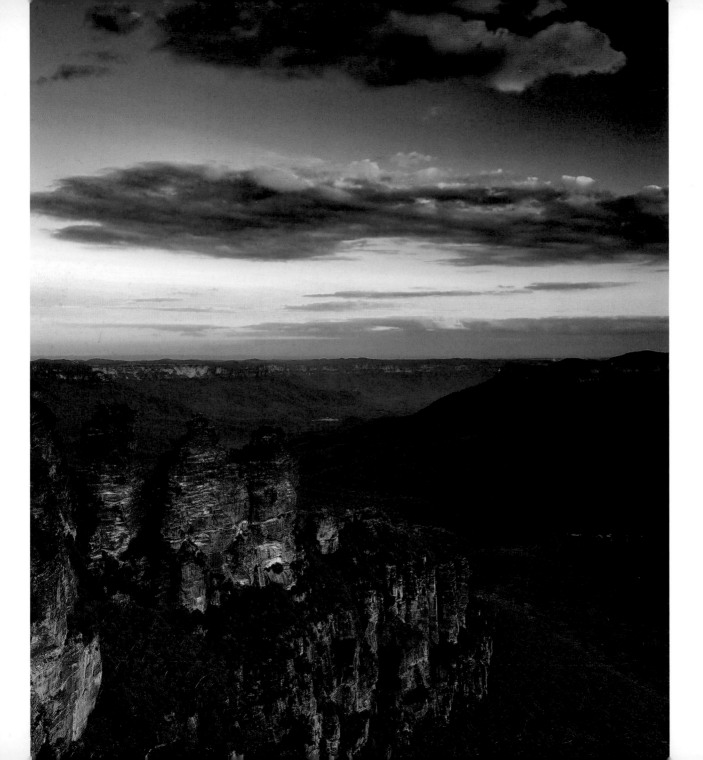

2.4 OUTDOOR FEATURES

A group of fellow photographers and I have wandered through numerous locations near here and a large number of renowned photographers have captured the beauty of this wilderness area. The 'Three Sisters' are probably the most photographed in this area due to the fact that you can drive right up to the nearby car park and wander some 100 metres along wide footpaths and snap away at the huge gorge.

The shot was taken late in the afternoon with the setting sun in the west, on the right-hand side of the photo. The red tinge of the cloud was caused by the lowering of the sun. I would recommend shooting there later in the afternoon to avoid the crowds and to capture the best light conditions.

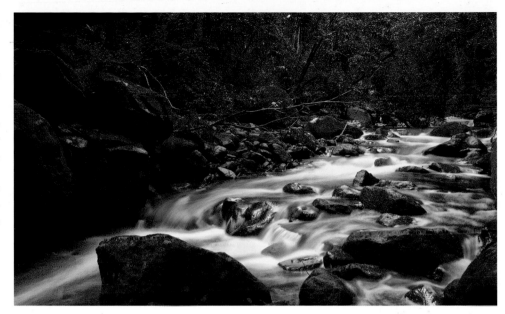

2.4B - f16, 4 sec, ISO 100

2.4C – f22, 0.3 sec, ISO 100

2.4A
CAMERA: Canon EOS 5D MkII
LENS: Canon EF 16-35mm f/2.8 L II USM
SETTINGS: f/14, ISO 100, 4 seconds manual
 mode
FLASH: no flash
METERING FOCAL MODE: evaluative
FOCAL LENGTH: 31mm
tripod used

2.5 SHADE

Minnamurra National Park is a rare subtropical and temperate rainforest. The habitat is truly spectacular and the purpose of our visit was to shoot the various flora, streams and waterfalls in constant low light conditions. We specifically positioned our visits after the area had experienced huge storms for a period of two weeks as we felt that the volume of water dumped in that region would be something worthwhile to experience and capture. We were not disappointed and the weather that day was still fairly grey and threatening, forcing other visitors indoors.

The target was to capture true wilderness and lots of waterfalls. For this shot, a tripod was positioned right in the flowing stream itself to get this shooting angle. I had a tight grip on the tripod at all times to limit any vibration from the flowing water around the tripod legs. If you intend to do some trekking through water and harsh conditions, invest in a robust and sturdy tripod. The shots will be enhanced greatly. By skimping out on the tripod you risk jeopardising the whole package, the results can be poor and, more importantly, you are putting your gear at risk.

– f7.1, 5 sec, ISO 100

2.5A
CAMERA: Canon EOS 5D MkII
LENS: Canon EF 16-35mm f/2.8 L II USM
SETTINGS: f/13, ISO 100, 1.6 seconds exposure
 manual mode
FLASH: no flash
FOCAL LENGTH: 35mm

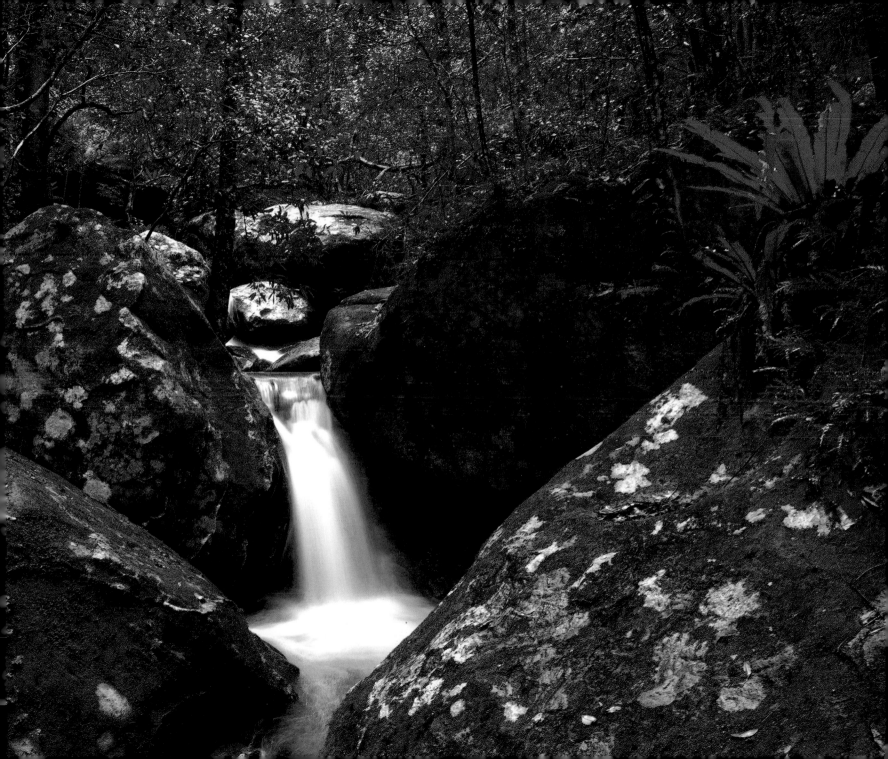

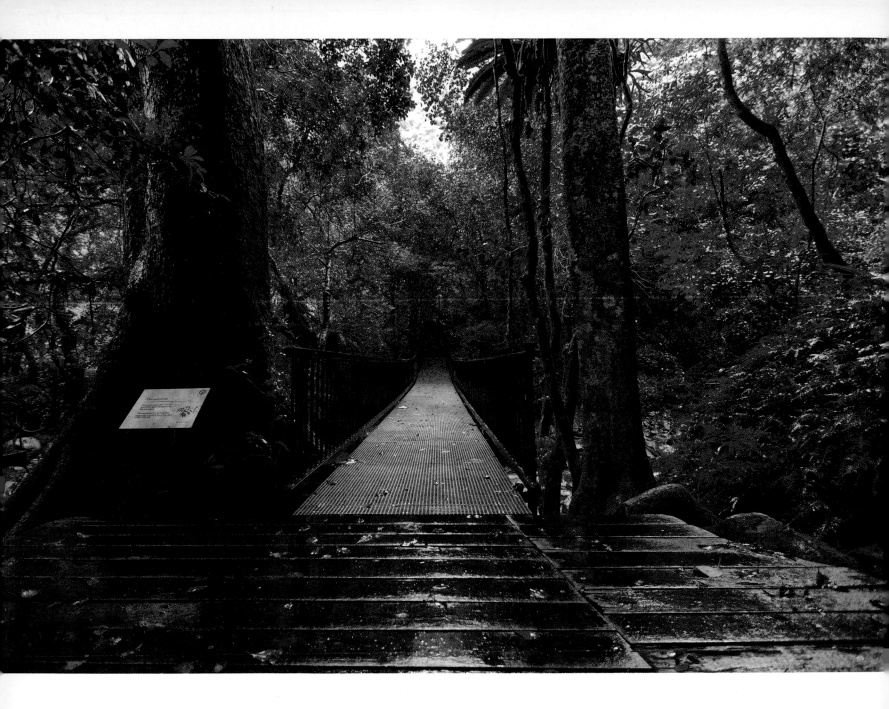

2.6 STREAMS

Rainforests in all their glory do offer the photographer lots of opportunities to shoot great photos. The subject in such locations is not always the flora or fauna part but can also be man-made infrastructure.

The concept of lines is a fundamental trait in photography and in this scenario an empty bridge is the perfect example. I'm always trying to get out in such locations when the weather has been less than perfect (for visitors and picnics). In this instance, the constant rain leading up to our visit has provided a total wet look on all aspects of the scene. The wet components will always provide a more vibrant shot and the reflections on the walkway add an extra level of detail and interest.

2.6A
CAMERA: Canon EOS 5D MkII
LENS: Canon EF 16–35mm f/2.8 L II USM
SETTINGS: f/2.8, ISO 100, 3/10th of a second exposure manual mode
FLASH: no flash
METERING FOCAL MODE: centreweighted average
FOCAL LENGTH: 16mm
tripod used

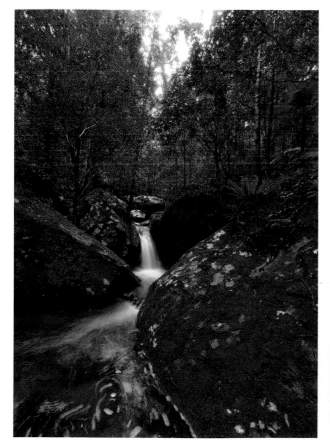

2.6B – f13, 1.6 sec, ISO 100

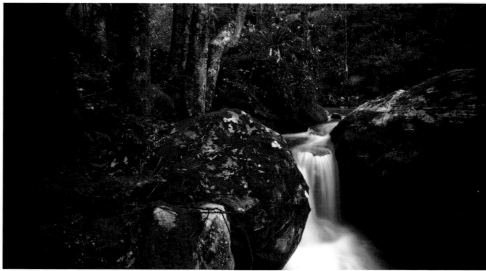

2.6C – f14, 5 sec, ISO 100

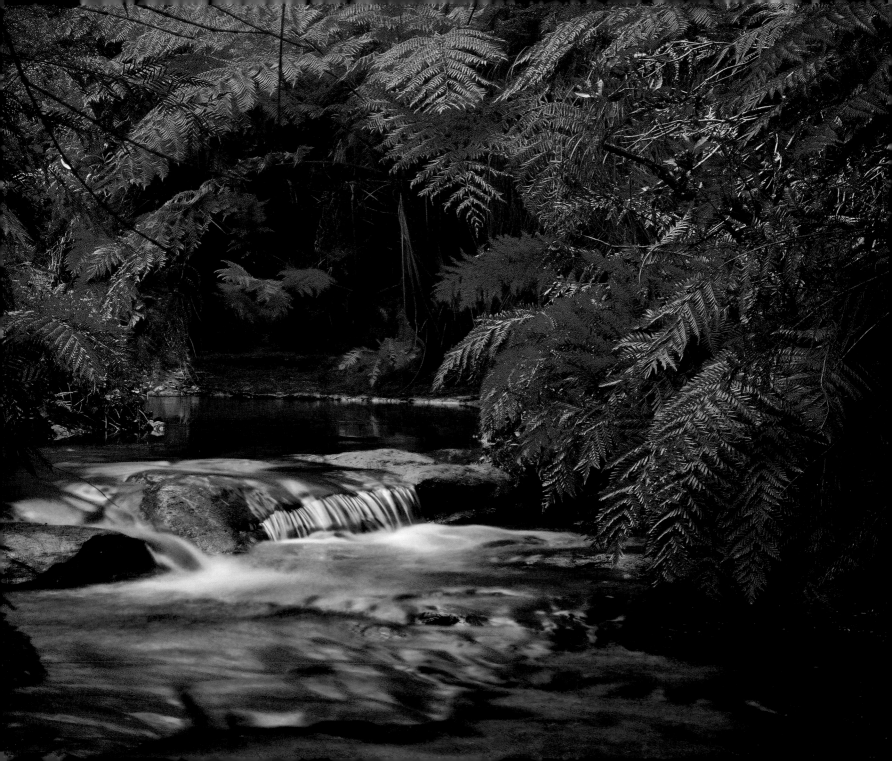

2.7 HIDDEN FROM VIEW

This photo was taken downstream from the majestic Leura Cascades. I basically followed the stream from the cascades and kept looking back to find interesting framed sections of the stream. The opening chasm two-thirds of the way up created a 'down light' effect amongst all the ferns—a very serene area in total immersion with nature.

The shot was subsequently cropped at the top to give a wide feel to the photo.

2.7A
CAMERA: Canon EOS 5D MkII
LENS: Canon EF 16-35mm f/2.8 L II USM
SETTINGS: f/22, ISO 100, 1.3 second exposure—manual mode
FLASH: no flash
METERING FOCAL MODE: centreweighted—average
FOCAL LENGTH: 16mm
tripod used

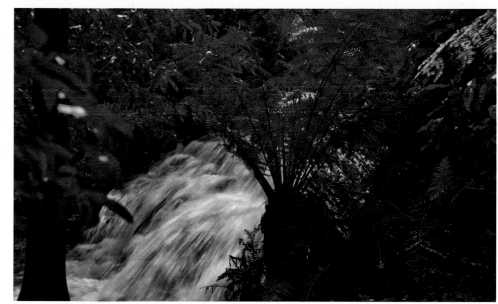

2.8B – f4,1/20 sec, ISO 100

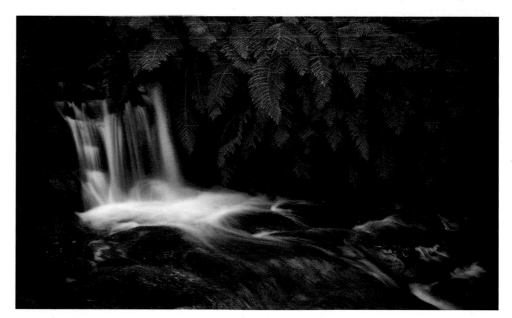

2.8C – f22, 1/3 sec, ISO 100

2.8 ROCK FORMATIONS

In a recent trip to the Finger Lakes district in New York State, a hidden treasure was unearthed. Watkins Glen State Park is located south of Seneca Lake, in the township of Watkins Glen, Schuyler County.

Arriving at a car park off the main road, nothing prepares you for the showpiece that is hidden in a series of gorges along a 1.5-mile (2.4km) man-made carved track. The trail starts from a dark tunnel cut into the limestone rock face on the cliff side. Once past the tunnel you enter a series of meandering, tight gorges with natural limestone stone walls that have been carved out by strong water flows. Gazing upwards, you soon realise that you are surrounded by very steep walls rising up to 200 feet (60 metres). The gorge trail provides access to a series of 20+ waterfalls of different size and intensity. My wife and I only stayed in this area for about three hours, however you could stay there all day and still not capture every interesting shot that this place has to offer.

This photo was taken by my wife Mary with her Canon EOS 550D camera.

2.8A
CAMERA: Canon EOS 550D
LENS: Canon EF 17-40mm f/4.0 USM
SETTINGS: f/4, ISO 160, 1/50th second exposure—manual mode
FLASH: no flash
METERING FOCAL MODE: evaluative
FOCAL LENGTH: 36mm
tripod used

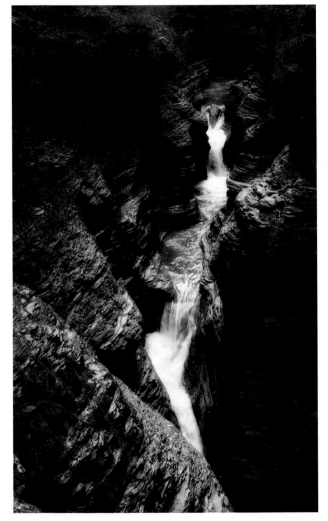

2.8B – f4, 1/30 sec, ISO 100

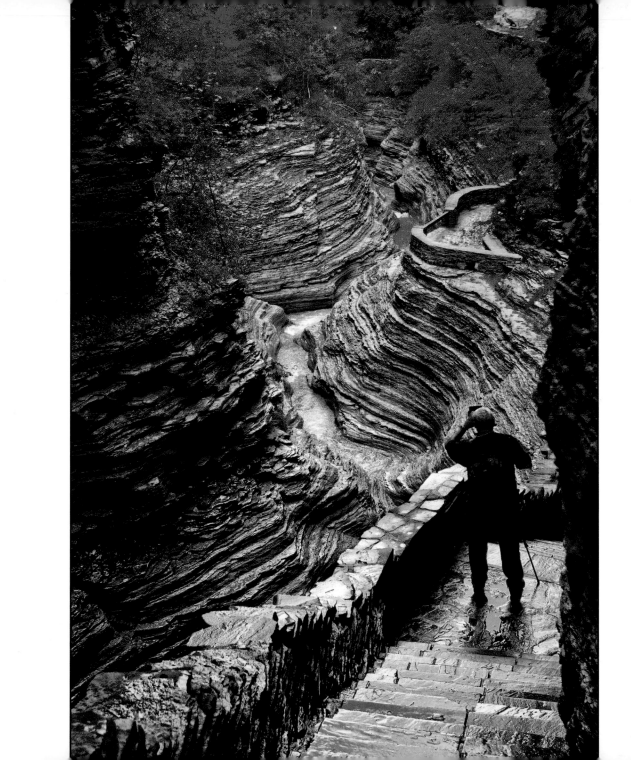

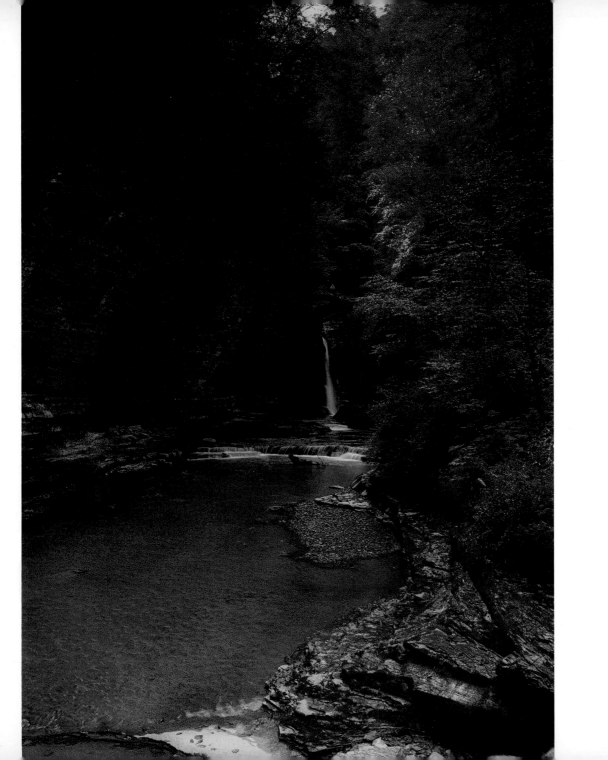

2.9 DARK AREAS

Some sections of the gorge open up providing more light to immerse the stream sections. I am told that after the winter snows have melted the flow of water within the gorge can rise up to 15 feet in some sections. The thunderous noise that this creates is something to behold. The water erosion from such events creates a variety of waterfalls, including small staircase, cascades, dripping curtains, punchbowls, plunges and chutes; ranging from a few feet to 60 feet (almost 20 metres) high. It is waterfall mecca!

I would also imagine that in late September, the fall season also provide a kaleidoscope of rich warm colours along the gorge walls.

2.9A
CAMERA: Canon EOS 5D MkII
LENS: Canon EF 16-35mm f/2.8 L II USM
SETTINGS: f/9, ISO 100, 1.3 second exposure manual mode
FLASH: no flash
METERING FOCAL MODE: centreweighted average
FOCAL LENGTH: 35mm
A tripod was used to secure the 1.3 second exposure.

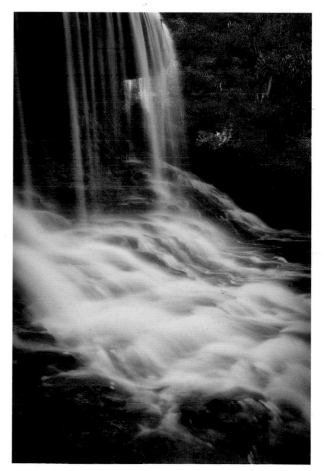

2.9B – f16, 2 sec, ISO 100

2.10A – f16, 3.2 sec, ISO 100

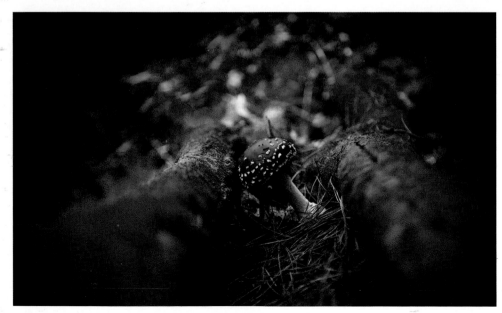

2.10B – f2.8, 1/640 sec, ISO 800

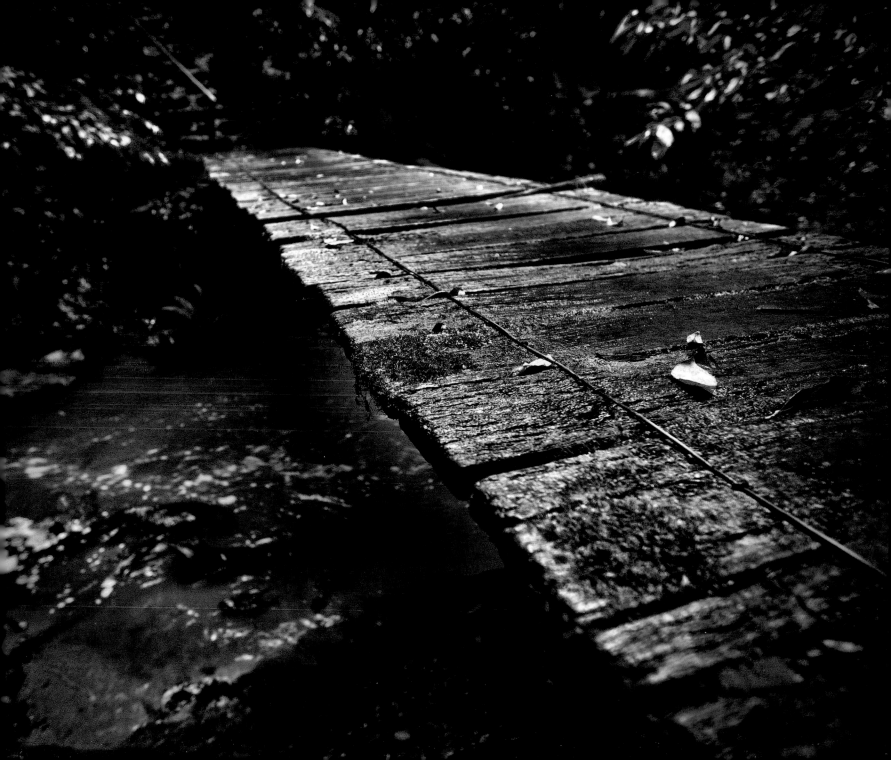

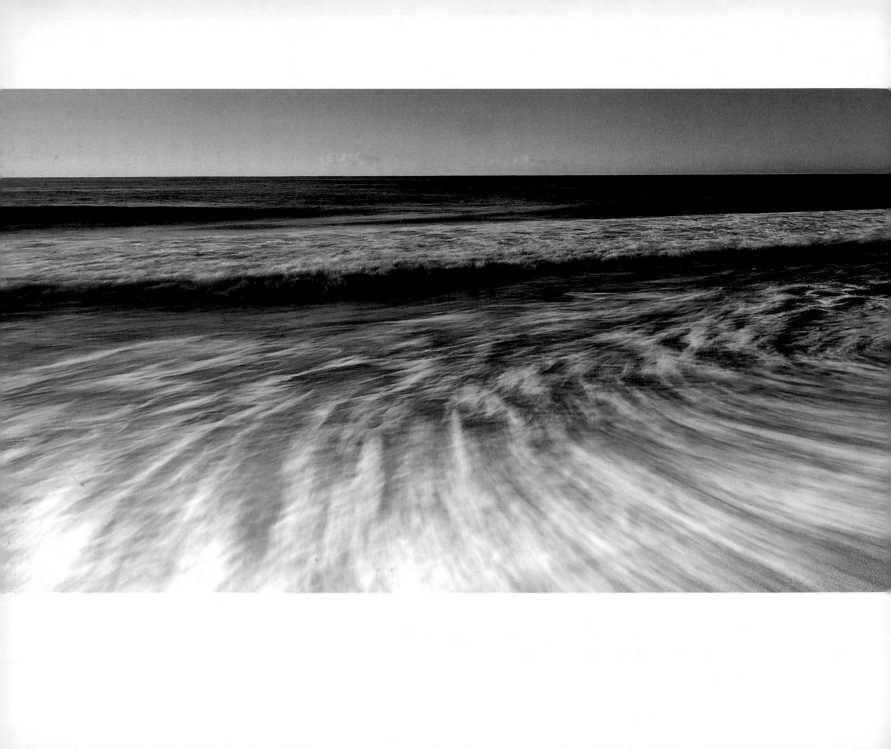

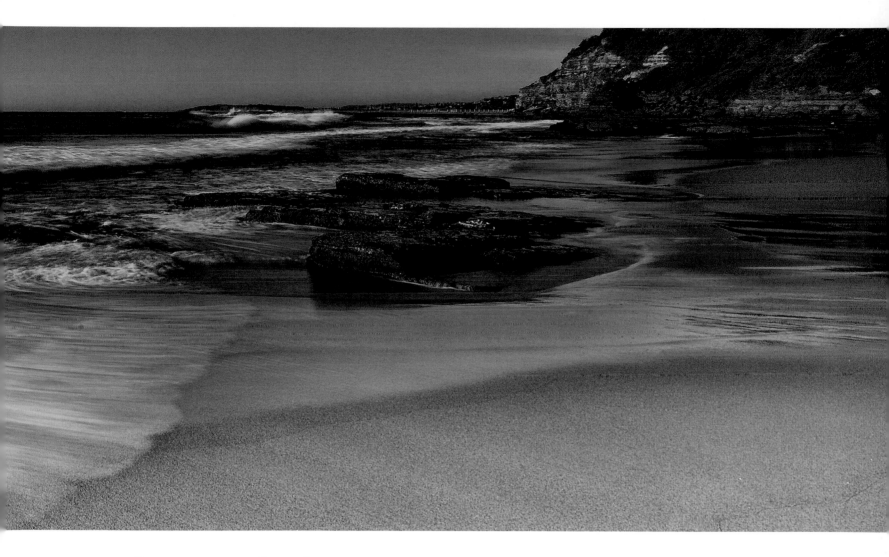

3. SEASCAPES

3.1 WATER OVERFLOW

Large contingents of beaches have ocean pools for public use. These ocean pools provide a wonderful canvas to capture both the serenity and drama of a man-made structure against the forces of nature. Being totally exposed to the elements, the pools are forever changing. I targeted this shot because of king high-tide patterns along the coast and I was keen to shoot the cascading overflow of water running through the pool, when the sunset was fast approaching. The glow of colour in the sky provided a great backdrop and, to some extent, softened the dramatic, rushing surges of water. It is important to ensure your safety at all times and no shot is worth putting yourself in danger for or jeopardising your equipment.

In landscape and seascape photography, the light condition plays a critical role. An indispensable piece of equipment to invest in is a neutral density graduated (ND grad) filter kit. The beauty of the ND grads is that it allows the photographer to reduce exposure in one part of the scene, while leaving the rest unaffected. ND grads are most commonly used when the sky is brighter than the foreground. By placing an ND across the bright area, the detail is retained, resulting in a more balanced composition. The other component that plays a crucial role is that it can allow you to take long shutter exposure shots whilst strong light is present. Two ND Grad filters were used in the main shot—0.6 and 0.9 thus enabling the capture of extended water flows effect.

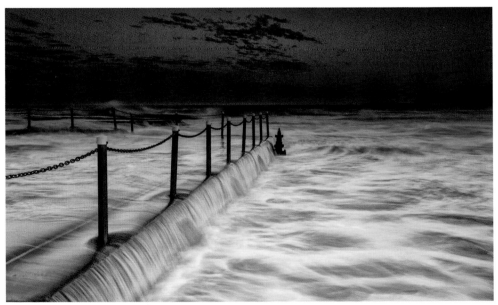

3.1A
CAMERA: Canon EOS 5D MkII
LENS: Canon EF 16-35mm f/2.8 L II USM
SETTINGS: f/22, ISO 100, 1.3 second exposure
 manual mode
FLASH: no flash
METERING FOCAL MODE: centreweighted average
FOCAL LENGTH: 16mm
tripod used

3.1B– f22, 1.3 sec, ISO 100

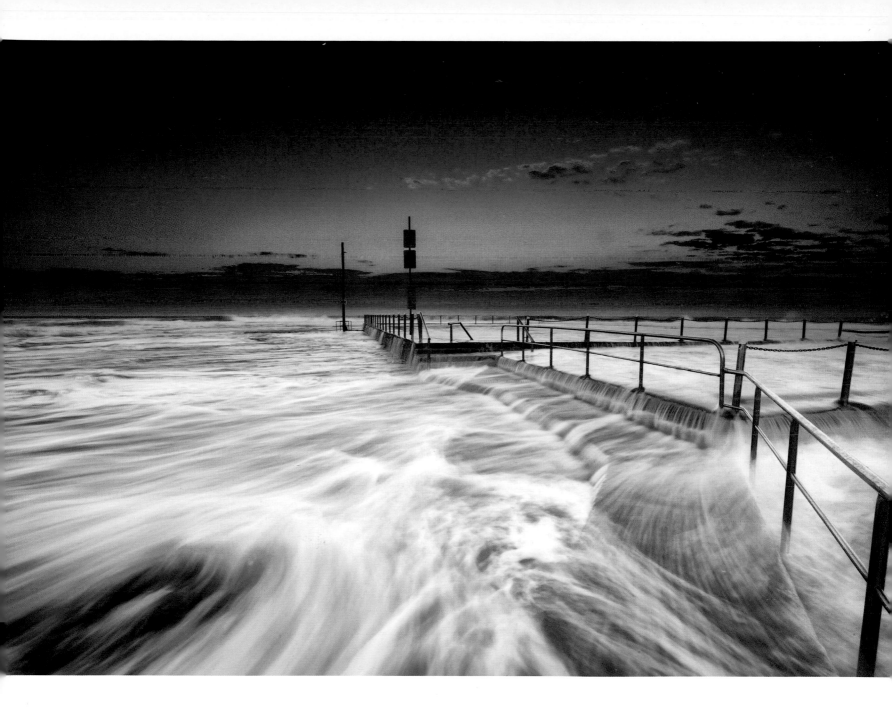

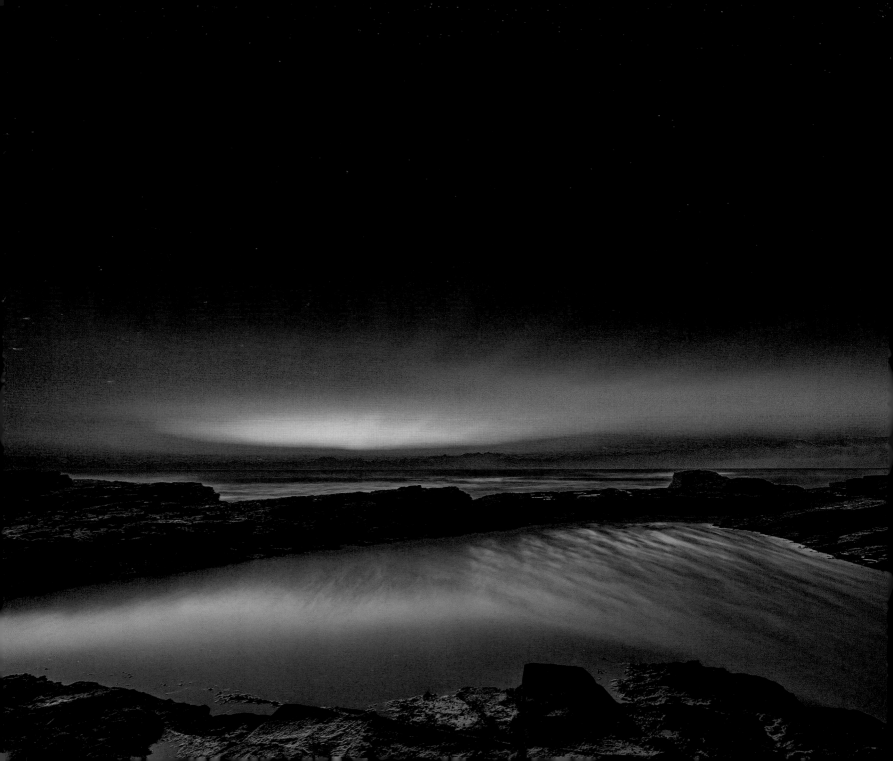

3.2 REEF SHOTS

This reef is renowned for its substantial large expanse of exposed rock shelves. It's made up of two primary rocky shores sections. The northern rocky reef area is protected from southerly swells by the prominent eastern headland, while the larger eastern platform is more exposed. It has a wide variety of habitats, including sheltered boulder fields and surf-exposed ledges. There is a constant change in conditions—from being totally underwater to dry and exposed to the sun. This intertidal location provides great photographic shooting conditions with spectacular results. Natural patterns in the landscape can lend themselves to abstract compositions in which colours and shapes play a dominant role.

We arrived on location almost one hour prior to sunrise, to get into position to take these shots. The location requires a 30 to 40 minute walk to the extremity of the rock shelf, in the dark. We made our way through the rock boulders and crevices that litter the entire rock shelf as shooting in such conditions provides additional opportunities to take photos that are truly different.

3.2A
CAMERA: Canon EOS 5D MkII
LENS: Canon EF 16-35mm f/2.8 L II USM
SETTINGS: f/7.1, ISO 100, 20 seconds exposure
 manual mode
FLASH: no flash
METERING FOCAL MODE: evaluative
FOCAL LENGTH: 16mm
tripod used

3.2B – f13, 20sec, ISO 100

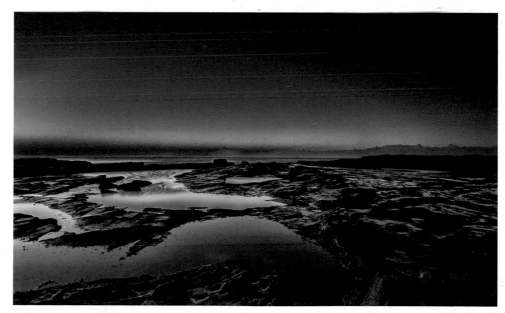

3.2C – f2.8, 15sec, ISO 100

3.3 GOLDEN DAWN

Early pre-dawn outings always give me an opportunity to enjoy and capture the period before and after sunrise. The 'golden hour', as it is often referred to, allows me to cram in as many shots as possible while the low angle of the sun produces long shadows, which create interesting patterns and textures to the scene. The quality of the light is also more 'golden' at these times and the dynamic colours are more pronounced and rich in their tone—a quality that is totally lost and burnt off once the sun is totally out. The results are usually also more aesthetic and can be quite surprising, even to the most experienced photographer. In this particular location, we again found ourselves pretty much alone with no one around, with the exception of a keen surfer catching the first waves of the day—a serene feeling to start a day.

3.3A CAMERA: Canon EOS 5D MkII
LENS: Canon EF 16-35mm f/2.8 L II USM
SETTINGS: f/13, ISO 100, 0.8 second exposure manual mode
FLASH: no flash
METERING FOCAL MODE: evaluative
FOCAL LENGTH: 23mm
tripod used

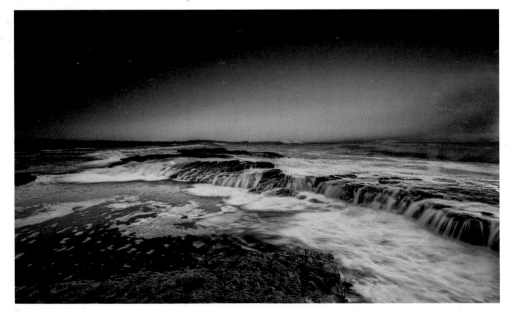

3.3B — f14, 0.8sec , ISO 100

3.3C — f13, 4 sec, ISO 100

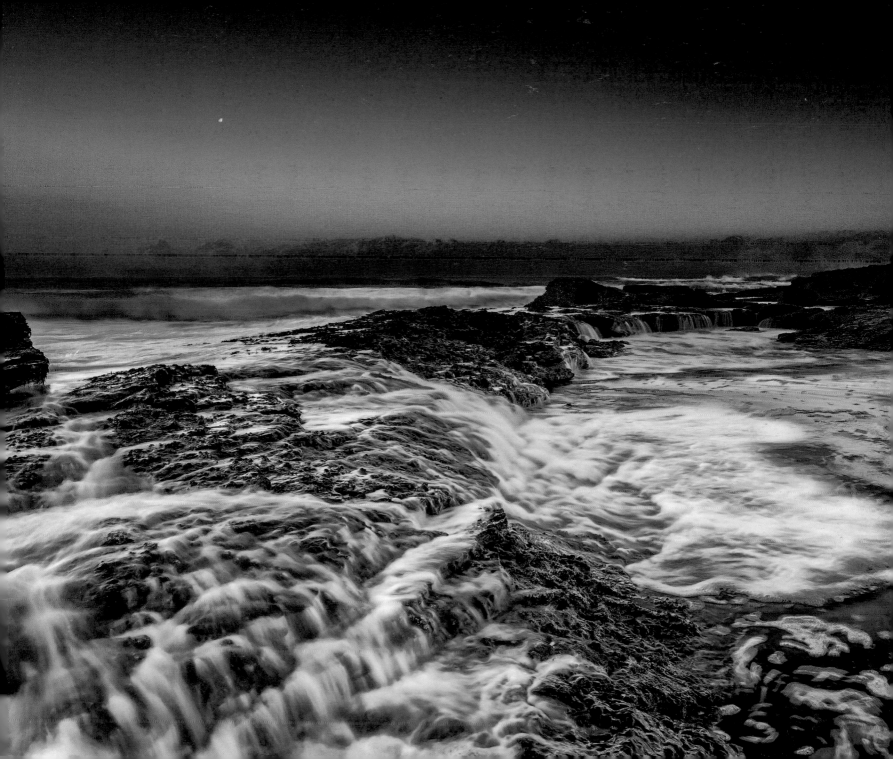

3.4 ABSTRACT SHOTS

Often the trekking you do to get to a specific location will take you through picturesque parts of the coasts or mountains. These tracks can also offer a photo opportunity and coupled with certain camera/lens combination techniques can record a more abstract scene. In this scenario, the focus was to bring attention to the open sandy patch that was surrounded by natural dune grasses. To achieve this, the shot was set up using a very narrow and shallow depth of field so as to blur out the background and forefront detail.

CAMERA: Canon EOS 5D MkII
LENS: Canon EF 16-35mm f/2.8 L II USM
SETTINGS: f/2.8, ISO 100, 1/60th of a second exposure
 manual mode
FLASH: no flash
METERING FOCAL MODE: evaluative
FOCAL LENGTH: 24mm

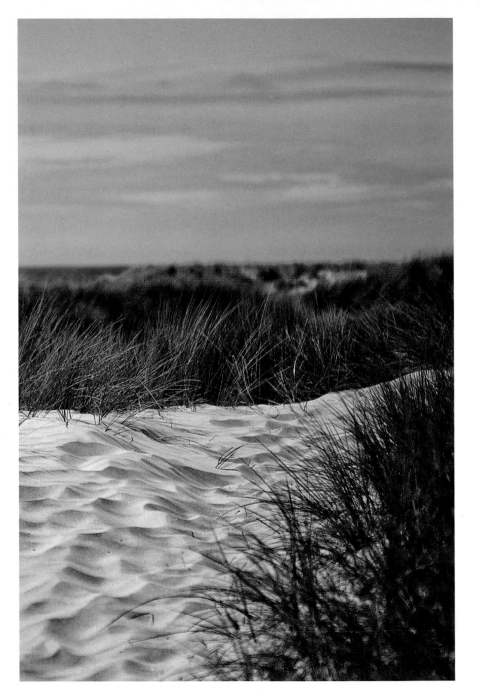

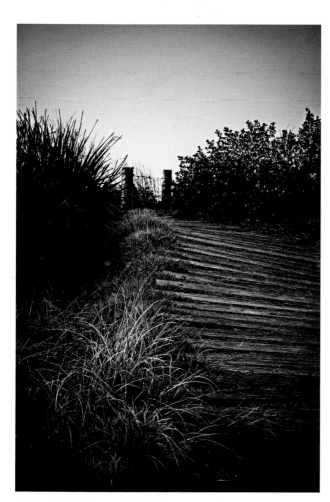

3.4B – f10, 1/80 sec, ISO 100

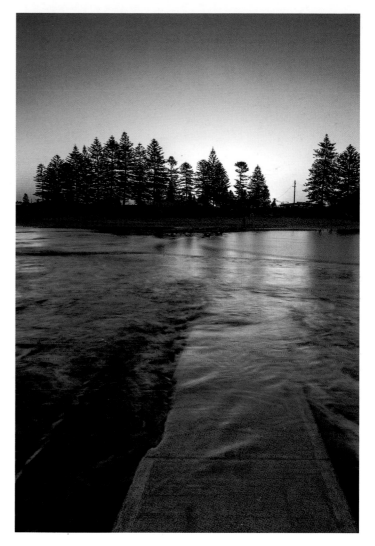

3.4C – f11,0 .8 sec, ISO 100

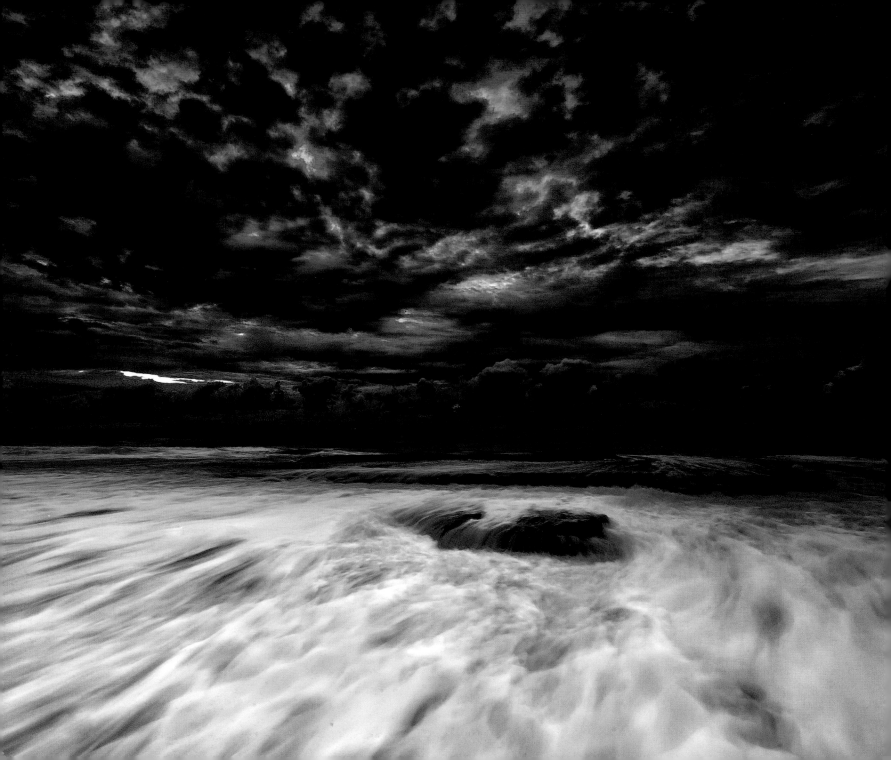

3.5 CLOUDY DAWN

For this particular location, my friend Johnny and I headed there knowing that, based on coastal watch information, a mid-tide and heavy cloud activity was on the cards. With almost an hour before first light was due to appear on the horizon, nothing prepared us for the show that was to unfold over the next 60 to 90 minutes. The waves could be heard crashing over a rock shelf some 262 feet (80 metres) out at sea and as the tide slowly eased back, we took the opportunity to wander ankle-to-knee deep in water towards the rock shelf. As the sun's rays started to filter through the line of the horizon, the light show that split the rolling cloudbanks gave us countless opportunities to capture some great dramatic scenes. The two of us fired off over 400 shots each to ensure our footprint had been made here.

I decided to use the neutral density graduated filter kit made by Cokin (XPro series). These filters do emit a stronger colour cast of pinks and mauves however they add drama to the composition of the shot. The other kit, a Lee Filter combination, provides true colour gradients and is exceptional in terms of quality.

All the photos on these pages were captured with the Canon EOS 5D MkII camera with the settings listed below. A tripod was well-anchored knee-deep in water for all shots. Given the constant rush of water, we took extra care to secure our equipment in waterproof backpacks as well as protective sleeve coverings for the camera and lens.

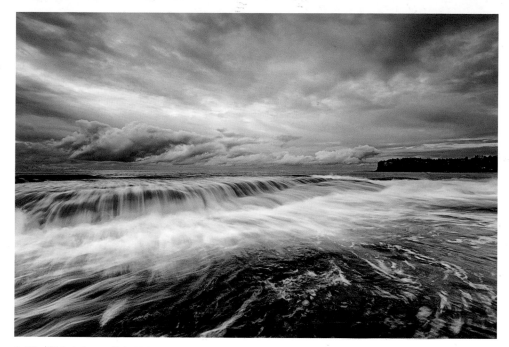

3.5B – f14, 0.8 sec, ISO 100

3.5A
CAMERA: Canon EOS 5D MkII
LENS: Canon EF 16-35mm f/2.8 L II USM
SETTINGS: f/14, ISO 100, 0.8 or 0.6 second exposures manual mode
FLASH: no flash
METERING FOCAL MODE: evaluative
FOCAL LENGTH: 16mm

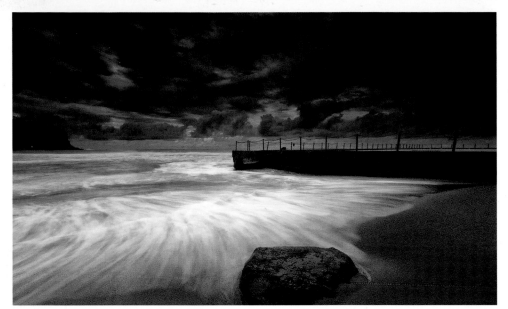

3.6 OVERCAST SKIES

3.6A
CAMERA: Canon EOS 5D MkII
LENS: Canon EF 16-35mm f/2.8 L II USM
SETTINGS: f/8, ISO 100, 10 seconds exposure
 manual mode
FLASH: no flash
METERING FOCAL MODE: evaluative
FOCAL LENGTH: 16mm
tripod used

3.6B — f13, 1.6 sec, ISO 100

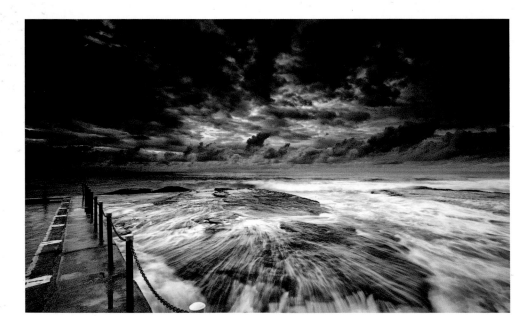

3.6C — f11, 1 sec, ISO 100

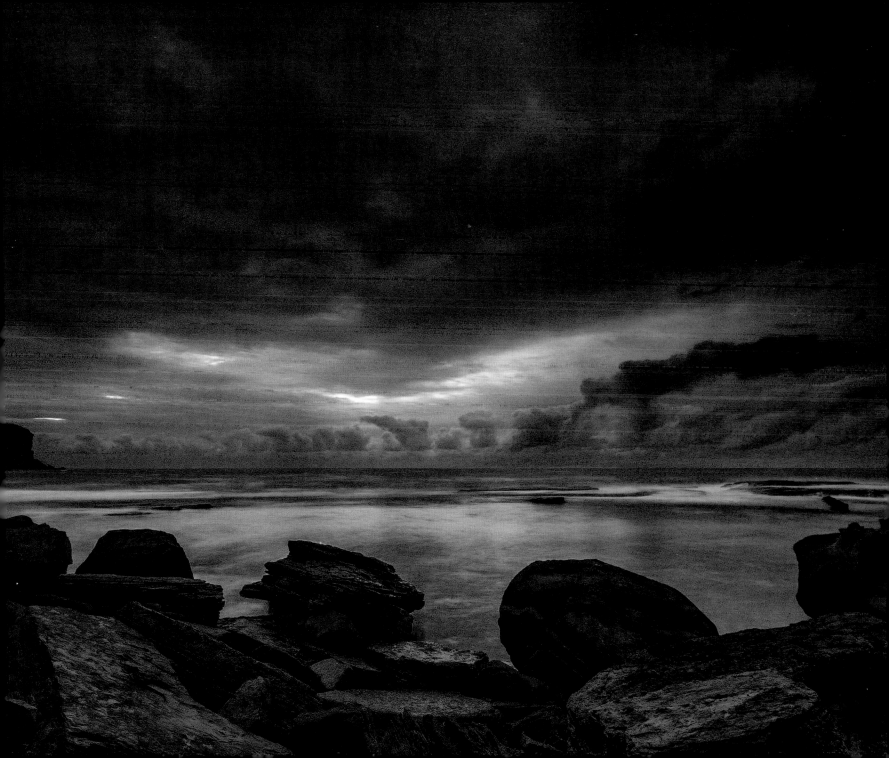

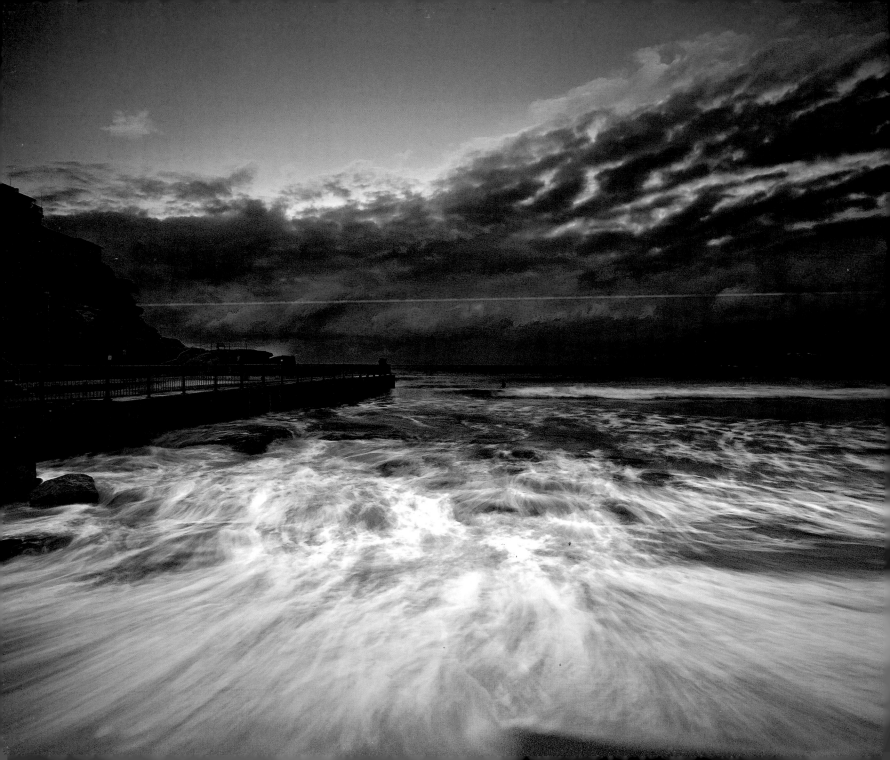

3.7 BEACH LOCATIONS

I am often surprised that sometimes you really don't need to wander off too far to get some really different shots. My wife Mary and I spent a seaside weekend and decided to head off for a walk an hour or so before sunset. We wandered down to the north end of the beach and after 40 minutes the two of us had fired off a series of shots, all with different outlooks and scenery. The weather had been fairly calm. No storms or excessive clouds brewing with little wind to speak off. Some good composed photos were taken with a range of interesting scenes.

The key point here is don't over-bake the lead up to taking some photos. Simply work with the gear that you have, think about why are you shooting these particular shots, experiment and judge the results to please yourself. Don't delete your failed attempts but try to learn why the shot is not what you like or expected. Review the shutter speed and aperture value and also the ISO range. If it's a composition issue, what parts do and don't work and what would you do differently given another chance? Before too long, you will be able to eliminate any poor shots from your initial attempts.

A tripod was also used with a ND Grad 0.9 filter (no-one got wet).

3.7A
CAMERA: Canon EOS 5D MkII
LENS: Canon EF 16-35mm f/2.8 L II USM
SETTINGS: f/7.1, ISO 100, 1.6 second exposure
manual mode
FLASH: no flash
METERING FOCAL MODE: evaluative
FOCAL LENGTH: 16mm

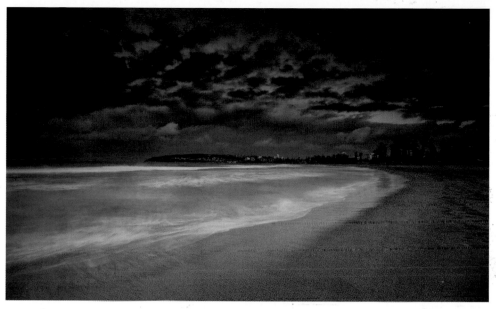

3.7B – f4, 5 sec, ISO 100

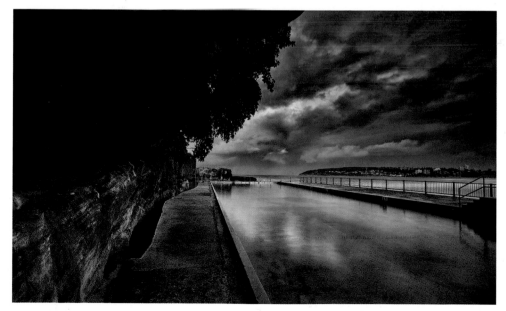

3.7C – f4, 8 sec, ISO 100

3.8 HEADLANDS

I have access to some wonderful locations within an hour of home. When the opportunity arises, I will go for leisurely drives and check out potential locations that might be worthwhile to photograph at a later point in time. Remembering that my photographic mates usually hit the coastal areas pre-dawn, it is prudent get a good idea about how certain locations can be best accessed and, more importantly, what potential dangers might be present in venturing out (especially in the dark). Yes, the camera is always in the back seat to assist with the record keeping. The other aspect of these drives is to appreciate proximity to wonderful seaside locations, with some pristine conditions, along heavily populated areas of suburbia.

3.8A
CAMERA: Canon EOS 5D MkII
LENS: Canon EF 16-35mm f/2.8 L II USM
SETTINGS: f/2.8, ISO 100, 1/40th of a second exposure manual mode
FLASH: no flash
METERING FOCAL MODE: evaluative
FOCAL LENGTH: 16mm

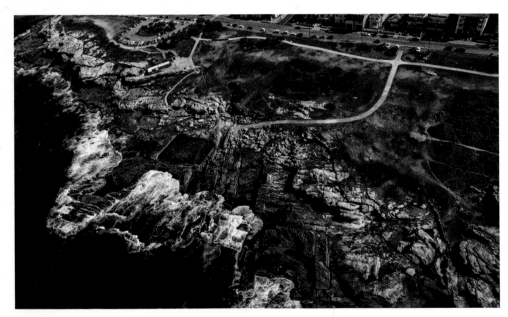

Above: 3.8B – f9, 1/160 sec, ISO 100
Following pages: 3.8C – f5, 1/500 sec, ISO100

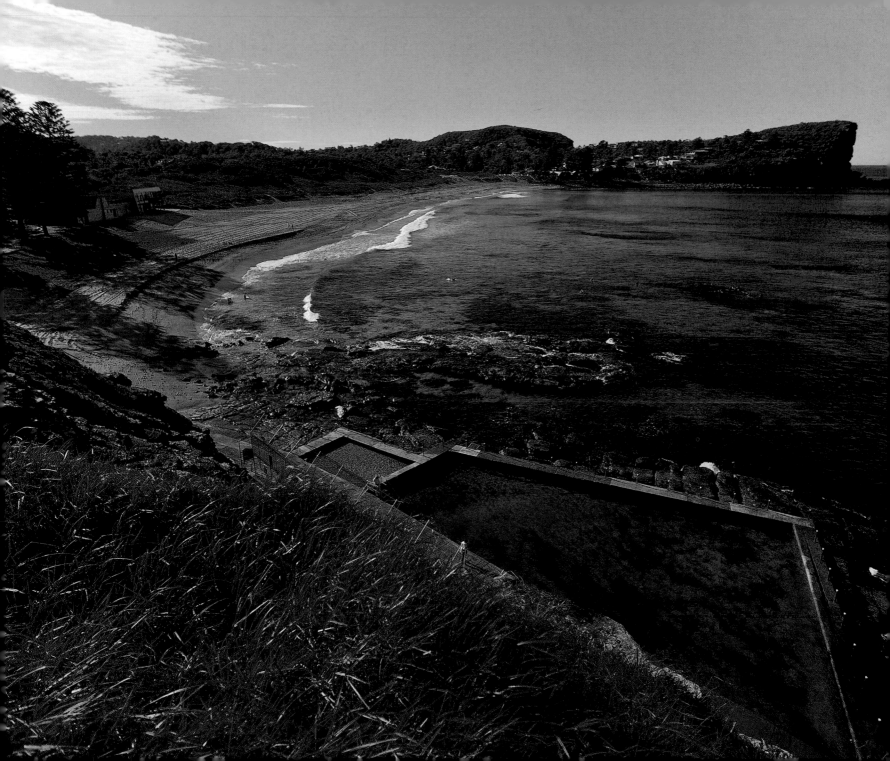

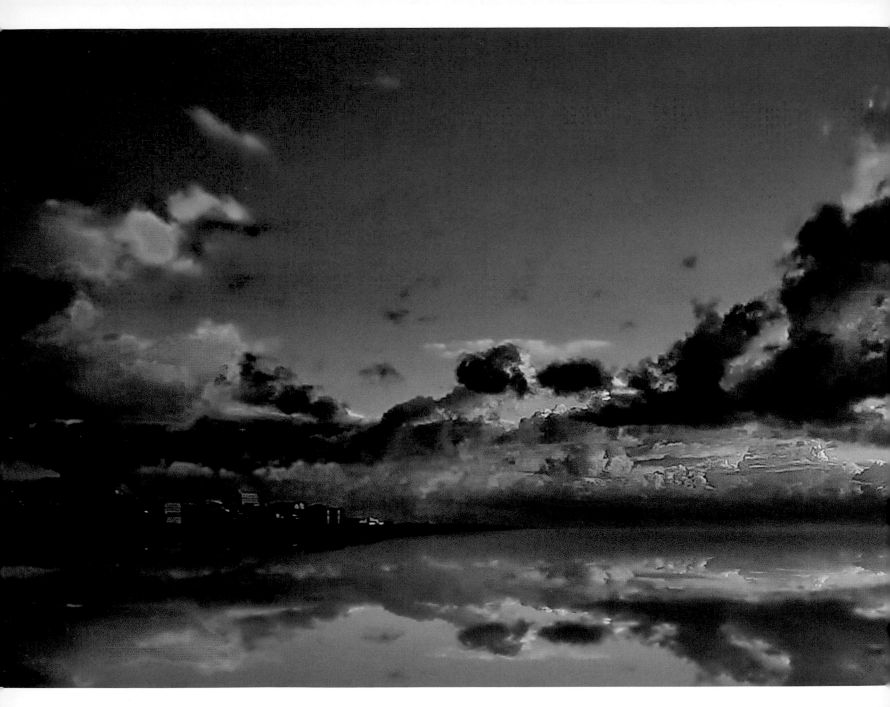

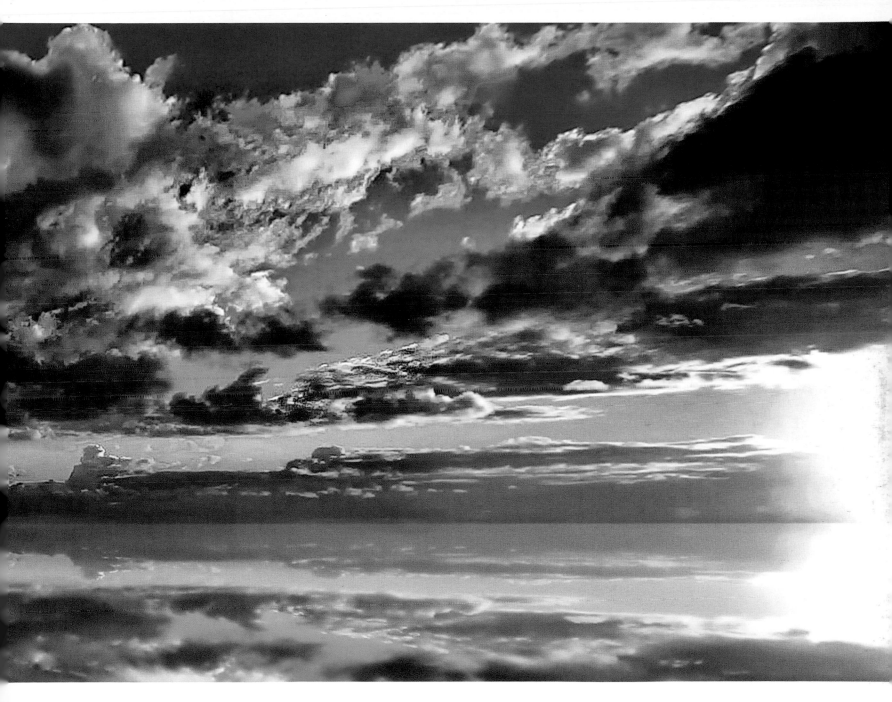

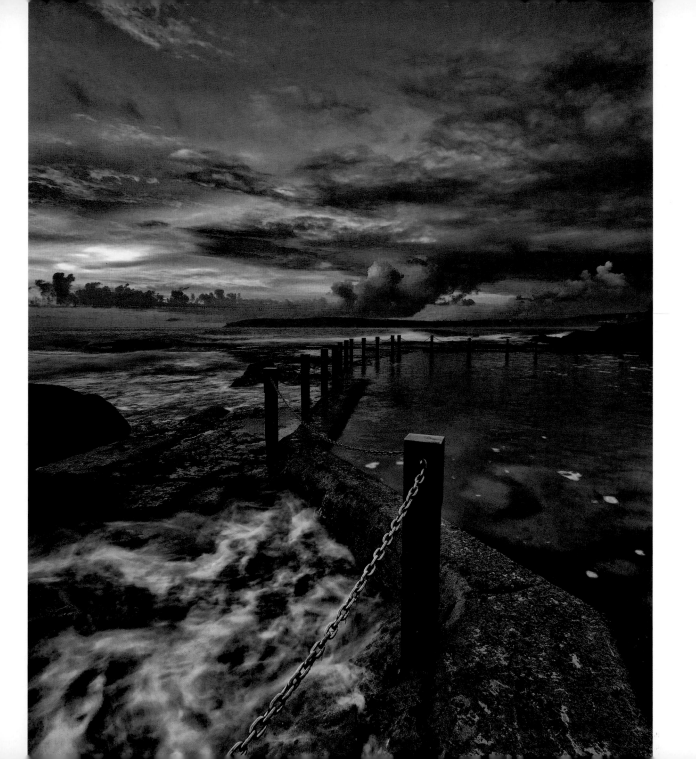

3.9 SUNSET

This ocean pool is one of my favourite locations to photograph. There is a lot to see in this area and the coastal sandstone rock features are very pronounced and evident throughout the area. It is one of the easiest places to access and is literally 100 metres from suburban streets. It is a very safe location and would be a great place for any amateur photographer to start learning to do seascape and landscape photography. The area is widespread and large footpaths lead you to various panoramic sections of the seashore.

For those that want some unique coastal shots, a large number of photographers make their way to this location at dawn and sunset times. The pool itself is mid-size and is nestled back from the sea and high tides and big swells will push a lot of water in the pool. Given the high sides around the natural swimming area, there are numerous safe vantage shots around and near the pool to photograph from. The pool often has the chance to have the water fairly still and the colours that are reflected in the shallow pool depths are in stark contrast to the adjoining rocky shore line. These vivid green and yellow colours appear more prominent just after sunrise. To obtain the rich colours in the sky and water, I attached Cokin XPro ND Grad 0.9 and 0.3 filters. All shots were taken with a tripod.

3.9A
CAMERA: Canon EOS 5D MkII
LENS: Canon EF 16-35mm f/2.8 L II USM
SETTINGS: f/9, ISO 100, 1 second exposure
 manual mode
FLASH: no flash
METERING FOCAL MODE: evaluative
FOCAL LENGTH: 16mm

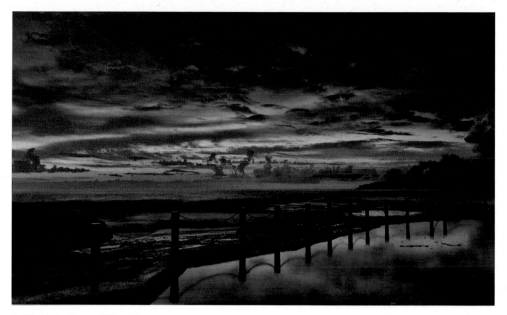

3.9B – f11, 6 sec, ISO 100

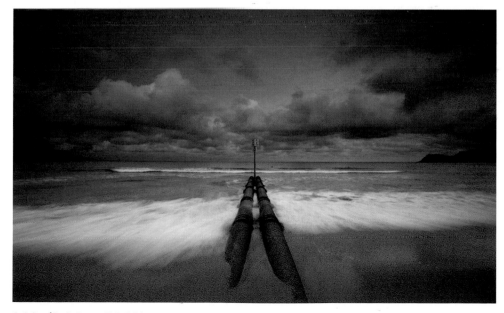

3.9C – f8, 0.8 sec, ISO 100

3.10 SUNRISE AND SUNSET

I often look at shots that I took a couple of years ago and reflect on whether or not I am challenging myself enough. Take, for example, this photograph of the stormwater outlet at the beach. Typically I have captured this location at sunrise and sunset when the light was very weak and low, allowing long shutter times to be used to blur out the movement of water. To challenge myself, I wanted to keep the photo simple and achieve the same type of look but at a time when the sun was at his brightest — directly overhead at midday, with little cloud protection.

To achieve this, the use of a tripod is critical. This photo was captured with the Canon EOS 5D MkII camera. Two sets of Lee filters were used — a Lee 0.9 neutral density graduated filter and also a 3-stop polarising filter. These filters are indispensable to provide you scope to alter both the aperture and shutter speed value.

3.10A CAMERA: Canon EOS 5D MkII
LENS: Canon EF 16-35mm f/2.8 L II USM
SETTINGS: f/8, ISO 100, 20 second exposure manual mode
FLASH: no flash
METERING FOCAL MODE: evaluative
FOCAL LENGTH: 16mm
tripod used

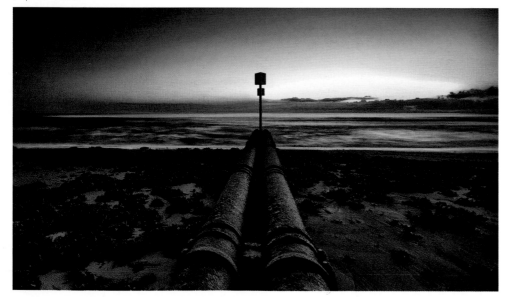

3.10B – f2.8, 13 sec, ISO 100

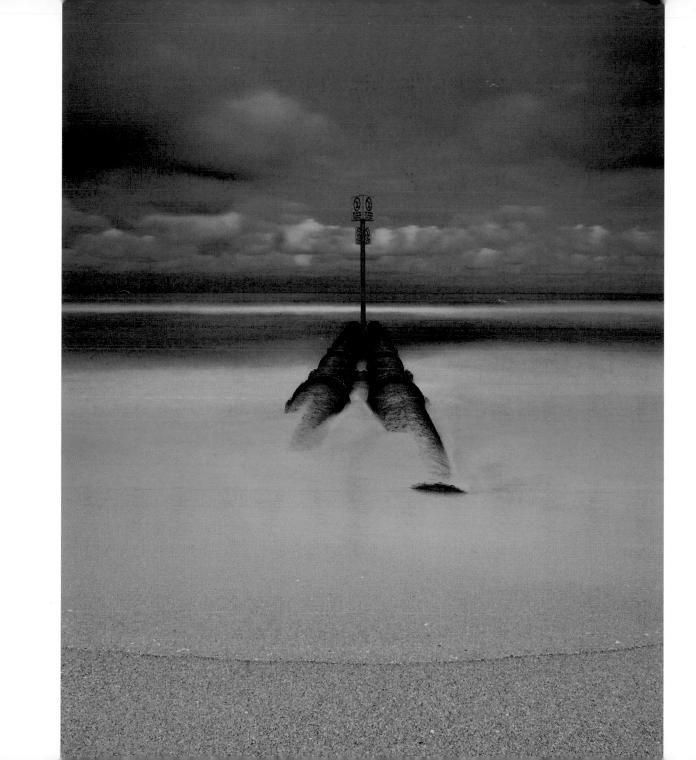

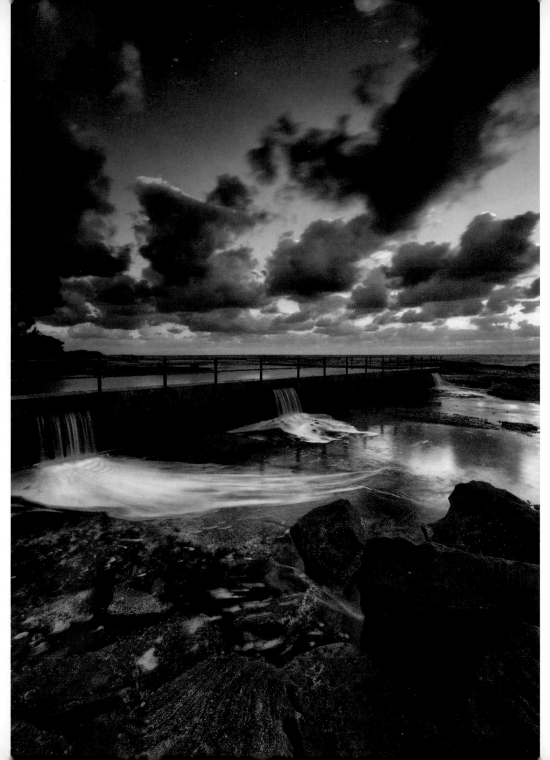

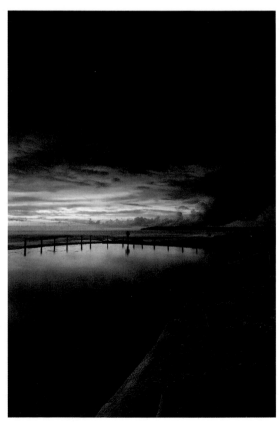

3.11C – f9, 6 sec, ISO 100

3.11 USING FILTERS

Most ocean pools will provide you with plenty of scope for your shots, both in terms of composition and interesting content. This pool is one of the smallest in size yet the adjoining area allows you to take tight angles with some interesting natural sculptured foregrounds. The pool also has a large submerged boulder in the middle of it, creating contrast and water flows.

This shot was taken at a low tide period and the water flowing out was a direct result of the occasional big wave coming in to top up the pool level. With big swells and high tides, the pool is extremely difficult to access and can be totally covered. This photo was captured with the Canon EOS 5D MkII camera. The Cokin XPro 0.6 Neutral Density Graduated filter was used for the warm tonal effects.

3.11A
CAMERA: Canon EOS 5D MkII
LENS: Canon EF 16-35mm f/2.8 L II USM
SETTINGS: f/22, ISO 100, 3.2 second exposure manual mode
FLASH: no flash
METERING FOCAL MODE: evaluative
FOCAL LENGTH: 16mm

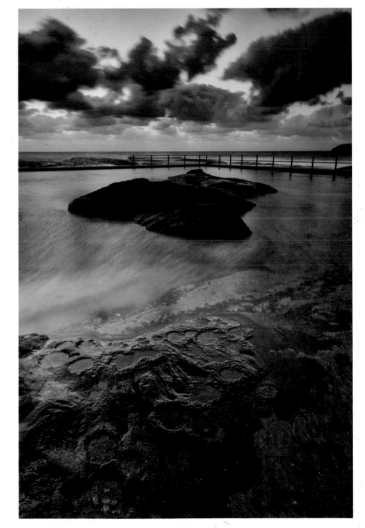

3.11B – f14, 10 sec, ISO 100

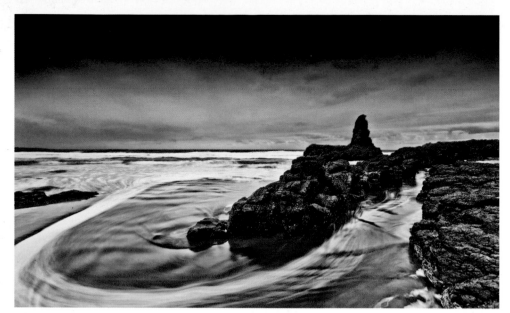

3.12B – f22 , 1.6 sec, ISO 100

3.12 WATER MOVEMENT

Movement of water interests me—the speed and flow of such is forever changing from one location to another. The challenge in composing photos is questioning whether or not the water movement plays a part in this and should it become the main focal point of interest or simply a mood-creating element.

The tidal patterns and conditions at the time of shooting will force you to experiment with various shutter speeds until the desired effect is obtained. Freeze-framing water at high shutter speeds (eg: 1/300th seconds) will not really add much interest and yet a photo with say a 0.8 or a 2 second lag will have a totally different feel. A 30 second shot will negate all movement of water and create a fog-like effect, which can also be very interesting.

For this shot, I wanted to create a 'washing machine' turbulence effect. The Cokin XPro 0.3 Neutral Density Graduated filter was used for the warm tonal effects.

3.12A
CAMERA: Canon EOS 5D MkII
LENS: Canon EF 16-35mm f/2.8 L II USM
SETTINGS: f/9, ISO 100, 1 second exposure
 manual mode
FLASH: no flash
METERING FOCAL MODE: evaluative
FOCAL LENGTH: 16mm

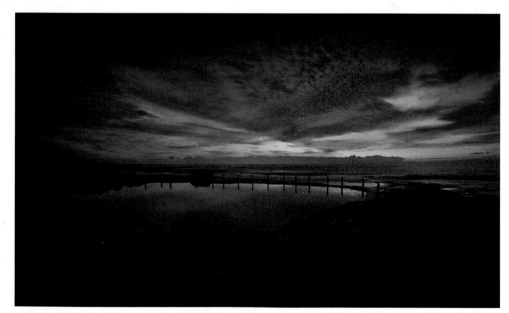

3.12C – f8, 2 sec, ISO 100

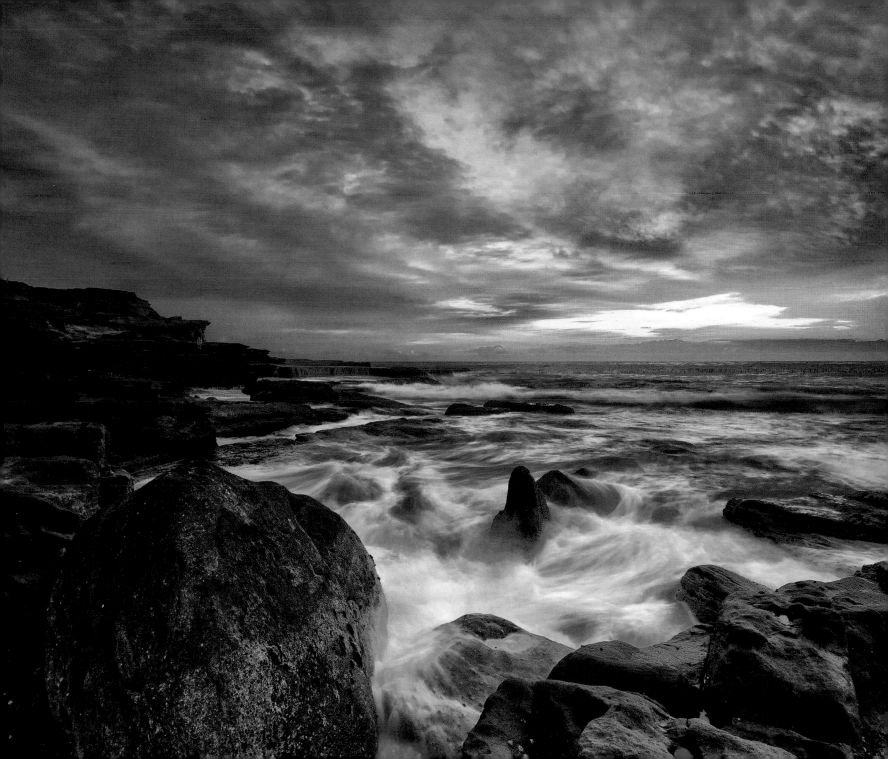

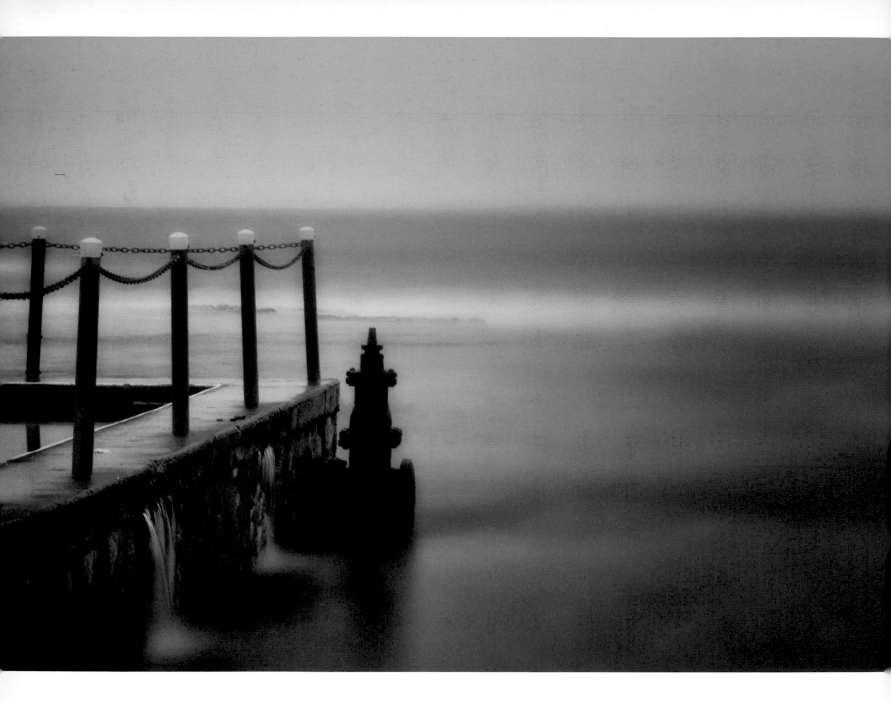

3.13 POLARISING FILTERS

Continuing on from the theme of water movement, the flow of water can also be considered with the prevailing ambient conditions.

In this instance, the cold dawn morning and warm seawater created a fog-like haze around the beach. The atmosphere was a little eerie and so to further enhance and amplify the look, capturing the water at a reduced speed became my goal.

To achieve this, the camera settings were locked in. A polarising filter was used to help diffuse the light.

3.13A
CAMERA: Canon EOS 5D MkII
LENS: Canon EF24-105mm f/4L IS USM
SETTINGS: f/13, ISO 100, 30 second exposure manual mode
FLASH: no flash
METERING FOCAL MODE: evaluative
FOCAL LENGTH: 105mm

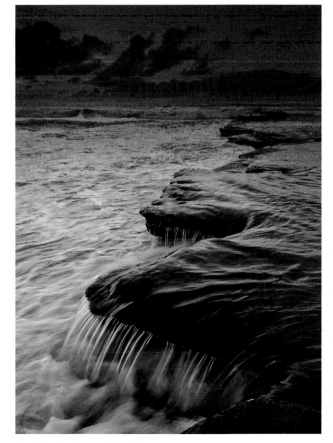

3.13B – f9, 3 sec, ISO 100

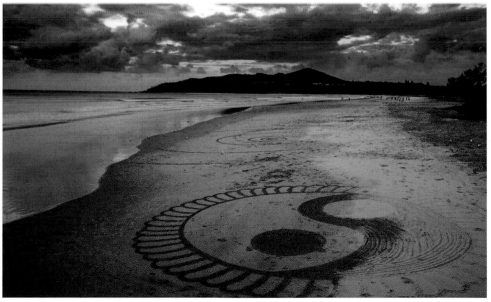

Main Beach, Byron Bay – f22, 2 sec, ISO 100

3.14 REVEALING THE NEW

This photo was one of the first taken with my then-newly acquired Canon EOS 5D MkII camera. A sense of excitement had built up about using the new gear and it was the first time I had done a pre-dawn shoot at this location.

The main aim that day was to acquaint myself with the equipment and learn the intricacies that are usually associated with the functions of any new camera.

Photography for all of us will trigger a different sensation. This photo, while certainly not brilliant, resonates with me on a different and personal level. It was a new dawn, new day, new location, new challenges, new camera kit and new experiences to enjoy. For these personal reasons, the photo is important to me.

3.14A
CAMERA: Canon EOS 5D MkII
LENS: Canon EF24-105mm f/4L IS USM
SETTINGS: f/13, ISO 100, 1/125th second exposure manual mode
FLASH: no flash
METERING FOCAL MODE: evaluative
FOCAL LENGTH: 58mm

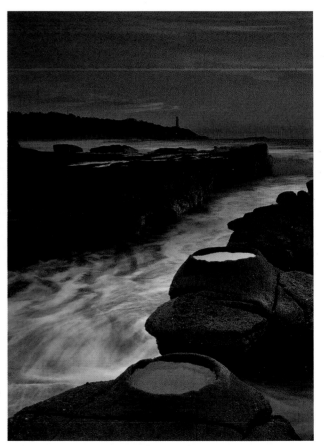

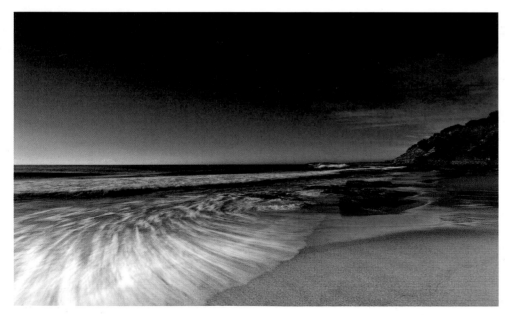

3.14B – f22, 1.3 sec, ISO100

3.14C – f18, 1 sec, ISO 100

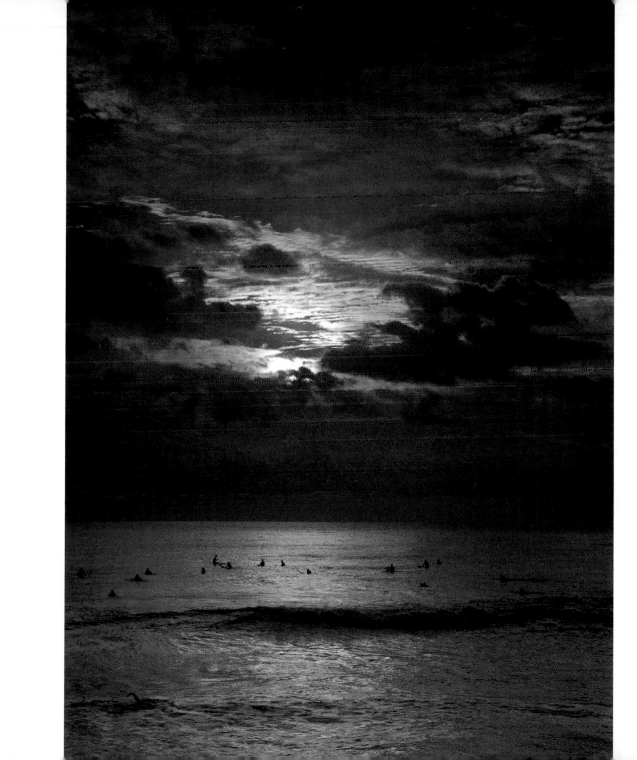

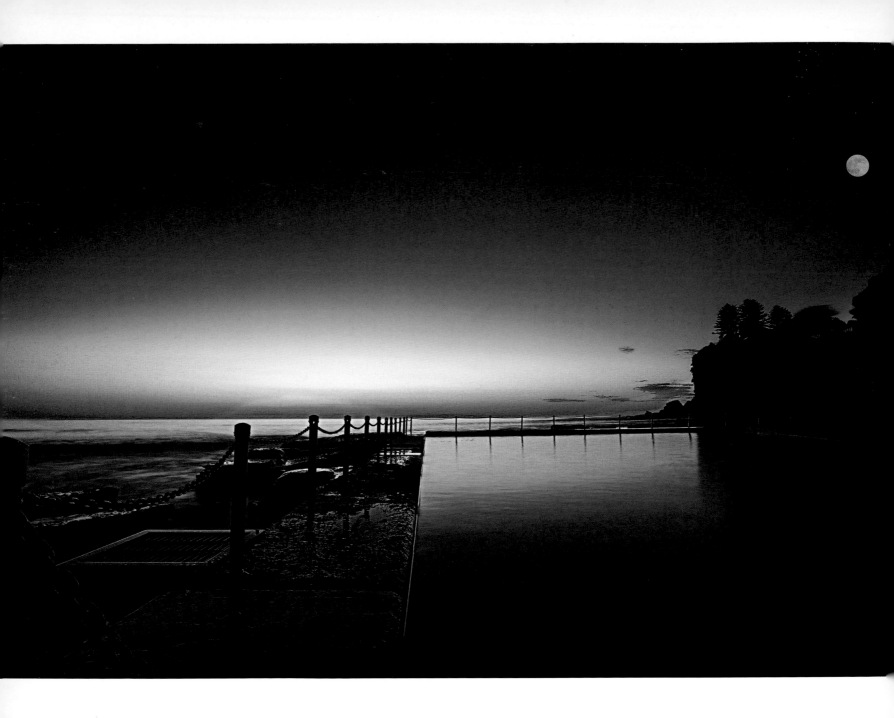

3.15 SILHOUETTES

In getting to this location I was amazed how much pre-dawn light was around with a full moon still high in the sky. In setting up the gear near the pool, the very still conditions and almost total absence of clouds meant that once the sun had risen, there would be little to shoot due to the fast-approaching strong and harsh light over the horizon. My aim shifted very quickly in order to capture the various points of interests—the stillness of the surrounding area, the moon, the shades of light emanating from the horizon, the contrasting silhouette of the trees/headland and the various lines along the edges of the pool.

3.15A
CAMERA: Canon EOS 5D MkII
LENS: Canon EF17-40mm f/4L USM
SETTINGS: EF17-40mm f/4L USM manual mode
FLASH: no flash
METERING FOCAL MODE: evaluative
FOCAL LENGTH: 17mm

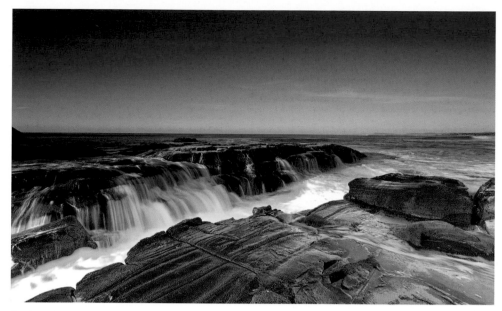

3.15B – f22, 0.5 sec, ISO100

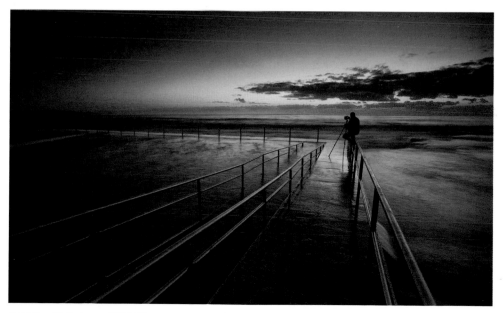

3.15C – f3.5, 6 sec, ISO100

4. HIGH DEFINITION RANGE (HDR)

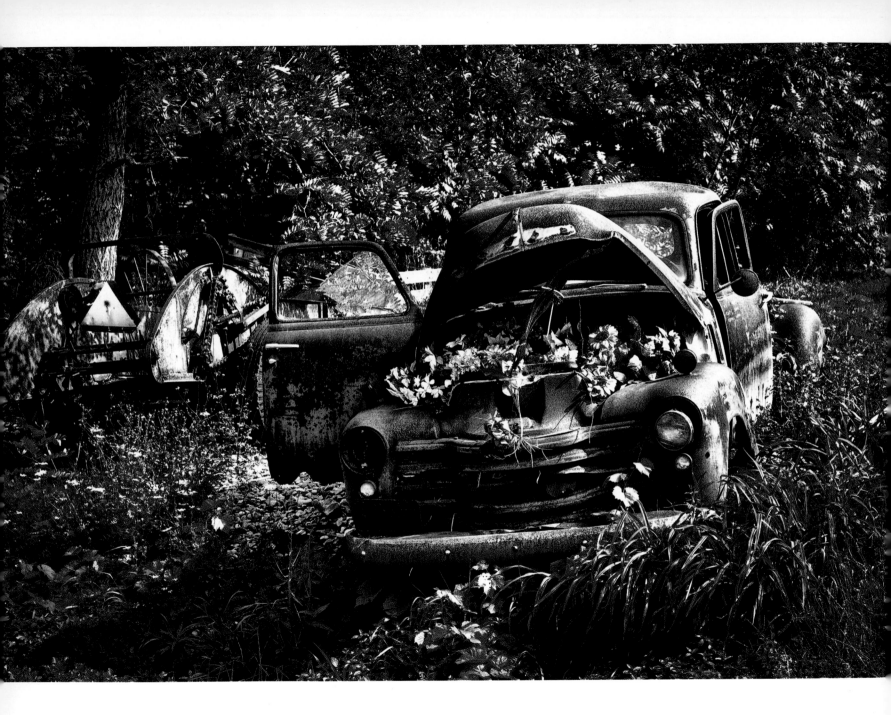

4.1 ENGINES

Travelling through New York State district, I stumbled upon this old car shell near some disused farming equipment on the side of the road. The immediate thing that came to mind was to capture this scene and consider how it would look with an added HDR-style effect. The antiquity of the car coupled with the HDR treatment was a nice combination. Typically this photo would also lend itself well to have a total sepia effect applied to it to give it an additional sense of age. The HDR effect was added with HDR Effex Pro software application.

4.1A
CAMERA: Canon EOS 5D MkII
LENS: Canon EF24-105mm f/4L IS USM
SETTINGS: f/6.3, ISO 100, 1/125th of a second exposure manual mode
FLASH: no flash
METERING FOCAL MODE: evaluative
FOCAL LENGTH: 50mm

4.1B – f11, 1/250 sec, ISO 400

Zigzag Railway Train – f4, 1/1250 sec, ISO 100

4.2 CHANGING LANDSCAPES

The daily walks I took while staying in Paris provided a huge array of opportunities to photograph many landmarks. On this particular day, a torrential downpour had just occurred and the overall mood was sombre. As sun started to break through, the light was inconsistent and changing continuously, which added to the difficulty of taking a well-balanced shot. I remembered reading an article that stated that such conditions tend to work well with HDR effects. I kept the photo with the view that upon my return home, I would consider applying an HDR look and feel and this is the result. The HDR effect was added with HDR Effex Pro software application.

4.2A
CAMERA: Canon EOS 5D MkI
LENS: Canon EF17-40mm f/4L USM lens
SETTINGS: f/14, ISO 400, 1/400th of a second exposure manual mode
FLASH: no flash
METERING FOCAL MODE: evaluative
FOCAL LENGTH: 33mm

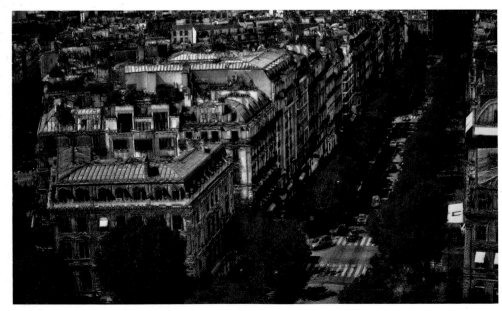

4.2B – f7.1, 1/200 sec, ISO 100

4.2C – f7.1, 1/100 sec, ISO 400

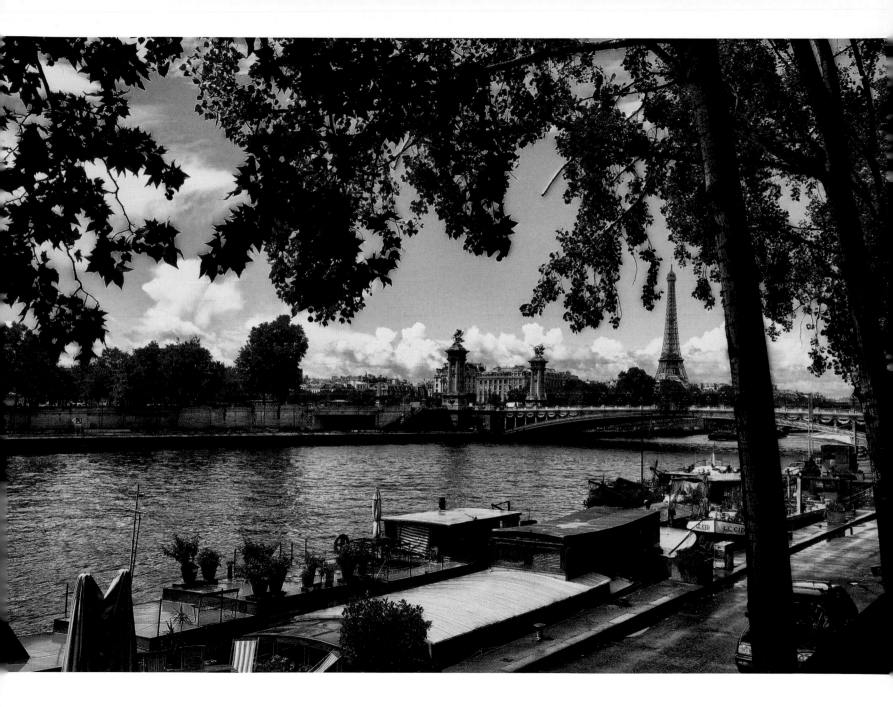

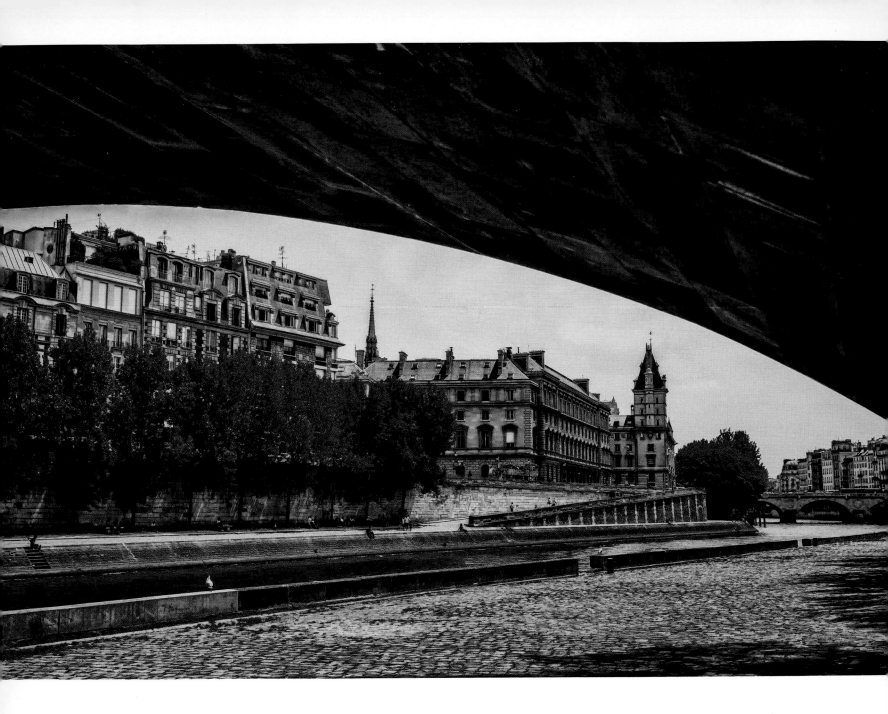

4.3 PHOTOGRAPHY IN SUMMER

Paris at the height of summer can be quite hot and unforgiving. I was keen to take advantage of photographing as much as possible as many people tried to avoid the heat and stay indoors so most shots would not have hundreds of people in them. This feat was successful and looking back through the shots Paris, in most parts, looked almost deserted.

The advent of hot weather and high temperatures also means that harsh strong light is prevalent and typically all detail in the shots is either lost or overblown, in terms of exposure. HDR effects work well in such scenarios and can bring back colour and tone that would normally be washed out. The HDR effect was added with HDR Effex Pro software application.

4.3A CAMERA: Canon EOS 5D MkI
LENS: Canon EF17-40mm f/4L USM lens
SETTINGS: f/9, ISO 400, 1/60th of a second exposure—manual mode
FLASH: no flash
METERING FOCAL MODE: evaluative
FOCAL LENGTH: 40mm

4.3B – f7.1, 1/100 sec, ISO 100

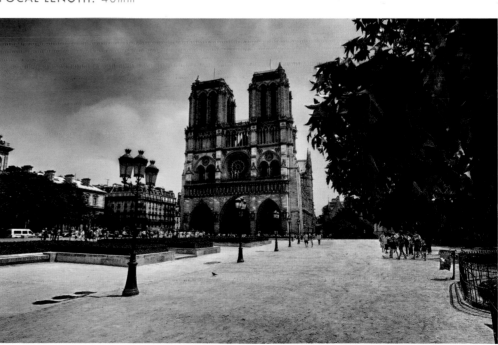

4.3C – f9, 1/200 sec, ISO100

4.4 MAN-MADE STRUCTURES

HDR works particular well with photos of man-made structures, such as buildings. The shot of the Bank of America building in Washington DC district provided a good opportunity to apply this style. The solidity and strong lines of the structure provide areas where strong contrast and tones work well. The lack of apparent life in the vicinity of the building also adds to the scene. The HDR effect was added with HDR Effex Pro software application.

4.4A
CAMERA: Canon EOS 5D MkI
LENS: Canon EF16-35mm f/2.8L II USM
SETTINGS: f/4.5, ISO 400, 1/100th of a second exposure manual mode
FLASH: no flash
METERING FOCAL MODE: evaluative
FOCAL LENGTH: 16mm

4.4B – f5, 1/200 sec, ISO 100

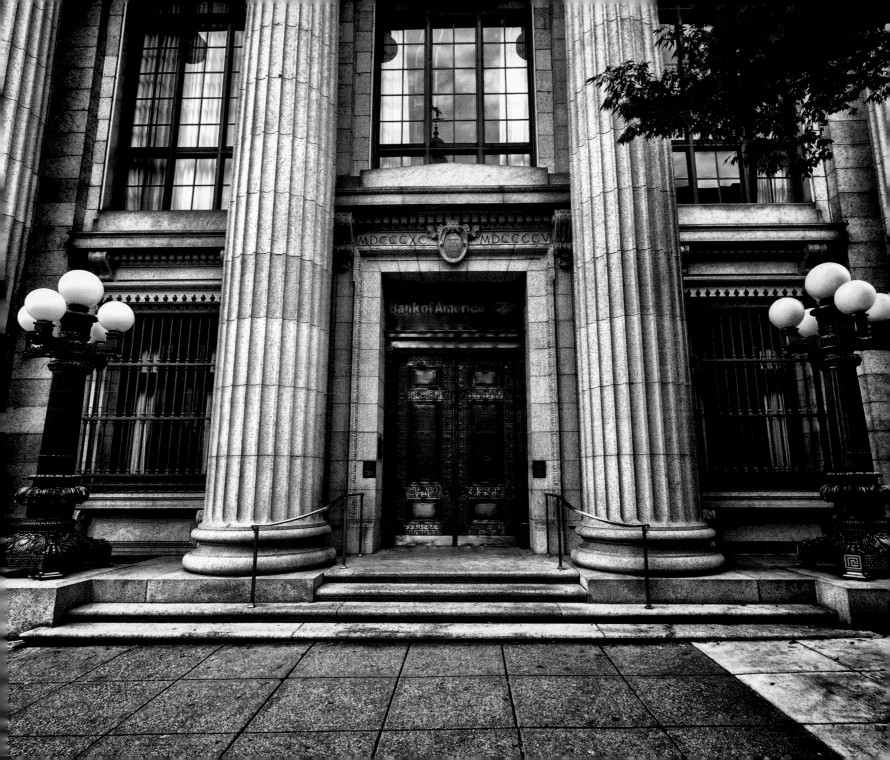

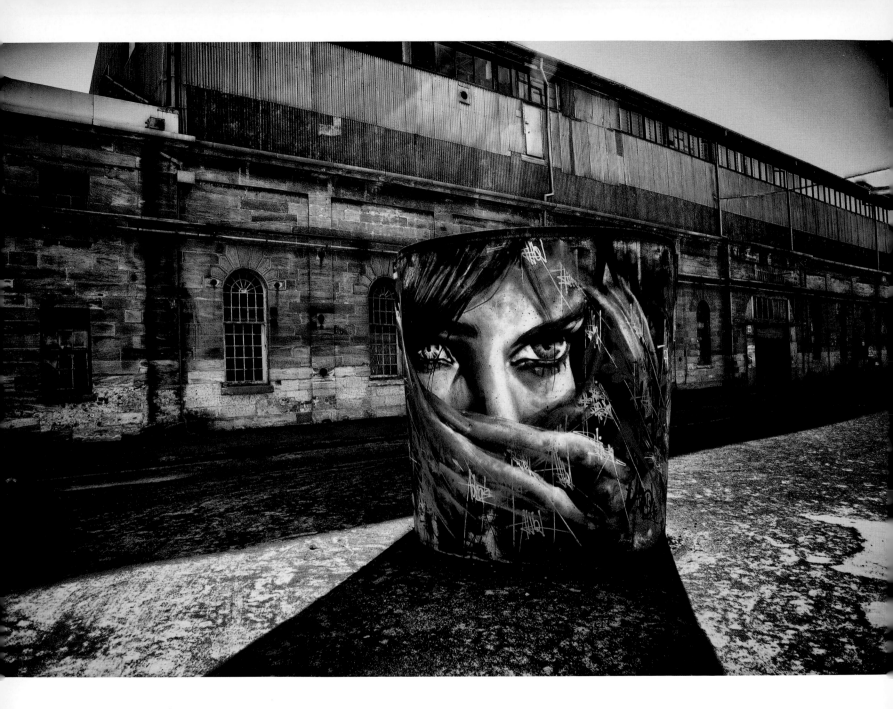

4.5 GRAFFITI ART

As a photographer, the various buildings provide countless sources to capture aspects of a past life. With the shipyard infrastructure still present, the old machinery and huge vacant warehouses have a ghostly appearance, especially if you are walking through the place by yourself. This ghostly sensation lends itself to the effects that HDR photography can bring. The next series of pages provide a good range of such examples. The modern graffiti art, which also adorns some of the structures, has also left a footprint, adding another interesting layer to the shots. The HDR effect was added with HDR Effex Pro software application.

Cockatoo Island is an island with a fascinating history as a former convict prison and shipyard building location. Access to the island is by regular local ferries and the National Trust now preserves the site. The attraction of this location is that the historical remnants of its past life remain there for visitors to see.

4.5A
CAMERA: Canon EOS 5D MkII
LENS: Canon EF24-105mm f/4L IS USM
SETTINGS: f/5, ISO 100, 1/160th of a second
 exposure manual mode
FLASH: no flash
METERING FOCAL MODE: evaluative
FOCAL LENGTH: 24mm

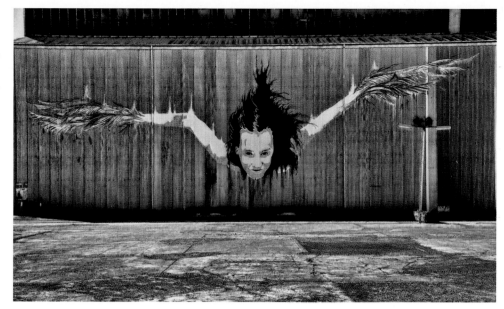

4.5B – f11, 1/80 sec, ISO 100

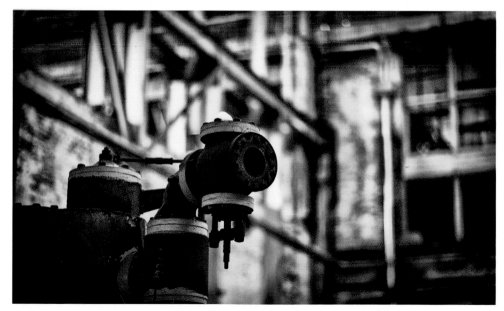

4.5C – f1.2, 1/20 sec, ISO 100

4.6 RURAL OUTPOSTS

In walking through the surrounds of this farm property, this flock of sheep blended in so well in their surroundings, it was at first difficult to see them. I was keen to capture the style of these natural paddocks with the mix of untouched forests and the rocky plains that abound the entire district. The added HDR treatment brings another level of contracts to such an iconic scene.

The bottom section of the original photo was cropped in Photoshop CS6 to highlight a more landscape look. A minor HDR effect was added with HDR Effex Pro software application.

4.6A
CAMERA: Canon EOS 5D MkII
LENS: Canon EF 16-35mm f/2.8 L II USM
SETTINGS: f/2.8, ISO 100, 1/400th of a second exposure
 manual mode
FLASH: no flash
METERING FOCAL MODE: evaluative
FOCAL LENGTH: 35mm

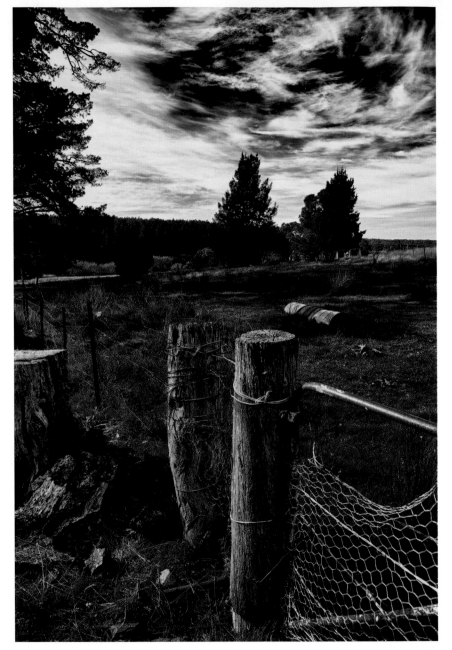

4.6B – f7.1; 1/60 sec, ISO 100

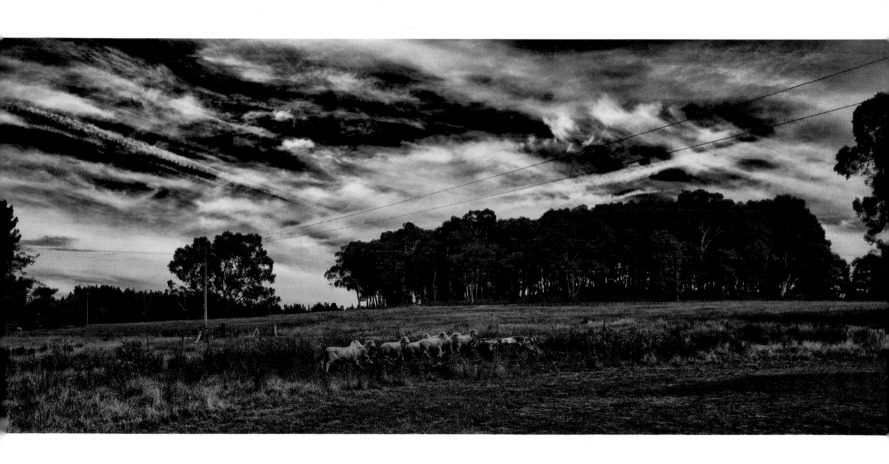

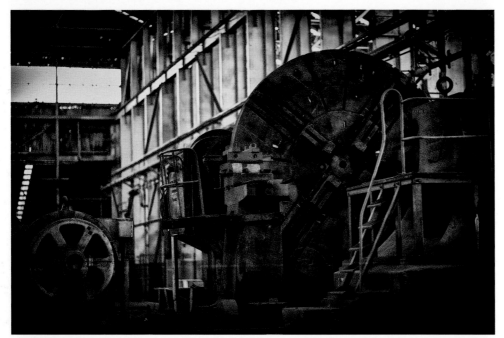

4.7 INDUSTRY

Sometimes, when you are surrounded by a vast expanse, the smaller, more intimate levels of detail can often be lost. The rolling cage door providing access to another industrial chamber is a prime example of this. The gate itself is interesting and its past use still shows the wear and tear. It also makes a questioning statement of a past life. I remember coming across it and thought it might be an interesting subject to record. Upon shooting it and reviewing its capture on the LCD screen at the back of the camera; I was pleased with its intended composition and felt straight away that it needed an additional level of tonal contrast to emit a stronger picture. The HDR treatment fits that purpose.

The HDR effect was added with HDR Effex Pro software application. A tripod was used to ensure tighter framing and also to avoid camera shake in maintaining the framed look.

4.7A
CAMERA: Canon EOS 5D MkII
LENS: Canon EF24-105mm f/4L IS USM
SETTINGS: f/4, ISO 100, 0.3 second exposure
manual mode
FLASH: no flash
METERING FOCAL MODE: evaluative
FOCAL LENGTH: 24mm

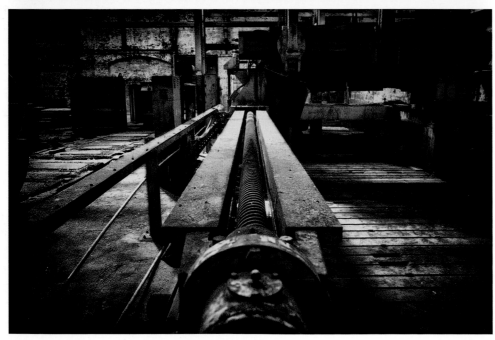

Above left: 4.7B – f1.2, 1/13 sec, ISO 100
Bottome left: 4.7C – f.4 , 1/5 sec, ISO 100

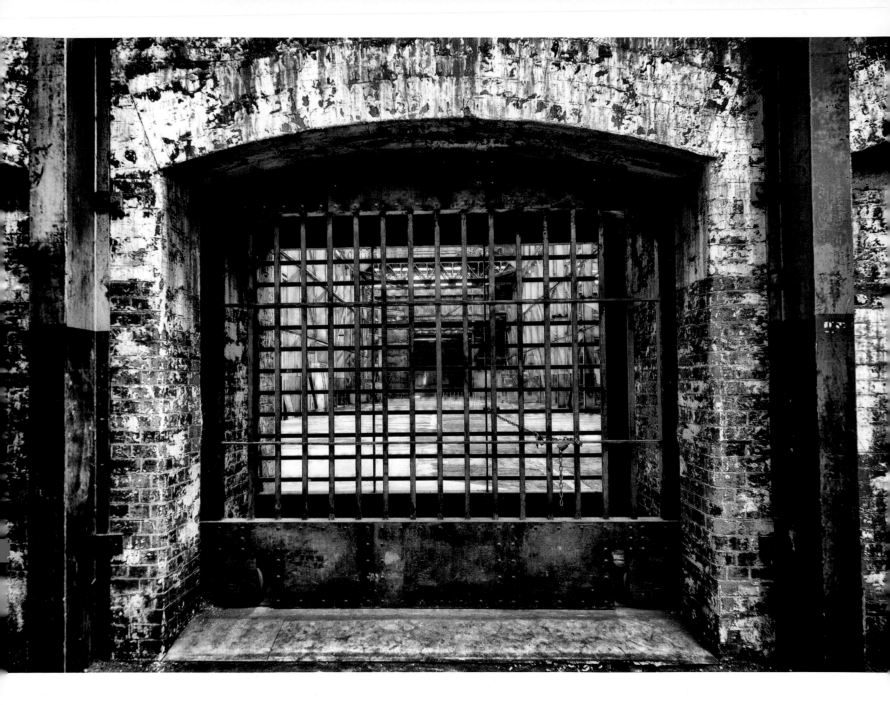

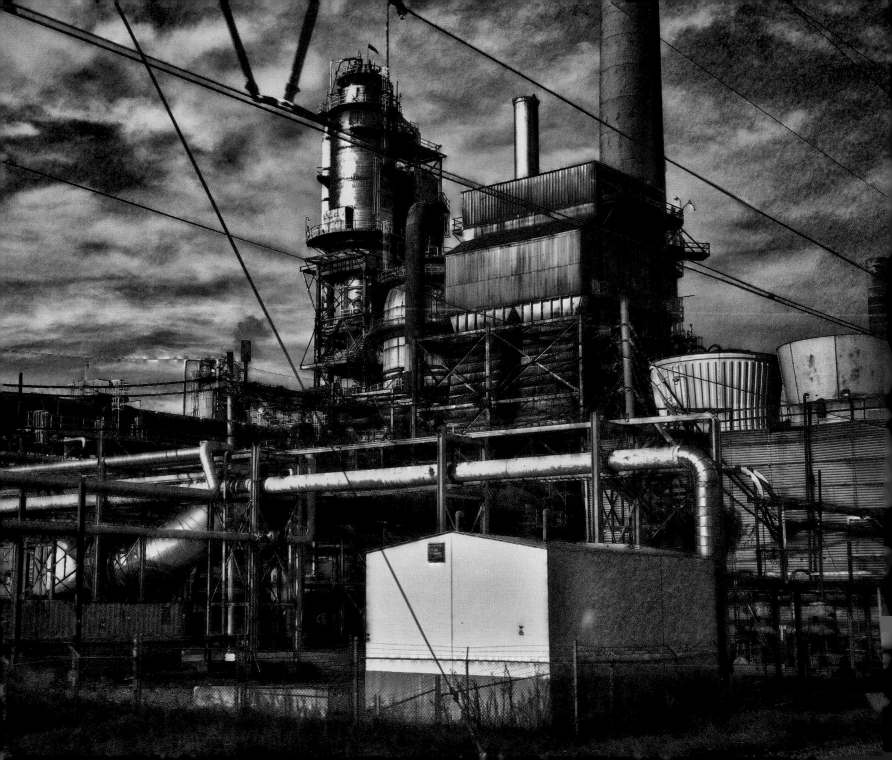

4.8 INDUSTRIAL FEATURES

Travelling by train between Washington DC and New York, the countryside went past very quickly. In the space of 2–3 minutes I had seen various industrial sites that were still in operation, yet their presence appeared somewhat eroded and tired. I found these installations quite interesting and it looked as if much had been crammed into tight spaces. I was able to capture this shot while moving at high speed and was pleased with the result. The rustic look it originally had in its natural state suggested that an HDR treatment would further enhance the output, giving it a sense of grunge and graininess. A warming effect was added with HDR Effex Pro software application.

4.8A
CAMERA: Canon EOS 5D MkII
LENS: Canon EF24-105mm f/4L IS USM
SETTINGS: f/4, ISO 1000, 1/800th of a second exposure manual mode
FLASH: no flash
METERING FOCAL MODE: evaluative
FOCAL LENGTH: 40mm

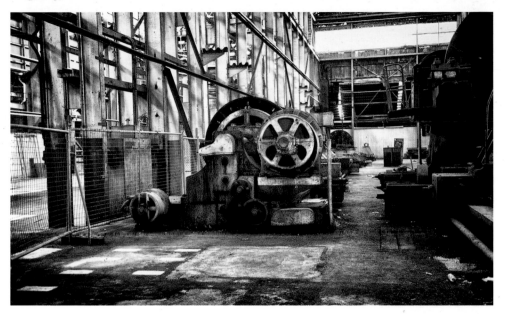

4.8B – f4, 1 sec, ISO 100

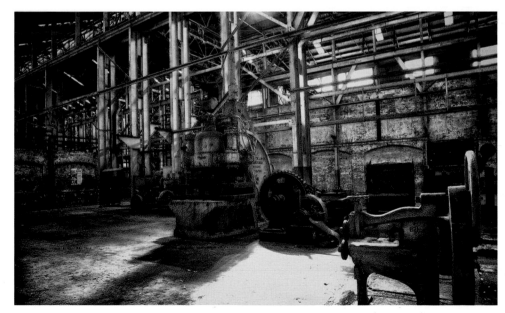

4.8C – f4, 1/5 sec, ISO 100

4.9 WAREHOUSES

While walking through a series of empty shelled warehouse rooms, I stumbled on an average-sized vacant room with a fairly new chair positioned dead in the centre of it. Was it an invitation to sit and reflect on its surroundings or an artistic statement of some sort? Either way I found it an interesting item to photograph and left it for the viewer of the photo to define its intended meaning. I can't say that I purposely went out of my way to find and photograph this however it has become one of my favourite shots albeit for my own personal reasons.

The HDR effect was added with HDR Effex Pro software application.

4.9A
CAMERA: Canon EOS 5D MkII
LENS: Canon EF 24-105mm f/4L IS USM
SETTINGS: f/4, ISO 1000, 1/800th of a second exposure—manual mode
FLASH: no flash
METERING FOCAL MODE: evaluative
FOCAL LENGTH: 40mm

4.9B – f6.3, 1/6 sec/ ISO 100

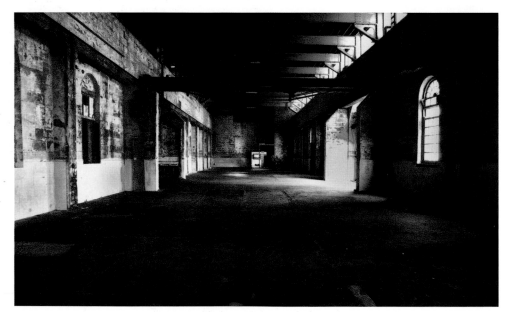

4.9C – f6.3, 1 sec, ISO 100

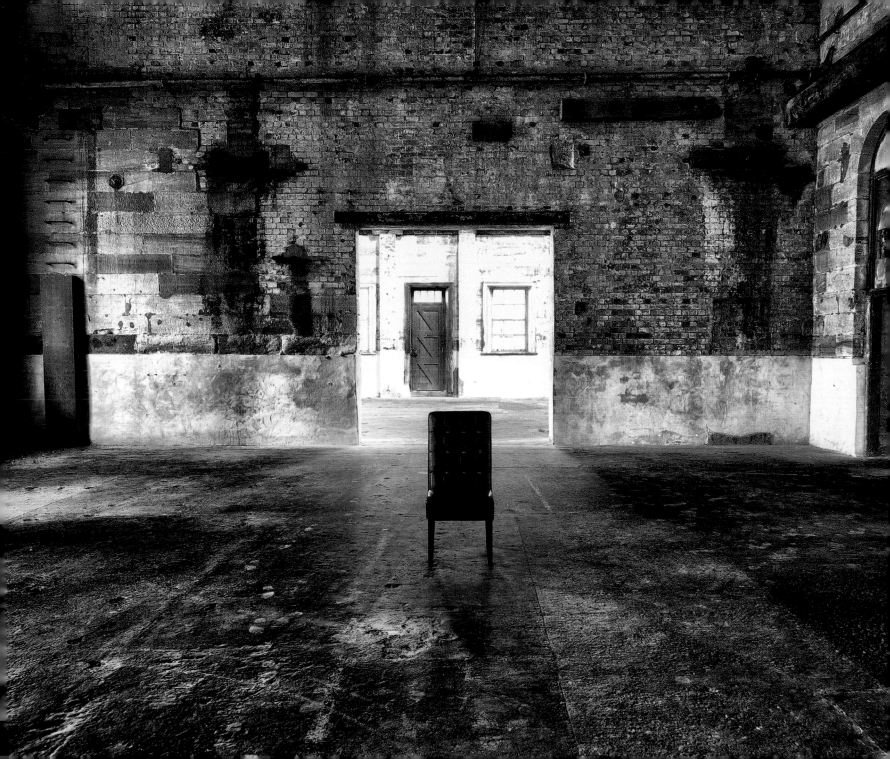

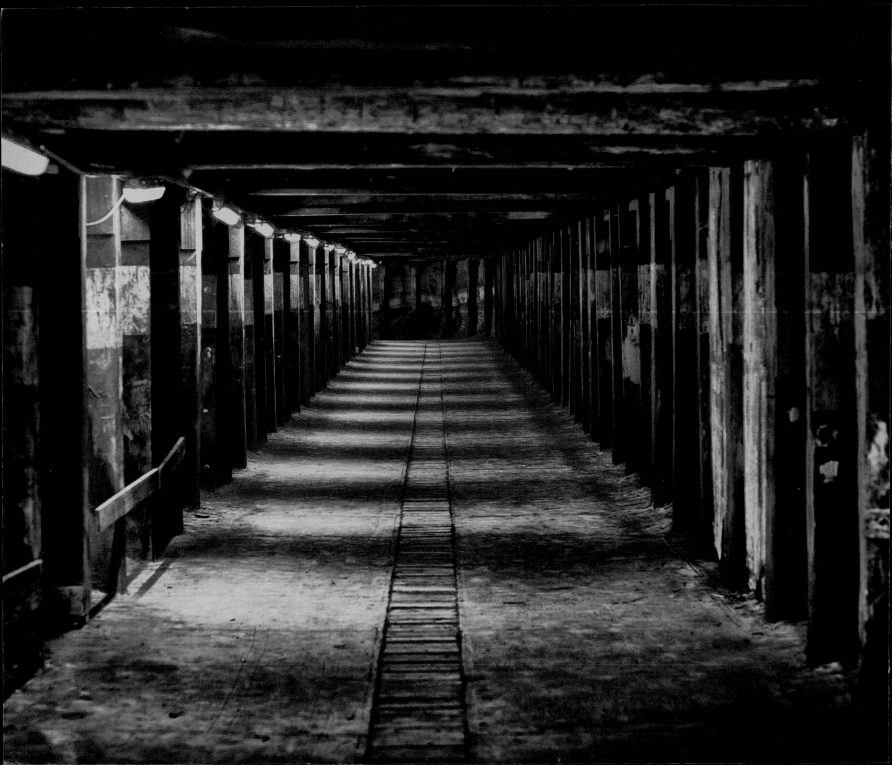

4.10 ARTIFICIAL LIGHT

This dog-leg-shaped tunnel cuts its way from one side of an island to the other side. In peering down the opening of this tunnel, one could hear an echoing noise of people far away inside the structure. What was revealed was in fact a uniform series of wooden supports along the entire length of the tunnel that provided a geometrically shaped frame and a photo opportunity.

The challenge in this shot was threefold—firstly, avoid having people in the tunnel during the shoot to give it a sense of isolation, secondly, try to frame the uniformity of the tunnel, and thirdly capture the detail along the full length of the structure. The light consistency also had to be carefully assessed given that natural light was being complemented with artificial lighting.

After numerous attempts with different camera settings, this shot was obtained. The contrast HDR effect was added with HDR Effex Pro software application.

4.10A
CAMERA: Canon EOS 5D MkII
LENS: Canon EF24-105mm f/4L IS USM
SETTINGS: f/4, ISO 1000, 1 second exposure
 manual mode
FLASH: no flash
METERING FOCAL MODE: evaluative
FOCAL LENGTH: 85mm

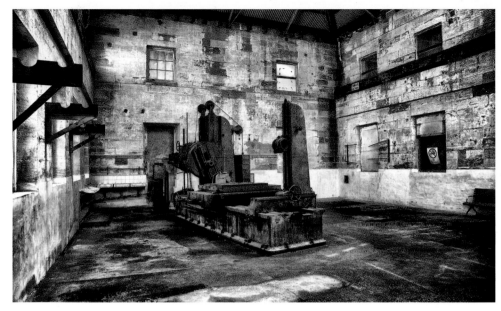

4.10B – f6.3, 1/3 sec, ISO 100

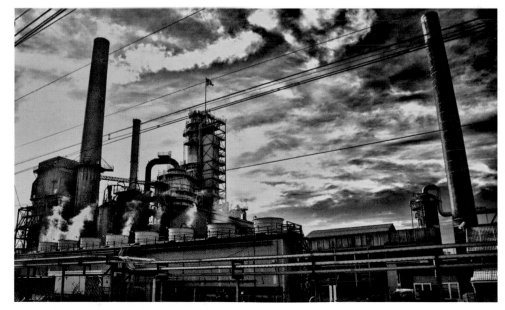

4.10C – f4, 1/800 sec, ISO 100

4.11 SMALL TOWNS

The various small towns sprinkled across some sections of New York State are very small and or very stylish reflecting their local culture and history. Watkins Glen was no exception, with the high number of vintage and retro vehicles present at every turn. This catches the eye and I was keen to capture several older-style cars and trucks making their way through this part of the world. As with vintage style periods, I wanted to apply an HDR makeover to enhance the period when these cars first came out.

The contrast HDR effect was added with HDR Effex Pro software application. The top of the photo was also cropped to provide a wider look and feel to the shot.

4.11A
CAMERA: Canon EOS 5D MkII
LENS: Canon EF24-105mm f/4L IS USM
SETTINGS: f/8, ISO 100, 1/200th of a second exposure manual mode
FLASH: no flash
METERING FOCAL MODE: evaluative
FOCAL LENGTH: 50mm

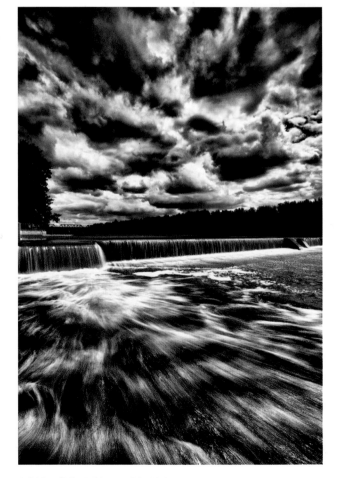

4.11B – f22, 1/4 sec, ISO 100

Following pages: 4.11C – f22, 2 sec, ISO 100

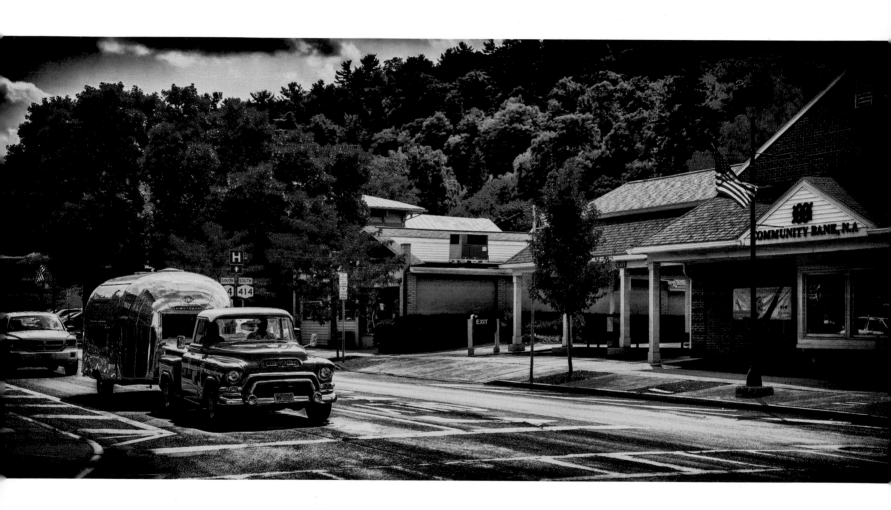

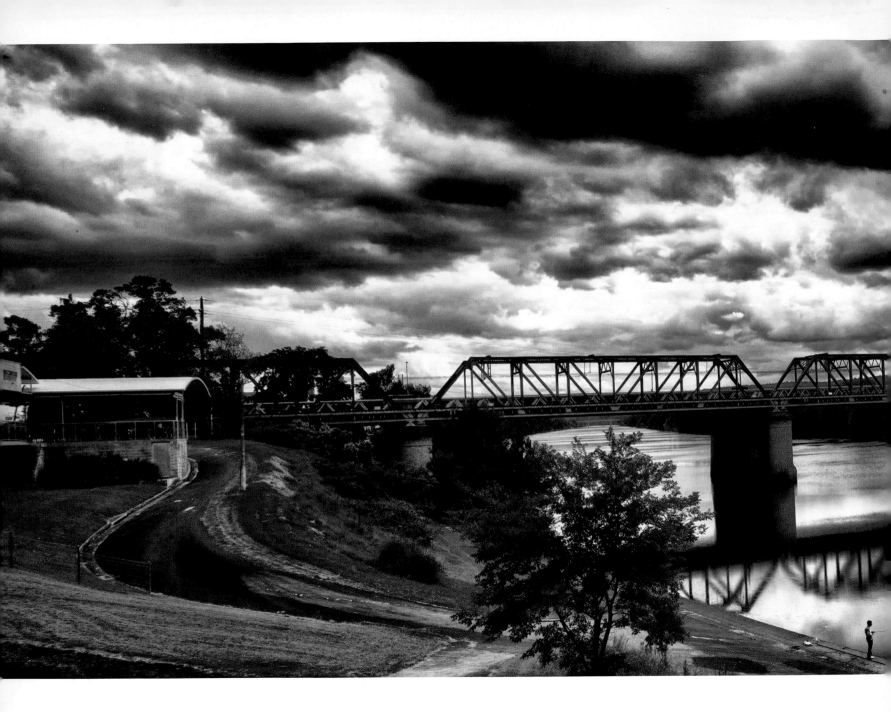

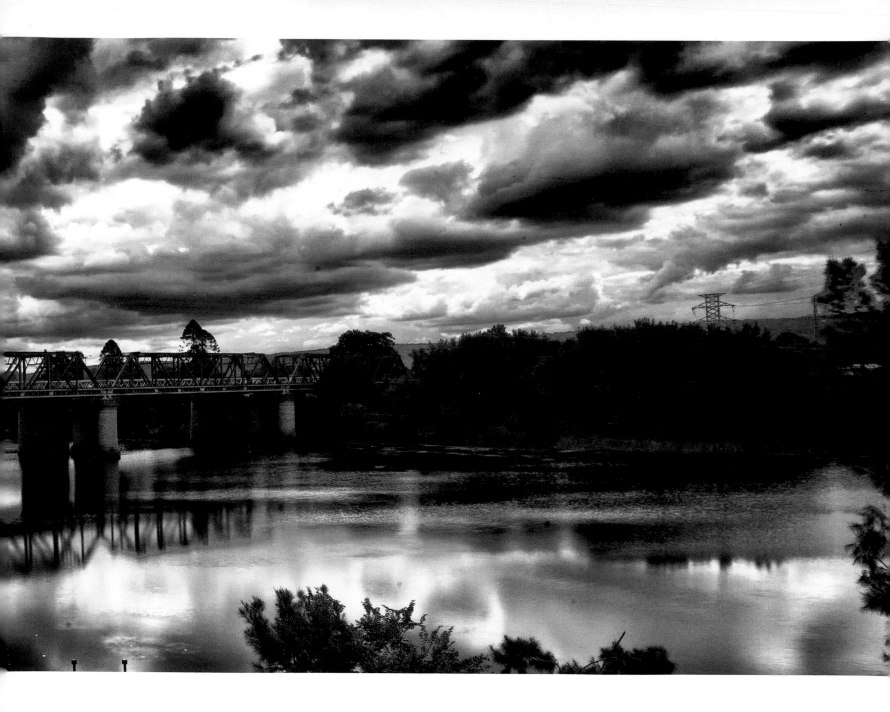

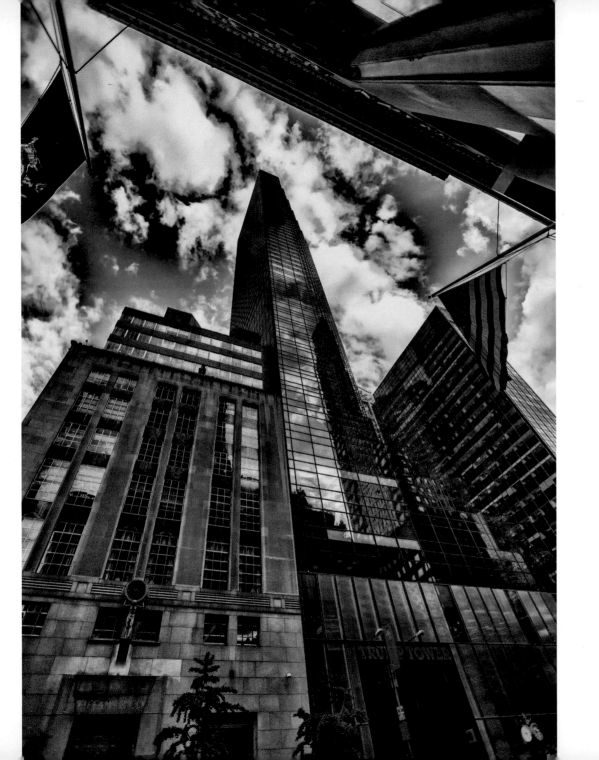

4.12 HEIGHT

I call this shot 'City Slang' for the nature and changing style of ever-rising skyscrapers that are spread throughout NY City.

I was keen to capture the height and over-bearing quality of these tall buildings, especially Trump Tower, which encroaches on its neighbouring buildings via the mirrored reflections on the front and side of the building. To some extent it appears to also merge with the sky above.

When I first saw Trump Tower and its Art Deco 'Tiffany' neighbour, I wanted to impose a defined HDR effect which would make them more saturated and conceptually intensified. In looking at the final result, I find myself questioning what goes on inside them.

The contrast HDR effect was added with HDR Effex Pro software application.

4.12A CAMERA: Canon EOS 5D MkII
LENS: Canon EF16-35mm f/2.8L II USM
SETTINGS: f/2.8, ISO 800, 1/1600th of a second exposure–manual mode
FLASH: no flash
METERING FOCAL MODE: evaluative
FOCAL LENGTH: 16mm

Above right: 4.12B – f12, 1/400 sec, ISO 400
Above: 4.12C – f5.6, 1/60 sec, ISO 100

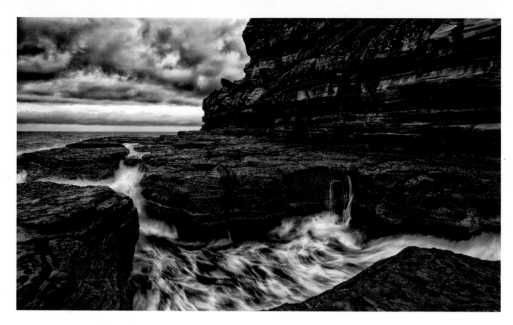

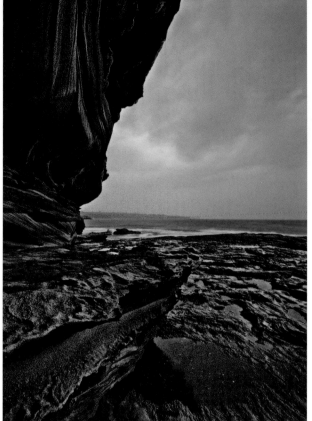

4.13 INTENSE SEASIDE VIEWS

HDR effects are meant to invoke a sense of intensity and in many cases heighten the drama of the photos. The success of this primarily relies on the scene that is captured. For landscape shots, it is often more difficult to achieve this level of intensity unless the landscape itself provides the ingredients to filter through. In these shots, each component plays a part in trying to lift that intensity. It can be the nature of the stormy sky, the turbulence of the waves and rapid water movement and or the textured coloured rock structures. In these three scenarios, the HDR approach was considered after the post editing of each photo was done. This is the opposite of the process taken for the other photos in this chapter, yet the final presentation still evokes intensity and drama.

The contrast HDR effect was added with HDR Effex Pro software application.

4.13A CAMERA: Canon EOS 5D MkII
LENS: Canon EF16-35mm f/2.8L II USM
SETTINGS: f/14, ISO 100, 0.8 second exposure—manual mode
FLASH: no flash
METERING FOCAL MODE: evaluative
FOCAL LENGTH: 16mm

Above: 4.13B – f22, 2.5 sec, ISO 100
Above left: 4.13C – f9, 1/2 sec ISO 100

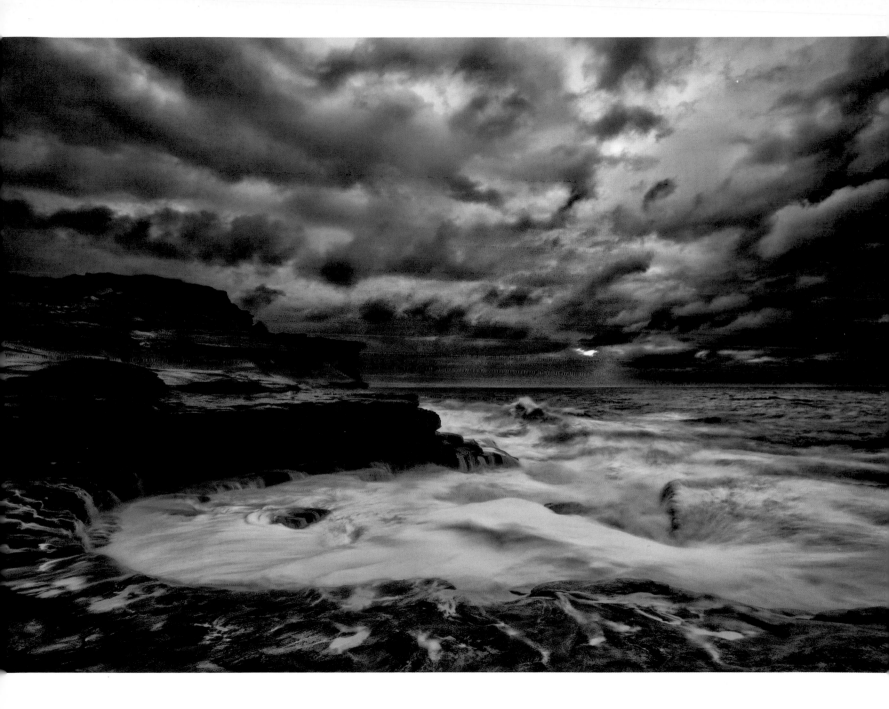

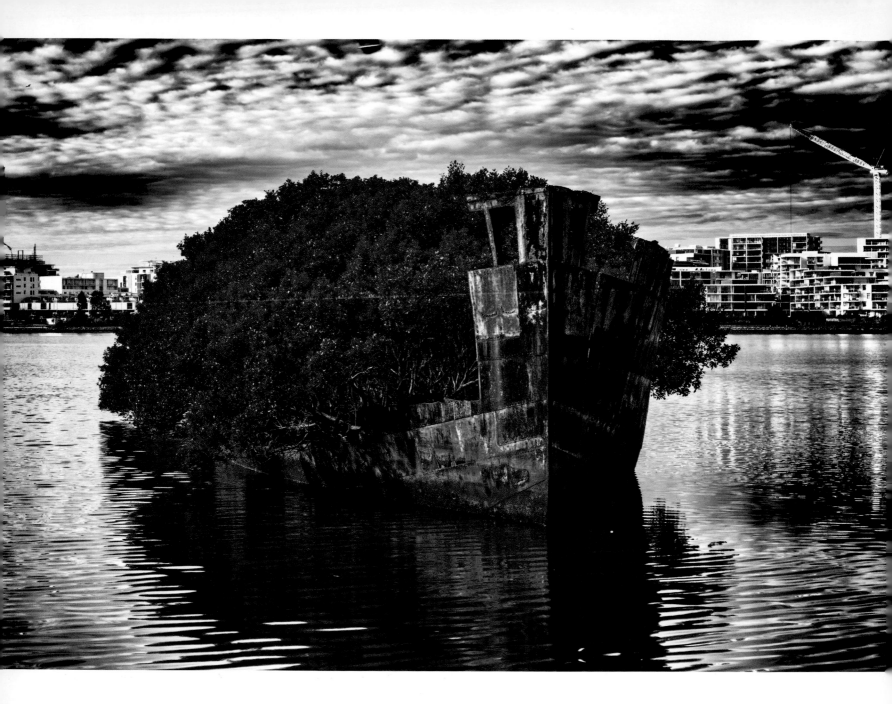

4.14 MAN VS NATURE

This shipwreck is positioned on this busy river only 50 metres from shore, adjacent to high density housing. The wreck was formerly known as the SS *Ayrfield*. In 1972, the registration of Ayrfield was cancelled and it was sent to its final resting place. A growing number of photographers are now looking to capture this wreck given its distinctive tidal mangrove location, in a fairly quiet and secluded inlet. The mix of thick low-lying mangrove vegetation, large expanse of water and good shooting vantage point makes for a great photo. Given the current state of the ship's hull with its rustic look and the surrounding colour range, a HDR treatment works well.

This shot was taken on my initial visit and was captured in mid-afternoon on a fairly bright day. The tonal contrast HDR effect was added with HDR Effex Pro software application.

4.14A
CAMERA: Canon EOS 5D MkII
LENS: Canon EF70-200mm f/2.8L IS II USM
SETTINGS: f/22, ISO 100, 1/10th of a second
exposure–manual mode
FLASH: no flash
METERING FOCAL MODE: evaluative
FOCAL LENGTH: 70mm

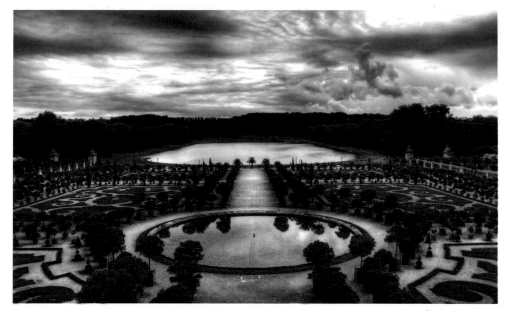

4.14B– f11, 3 sec, ISO 100

4.14C – f13, 1/5 sec, ISO 100

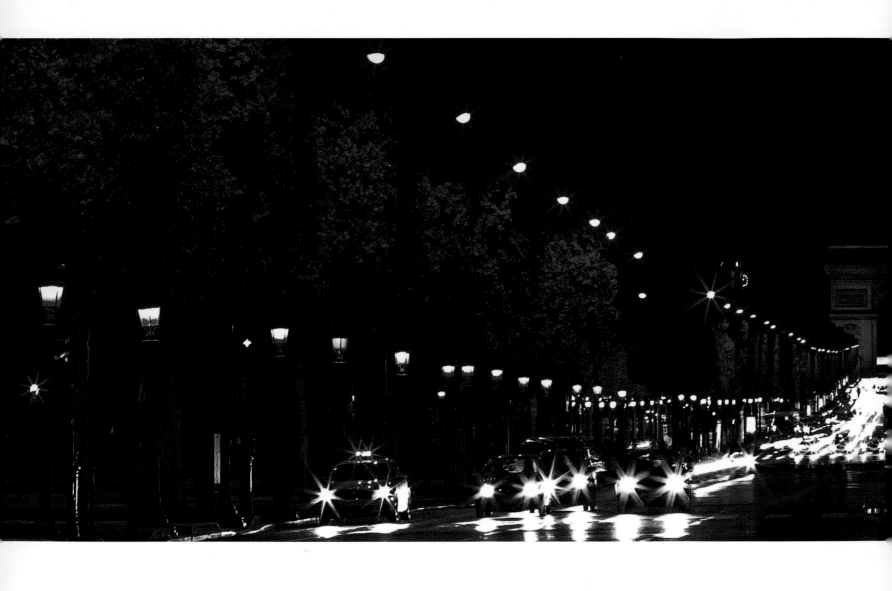

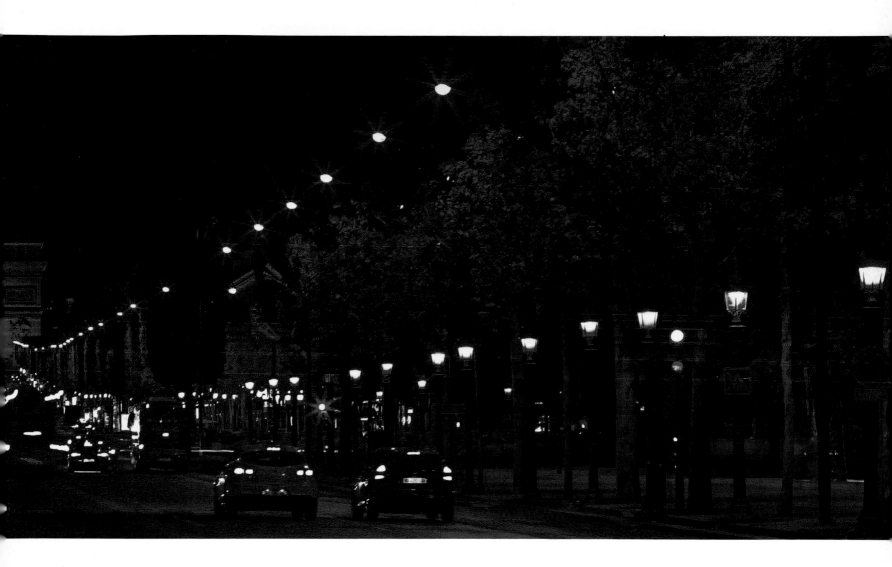

5. NIGHT

GENERAL

The challenges that night photography will throw your way are not always dealt with sufficiently by photographers. Over time, I have come up with some steps to follow when tackling night photography:

- Unlike day time, when one can access places fairly easily, once the sun disappears your bearings may be tested. Know in advance exactly how you will get to your location—that includes parking and access to the shooting point.

- Be aware of when and where the sun will be setting and be ready when this occurs. The results of that period of time are usually wonderful, because of the softening and glowing light that typically accompanies a sunset. Try taking some pictures before it gets completely dark. Sometimes having a little colour left in the sky can add an extra dimension to the photo. Some of the best photography takes place just after twilight.

- Invariably when the sun goes down, a change in temperature also follows. Pack something warm just in case. Once you are in a position, you've typically stopped moving. Just standing around behind your camera and tripod will not keep you warm. It might also be worthwhile to pack some insect repellant for mosquitoes or other biting creatures.

- Make sure you always bring and use a tripod. Your night shoots will cover exposures ranging from 1–2 seconds to several minutes. Anything less than 1/40th of a second will create camera shake (unless you are a statue) and so every shot taken without this key accessory is likely to be spoiled. Bring along a bubble level or, better still, get a tripod with one built in. Post editing every shot to straighten a vista is not much fun. For a small investment, I would also recommend using a cable release for your camera. If your camera is equipped to use a cable release for remote operation of the shutter button, be sure to use it. On lengthy exposures, the camera shake caused by pressing the shutter button will often affect the sharpness of your pictures. If your camera isn't equipped for use with a cable release, a self-timer is a good alternative.

- Unless you have in-built night vision powers, bring along a flashlight. This is essential for multiple reasons:
 - ø You can light up your camera dials to adjust your camera settings properly.
 - ø If you drop anything, you have a greater chance of finding it.
 - ø Getting back to your car or other form of transport may require you to walk back along unlit parts of walkways or nature tracks.

- I have invested in a very compact Headband-style LED light kit unit that fits comfortably over my head or hat. The advantage of this is that your hands are free, allowing you total control of your equipment.

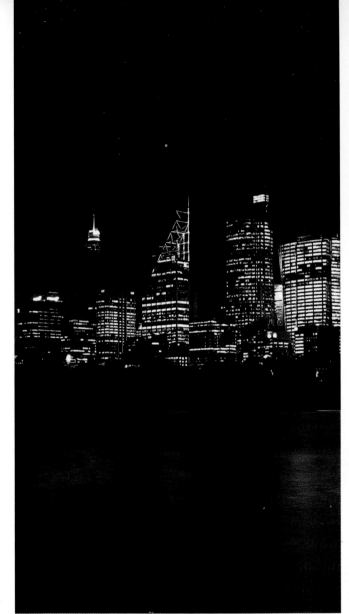

5.0A f5.6, 13 sec, ISO 100

- The more control you exercise over the camera settings, the greater your chances of taking some great night-time photographs. If your camera has automatic settings only, you may face some serious limitations when shooting in the dark. Avoid using the flash as most on-camera flashes aren't effective past one or two metres. In these scenarios you may well overexpose anything that's in the foreground while underexposing the primary subject of the picture that may be a considerable distance away. If you are shooting scenes where the focal distance is in excess of 10 metres, the flash will be your enemy.

- Where warranted, adjust the ISO setting higher on your digital camera to allow the use of a faster shutter speed. The higher the ISO/ASA, the shorter the exposures you can use. For example, if you plan to use an exposure of ISO 100 for 2 seconds at F8.0, you can alternatively use ISO 400 for ½ a second exposure at the same F8.0. The downside of shooting at high to very high ISO settings is that high 'noise' levels will creep into your shots (noise is defined by the presence of colour grainy speckles where there should be none).

- If you are going to capture multiple exposures of the same shot, set the first shot using auto-focus, then without changing the focus, switch to manual focus. That way, if your camera has difficulty focusing in the dark, it won't repeatedly search for a focus lock. The other advantage being that if there is any movement in the scene you are shooting (e.g. a passing boat/car, people, etc.), the focus will not shift to the moving subject.

- With the advent of digital cameras, you can afford to take a lot of shots so take full advantage of this. Don't be afraid to try different exposures and shutter speeds. Review your shots and look for components that you are not happy with. This instant feedback will help you check that you're getting the results you want. Most cameras feature a histogram function—be sure to check it often to make sure you aren't underexposing or overexposing parts of your images. Remember to take your spoilt shots back home with you and look at them on your computer screen and try to learn what went wrong. I have learnt more in reviewing dud shots then by taking good ones.

5.0B – f5, 15 sec, ISO 100

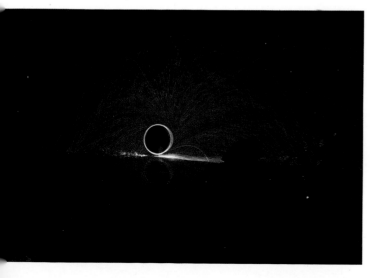

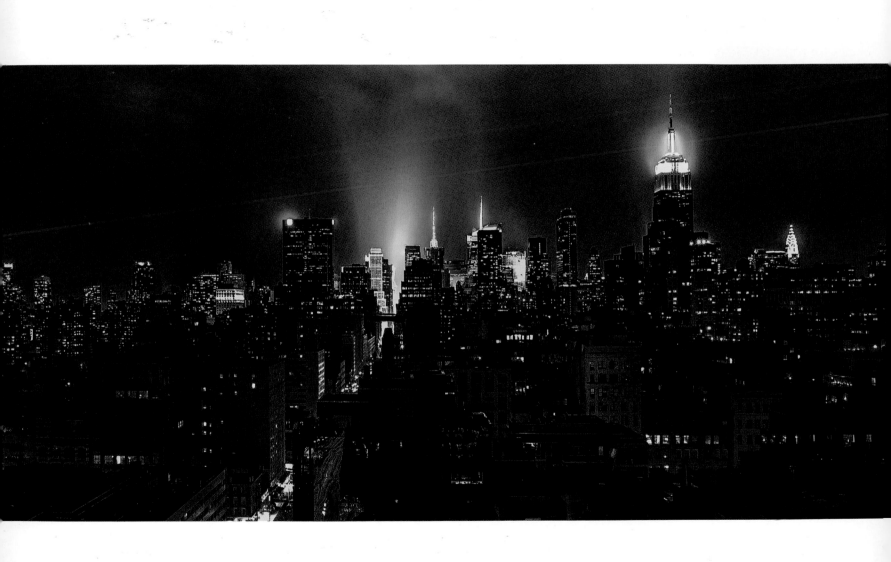

5.1A CAMERA: Canon EOS 5D MkII
LENS: Canon EF16-35mm f/2.8L II USM
SETTINGS: f/5.0, ISO 100, 30 seconds exposure
manual mode
FLASH: no flash
METERING FOCAL MODE: evaluative
FOCAL LENGTH: 16mm

Above: 5.1B – f13, 30 sec, ISO 100
Above right: 5.1C – f5.6, 1.3 sec, ISO 100

5.1 TRIPOD

One of the best locations to do night photography is New York. The sheer size of this city provides unlimited scope to capture some pretty special places with almost every corner lit up like Christmas trees.

Mary and I were fortunate enough to use the top deck of a building to fire off a series of shots over the ensuing skyline near Time Square. Once up there, I was astounded to see that most of the buildings have rooftop platforms and gardens. I was informed that a large number of these buildings across the city allow public access to their rooftop gardens/areas allowing you to go up and capture the surrounding vistas. You can also go up such buildings as the Rockefeller Centre with your camera kit and shoot away.

These three shots were all taken from this particular apartment's rooftop garden. All photos were taken with a tripod and a cable release was used in all shots to avoid any blurring that can sometimes happen from depressing the shutter button on your camera. The main photo was shot in manual mode with the Canon EOS 5D MkII camera. The other shots had similar exposure times however the zoomed-in photo of the Time Square district in 7th Avenue was shot with the EF70-200mm f/2.8L IS II USM lens with the focal length at 200mm.

5.2B – f2.8, 1/20 sec, ISO 1600

5.2C – f2.8, 1/20 sec, ISO 1600

5.2 FIXED VANTAGE POINT

The Customs House is a historic building. The building served as the headquarters of the Customs Service until 1990 and is now a public site for tourists and visitors. The location of this building is one of the key attractions for the Vivid Festival where the main façade of this historic site is totally transformed with laser shows. The spectacular transformations are hugely popular and the traffic of people is very high.

These series of shots were all taken from a fixed vantage point with a sturdy tripod and shutter release cable. High ISO settings were also used due to the constant change in imagery being displayed.

5.2A
CAMERA: Canon EOS 5D MkII
LENS: Canon EF16-35mm f/2.8L II USM
SETTINGS: f/2.8, ISO 1600, 1/20th of a second
 exposure manual mode
FLASH: no flash
METERING FOCAL MODE: evaluative
FOCAL LENGTH: 16mm

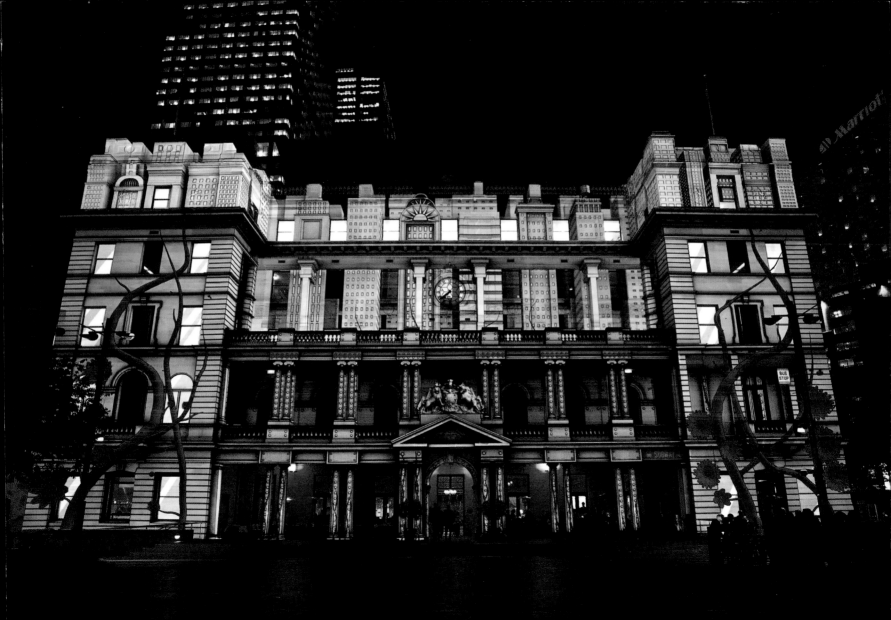

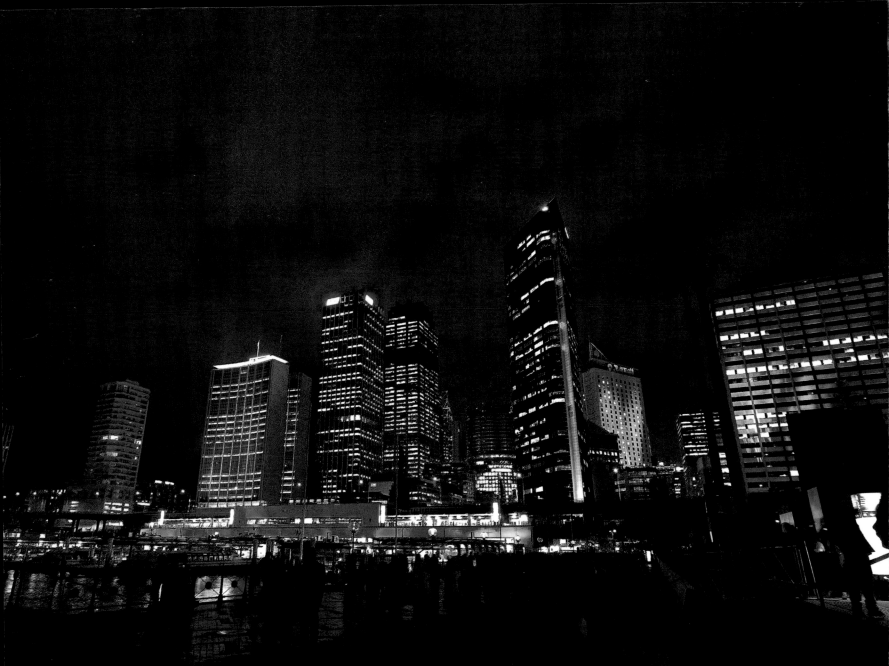

5.3 BLURRED ACTION

Looking back over my shoulder at the skyline, the moving clouds over the contrasting hard lines of the buildings caught my eye and provided an interesting angle for a series of shots. Movement of people also provides some blurred action.

The Vivid Festival is a festival of lights. This shot was taken fairly late at night with the city skyline still enveloped with colour. The throng of large crowds had already dispersed and for us avid photographers, the extra space was very appreciated.

5.3A
CAMERA: Canon EOS 5D MkII
LENS: Canon EF16-35mm f/2.8L II USM
SETTINGS: f/6.3, ISO 1600, 1.6 second
 exposure manual mode
FLASH: no flash
METERING FOCAL MODE: evaluative
FOCAL LENGTH: 16mm

5.3B – f2.8, 1/25 sec, ISO 1600

5.3C– f2.8, 1/25 sec, ISO 1600

5.4 INTENSE LIGHT

Our small group of photography colleagues are always on the lookout for new ventures and places to visit. This form of networking has unearthed many great places and, in this instance, my sights were set to photograph a balloon festival in Canowindra. None of us had seen these balloons up close yet alone photographed them at night.

The impressive sight of these structures coming to life was eagerly awaited and the radiant glows emanating from the burners provided sufficient ambient light to capture the colours of the balloons as they were being inflated. While the intense light of the burners was evident at the base of each balloon, the sheer size of each balloon shape diffused the light beautifully. Our main challenge was to capture these moving juggernauts without any form of blurring with the current light conditions. To overcome the blur factor, high ISO settings were used (between 1600–3200) with shutter speeds in the range of 1/20th–1/40th of a second. Camera noise emanating from using these ISO settings was eliminated using Adobe Camera Raw software without affecting the overall quality of each shot.

Our next challenge will be to a flight shoot from one of these majestic balloons.

5.4B – f4, 1/15 sec, ISO 3200

5.4A
CAMERA: Canon 5DMkII
LENS: Canon EF24-105mm f/4L IS USM-manual mode
SETTINGS: f4, 1/20th sec, ISO 800
FLASH: no flash
METERING FOCAL MODE: evaluative
FOCAL LENGTH: 24mm

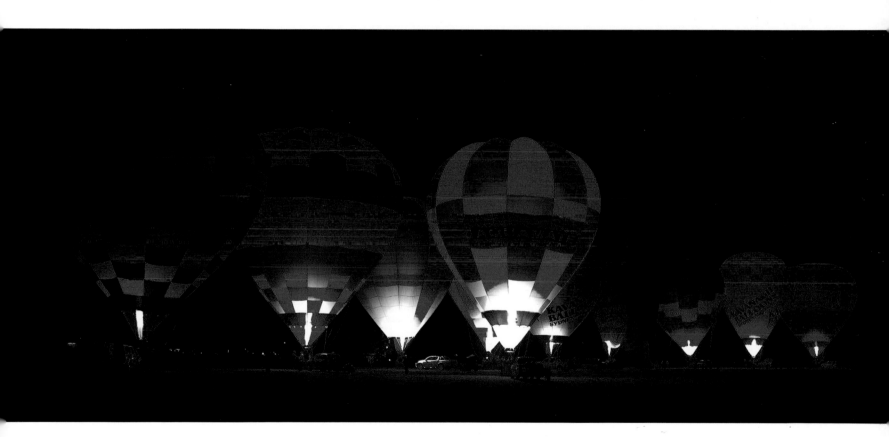

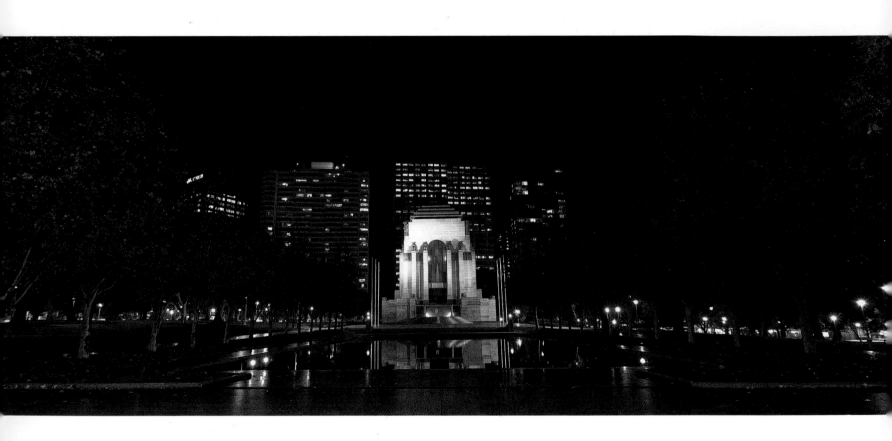

5.5 SYMMETRY

The symmetry of the area lends itself to photos at various standard angles and the use of leading lines also provides an element of interest for the viewer.

 The main challenge you will face with this location is the constant stream of people making their way through the park—if this is an issue you will need to wait for less busy times to shoot at this location. This photo was taken fairly late at night during a normal business week to avoid the crowds. It was also the middle of winter. I was keen to capture the overall location and its intrinsic calm, serenity and beauty. The weather was kind with no wind and a very clear night.

CAMERA: Canon EOS 5D MkII
LENS: Canon EF16-35mm f/2.8L II USM
SETTINGS: f/4.5, ISO 100, 15 seconds exposure
 manual mode
FLASH: no flash
METERING FOCAL MODE: evaluative
FOCAL LENGTH: 16mm

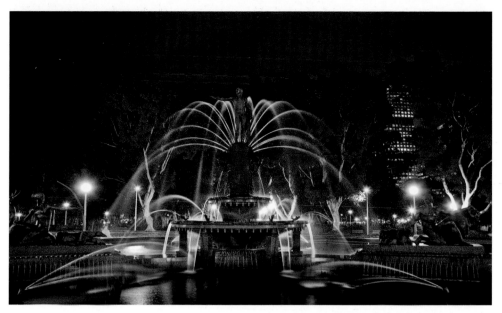

5.5B – f5, 10 sec, ISO 100

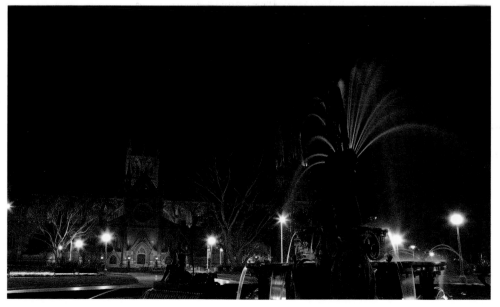

5.5C – f10, 30 sec, ISO 100

5:6 NIGHT SKY

For several years now, the Vivid Festival has occurred from mid to late May to early June. Each year there is a focus on lighting up the city and the most iconic foreshore attractions. Sydney is transformed into a spectacular canvas of light, music and ideas when Vivid Sydney takes over the city after dark.

The festival each year grows in size and the colour displays, with lasers and projections, attract large crowds every night. Photographers from all parts of Sydney descend here amongst the throng of tourists who are also visiting Sydney. As with such festivals, crowds do become your worst enemy especially for photographers carting equipment and tripods but there is room for everyone if you are patient and courteous.

I've ventured out every year more than once because of the large variety of places to photograph. Each outing has unearthed some great shots and special effects (straight out of the camera). I would highly recommend the festival for anyone but especially for us photo takers.

5.6A
CAMERA: Canon EOS 5D MkII
LENS: Canon EF24-105mm f/4L IS USM
SETTINGS: f/4.5, ISO 100, 15 seconds exposure
 manual mode
FLASH: no flash
METERING FOCAL MODE: evaluative
FOCAL LENGTH: 35mm

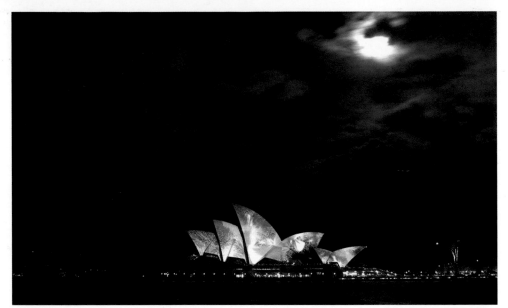

5.6B – f11, 12 sec, ISO 100

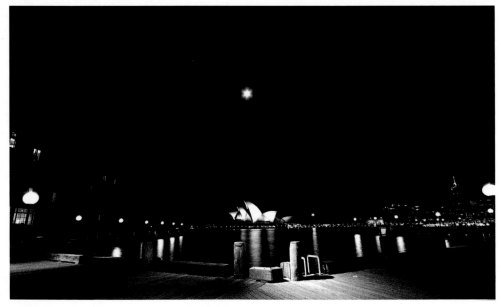

5.6C – f6.3, 10 sec, ISO 100

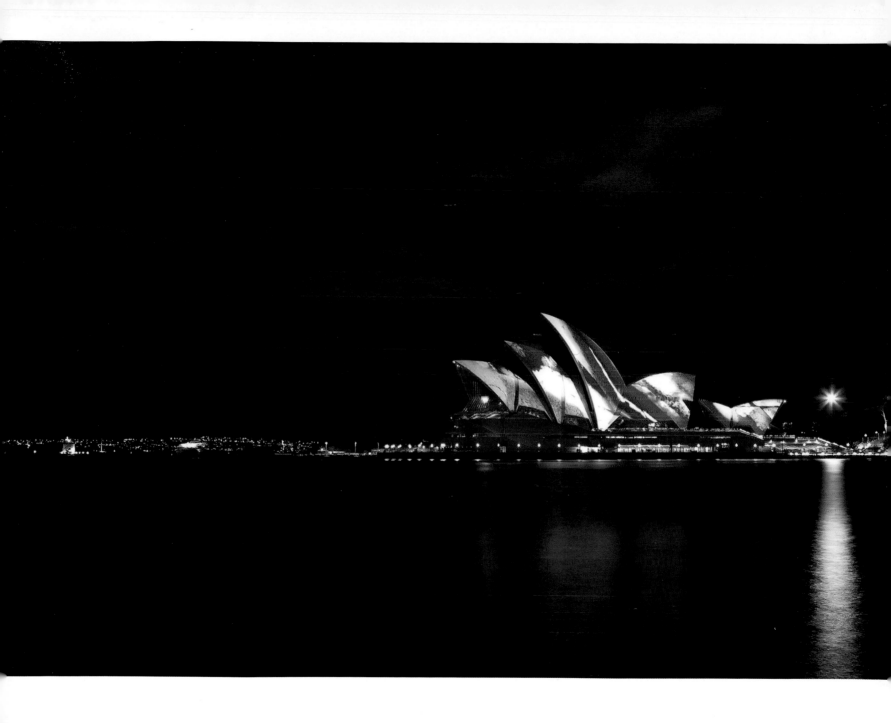

5.7 CLOUDY SKIES

Prior to going to New York, a friend informed me that the viewing platform at the top of the Rockefeller Centre was exceptional as photographers can take and use their tripods and have some great uninterrupted views of the entire city in all directions. The other bonus was that views over Central Park were very good and you can also capture the Empire State building with some great background vistas.

While walking through the streets of New York, huge storms were rolling in bringing some torrential downpours. Mary and I headed straight to the Rockefeller building knowing that storms usually create very dramatic shots. We were keen to get up the top and weren't disappointed to see that upon stepping onto the viewing platform the storm clouds were just breaking up. The other bonus was most of the viewing dock was empty as most visitors had left because of the weather.

We must have fired off some 150 shots that afternoon of amazing scenes.

5.7A
CAMERA: Canon EOS 5D MkII
LENS: Canon EF16-35mm f/2.8L II USM
SETTINGS: f/2.8, ISO 800, 1/4th second exposure manual mode
FLASH: no flash
METERING FOCAL MODE: evaluative
FOCAL LENGTH: 19mm

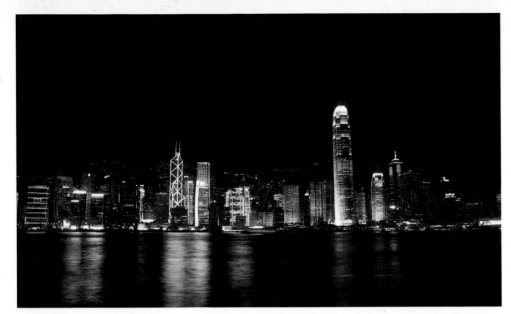

5.7B – f5, 6 sec, ISO 100

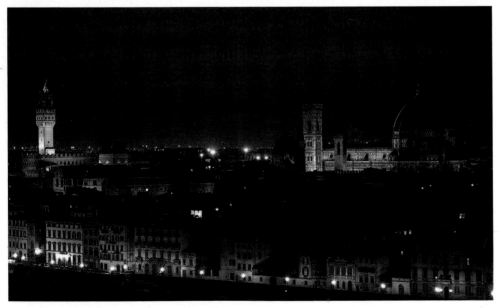

5.7C– f11, 20 sec, ISO 100

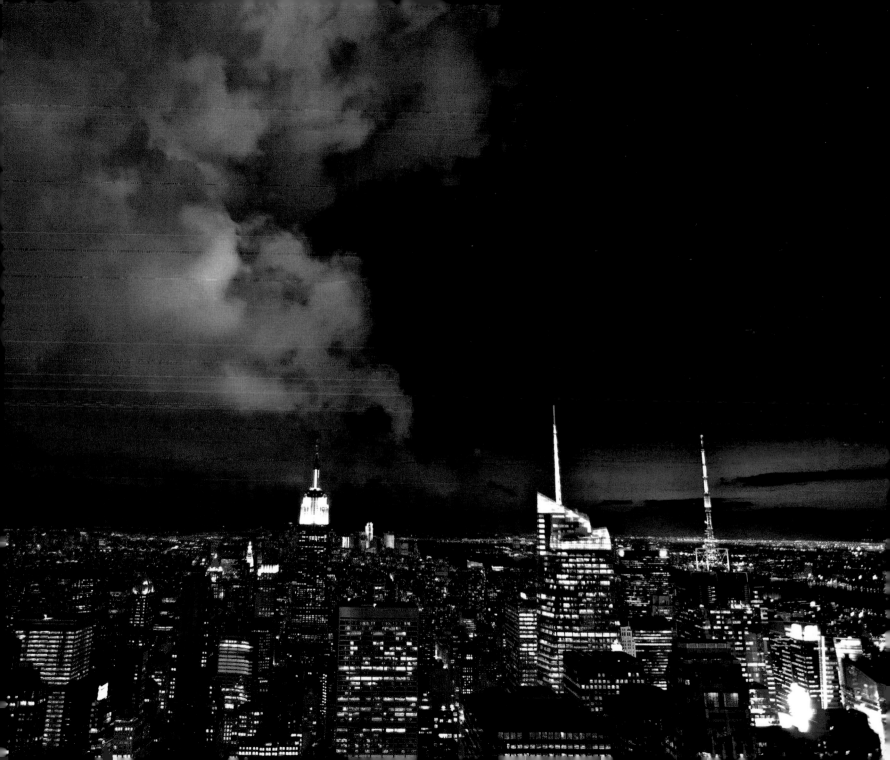

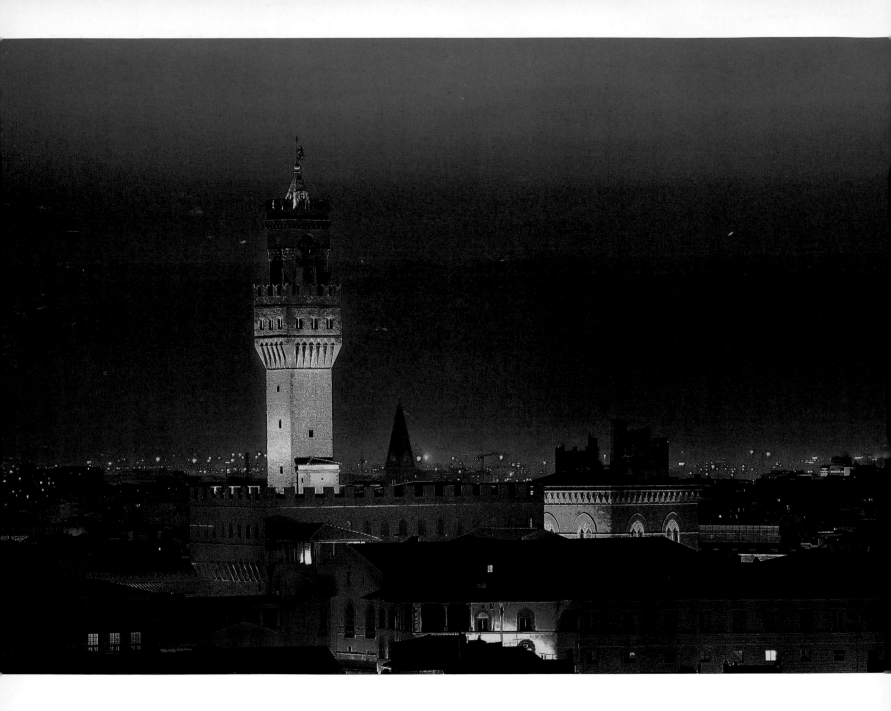

5.8 ARCHITECTURE AT NIGHT

Architecture at night takes on a totally different look and in most instances can be majestic. Florence is a magnificent city with some amazing sights. Getting around the city is very easy and around each corner, treasures reveal themselves. During the day, a large number of tourists head to a special vantage point—the Piazzale Michelangiolo. This piazza was designed in 1869 to provide a viewing point from which to admire the city of Florence below. The Florentine's have named it the city's balcony as it offers the most spectacular views of the city by far.

We visited this site during the day and made a note that the night scenes would also be spectacular. We weren't disappointed.

5.8A
CAMERA: Canon EOS-1D Mark II
LENS: Canon 70-200mm IS II USM
SETTINGS: f/11, ISO 100, 30 seconds exposure manual mode
FLASH: no flash
METERING FOCAL MODE: evaluative
FOCAL LENGTH: 190mm

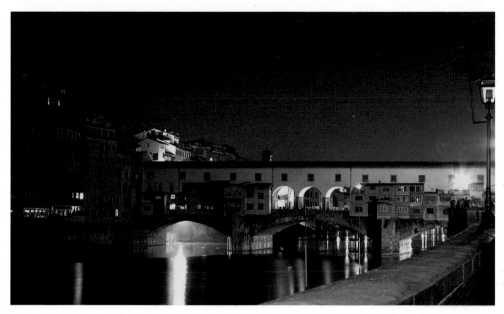

5.8B – f6.3, 13 sec, ISO 100

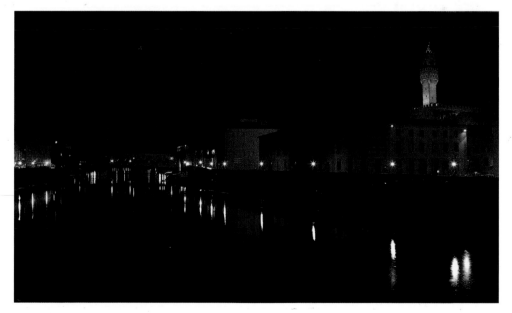

5.8C – f7.1, 8 sec, ISO 100

5.9 STREET LIGHTS

I sense that every person who has visited Venice has photographed the Rialto Bridge at some stage during their stay. As with all popular places, crowds will be your biggest challenge although if you are willing to go out really early or late in the day, you will be rewarded with a somewhat more serene scene. I was keen to photograph this bridge from as many angles as possible at night as the city takes on a totally different mood during this time. With Venice, some of the walkways are extremely narrow and you should be conscious that tripods can be somewhat limiting around the very popular spots. A tripod and cable release for remote operation of the shutter button was also used.

5.9A
CAMERA: Canon EOS-1D Mark II
LENS: Sigma 10–20mm lens
SETTINGS: f/5, ISO 100, 4 seconds exposure
 manual mode
FLASH: no flash
METERING FOCAL MODE: evaluative
FOCAL LENGTH: 15mm

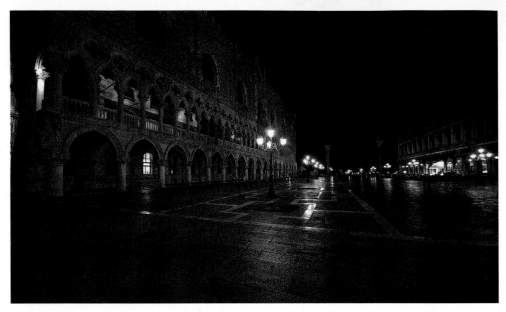

5.9B – f5.6, 4 sec, ISO 100

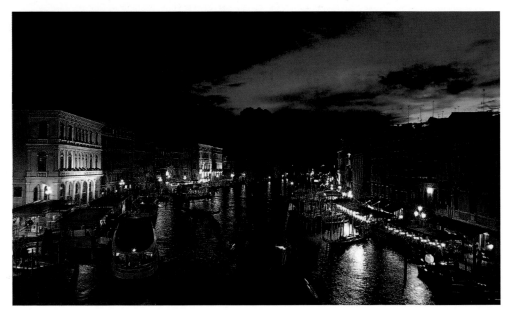

5.9C – f4, 2 sec, ISO 100

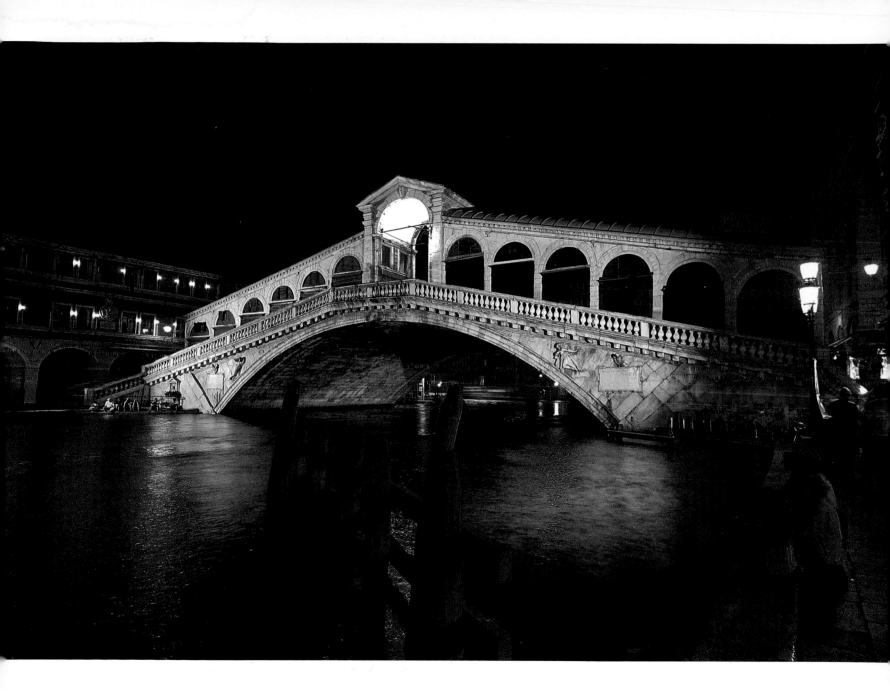

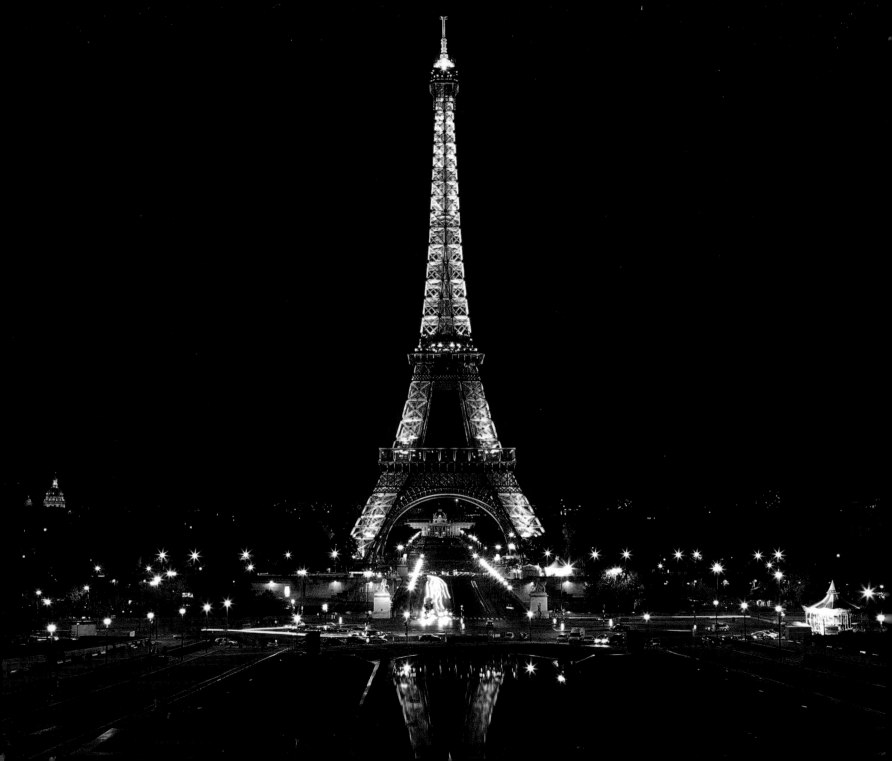

5.10 TOWER OF LIGHT

With family living in France, I often make Paris my first stop and allow several days to pass to adjust to the time zone difference. Adjusting sometimes works in your favour as you can often find yourself wide awake at 2.00am and ready to do something. Going out at that time of morning allows you to have complete access of the most popular places without being rushed or jostling to get the best position for some scenic shots. In this particular instance, my son and I went out for four to five hours and managed to capture some of the best iconic landmarks in Paris without any hassles whatsoever. By the way, catching a taxi at that time of morning becomes a fairly cheap exercise as it takes very little time to get from one place to another.

This shot was taken from the terrace of the Trocadéro, which looks down towards the river Seine and Eiffel Tower. This terrace is an ideal platform to capture the entire foreground area. A tripod and cable release for remote operation of the shutter button was also used.

5.10A
CAMERA: Canon EOS-1D Mark II
LENS: Canon 17–85 lens
SETTINGS: f/9, ISO 100, 15 seconds exposure
 manual mode
FLASH: no flash
METERING FOCAL MODE: evaluative
FOCAL LENGTH: 24mm

5.10B – f5.6, 6 sec, ISO 100

5.10C – f13, 8 sec, ISO 100

5.11 LANDMARKS AT DUSK

The Louvre is one of the world's largest museums, the most visited art museum in the world and a historic monument. A central landmark of Paris, it is located on the Right Bank of the Seine. Photo opportunities are limitless given the sheer size and spread of this landmark. In photographing this site at 2:30am, my son and I were surprised to learn that the use of tripods within the surrounding area of the Pyramid Dome is actually banned. Yes you can take pictures but not with a tripod! You can overcome this if you use parts of the buildings or pool walls to prop your camera up for long exposure shots.

A tripod and cable release for remote operation of the shutter button was also used. The bottom section photo was subsequently cropped in Adobe Camera Raw to reveal a more panoramic effect.

5.11A
CAMERA: Canon EOS-1D Mark II
LENS: Sigma 10–20mm
SETTINGS: f/5.6, ISO 100, 8 seconds exposure
 manual mode
FLASH: no flash
METERING FOCAL MODE: evaluative
FOCAL LENGTH: 10mm

5.11B – f5.6, 3 sec, ISO 100

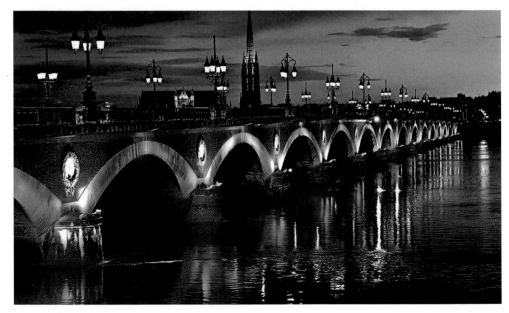

5.11C – f13, 3 sec, ISO 100

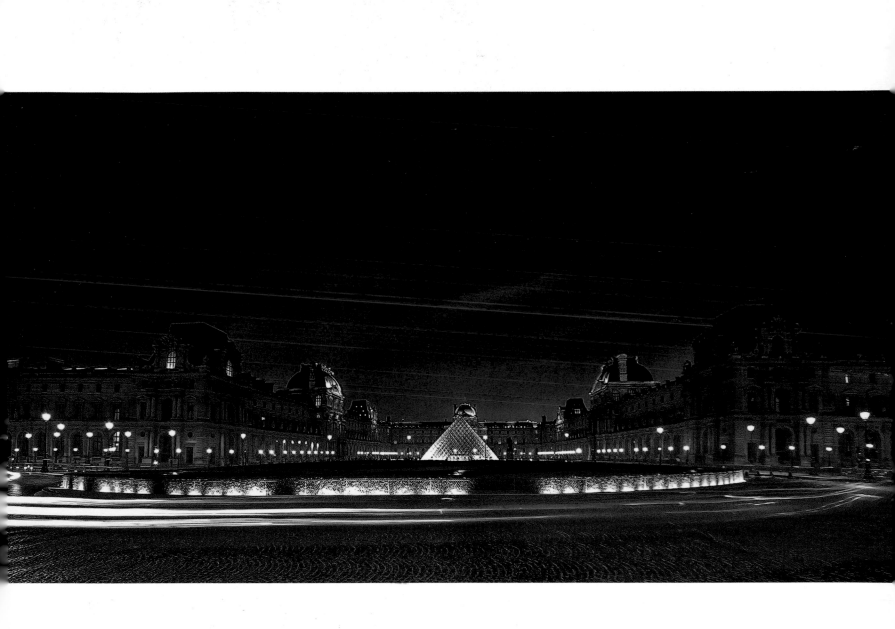

6 .LANDSCAPES

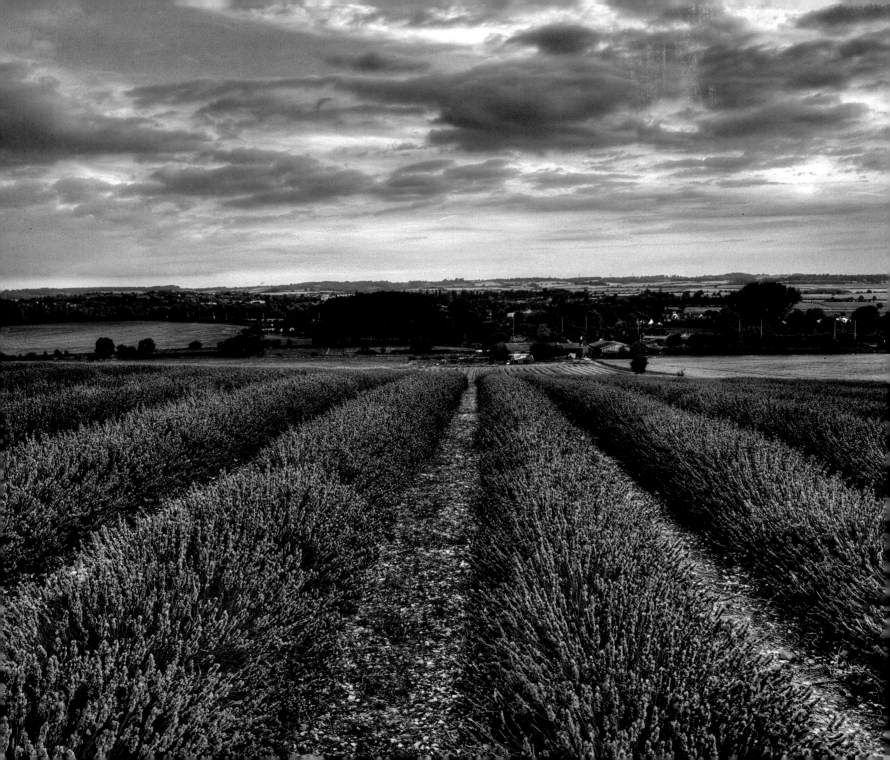

6.1 TONE

I've had the pleasure of travelling through the south of France many times and the Provence Region would have to be one of the most picturesque rural areas to tick off on your list of 'must see'. The lavender fields are spectacular and will complement any landscape shots you take. Lavender usually blooms from late June to September and is harvested from mid-July to late August. The vibrant colours these plants provide will add a wow factor to your shots—the rest is up to you in terms of composition. In this photo, the planted lines of lavender lead you away from the field and that component adds to the depth of the photo.

6.1A
CAMERA: Canon EOS-5D Mark II
LENS: Canon EF17-40 f/4 USM
SETTINGS: f/13, ISO 100, 1/250th of a second
 exposure manual mode
FLASH: no flash
METERING FOCAL MODE: evaluative
FOCAL LENGTH: 20mm

6.1B – f22, 1/20 sec, ISO 100

6.1C – f2.8, 1/100 sec, ISO 100

6.2A – f7.1, 1/100 sec, ISO 100

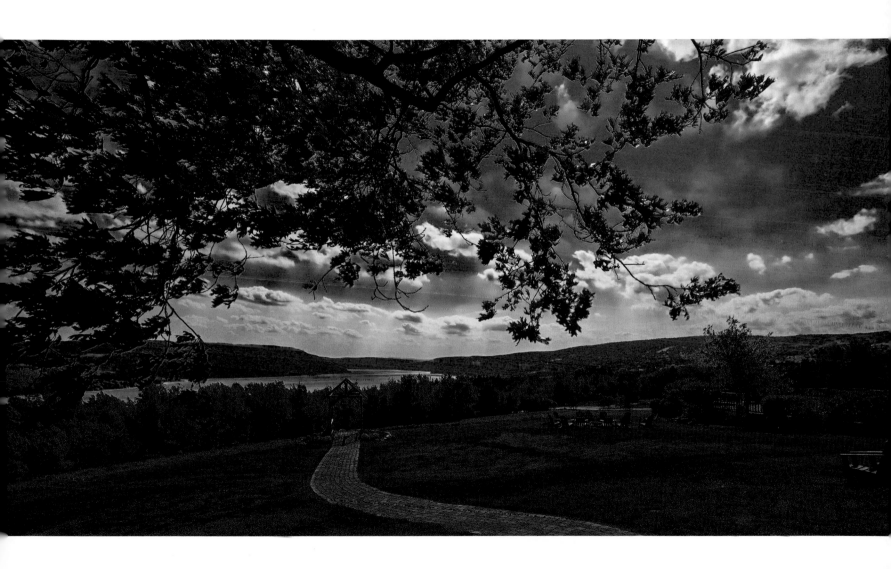

6.2B — f22, ISO 200, 1/100sec

6.3A
CAMERA: Canon EOS-5D Mark II
LENS: Canon EF16-35mm f/2.8L II USM
SETTINGS: f/22, ISO 100, 1.3 seconds
 exposure manual mode
FLASH: no flash
METERING FOCAL MODE: evaluative
FOCAL LENGTH: 16mm

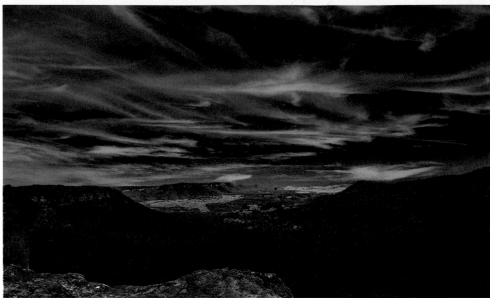

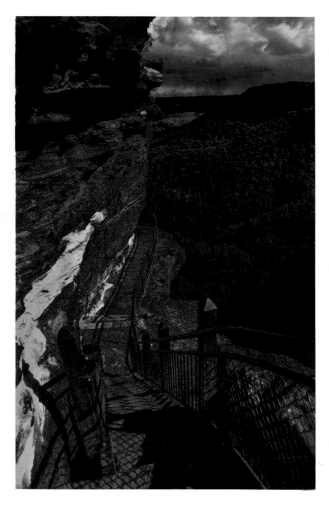

6.3 RIVER VIEWS

Nepean River is located at the foot of the Blue Mountains region some 55 km (about 34 miles) from Sydney and is the natural dividing line of the Sydney Basin and the mountain ranges that spread towards the west.

Landscape shots are one of my favourite segments of the photography that I do as they often capture the very essence of these places. They serve as a gentle reminder of good things associated with the place itself. As I look through my ever-growing portfolio long after shots are taken, I often stall at specific ones and reflect on these good parts.

This shot was taken near Penrith where nature walkways hug both sides of the river. The area is very picturesque and is visited by lots of photographers who seek to capture the river itself and the natural surrounds that the area offers. This is a good place also to finetune your photographic skills with water cascading through the weir and other adjoining streams. A tripod and cable release for remote operation of the shutter button was also used.

Above: 6.3C – f13, 1/400 sec, ISO 400
Left: 6.3B – f6.3 , 1/200 sec, ISO 100

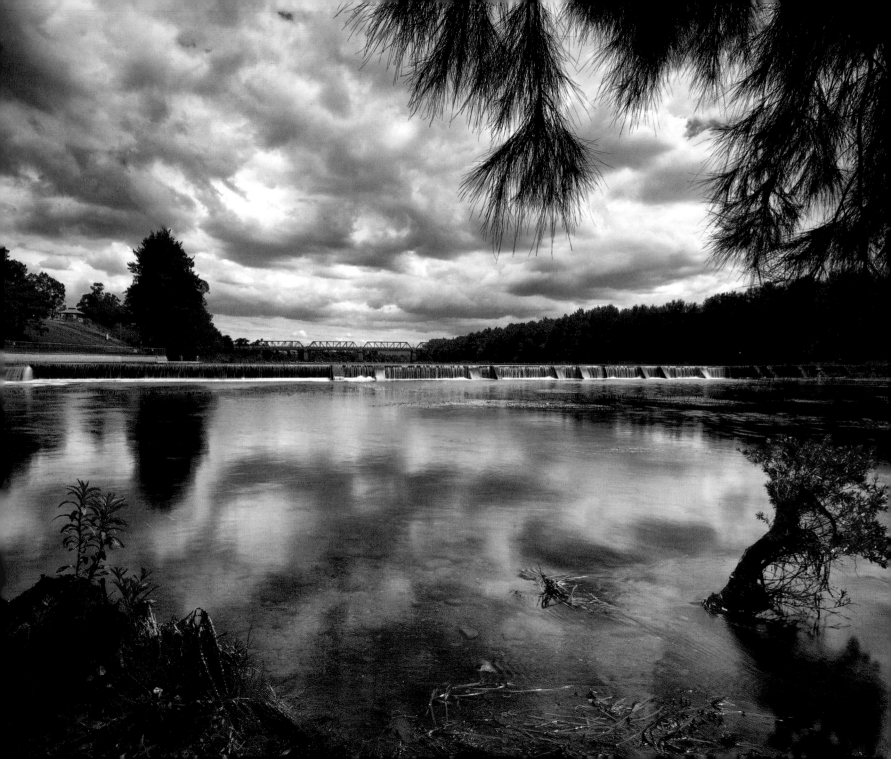

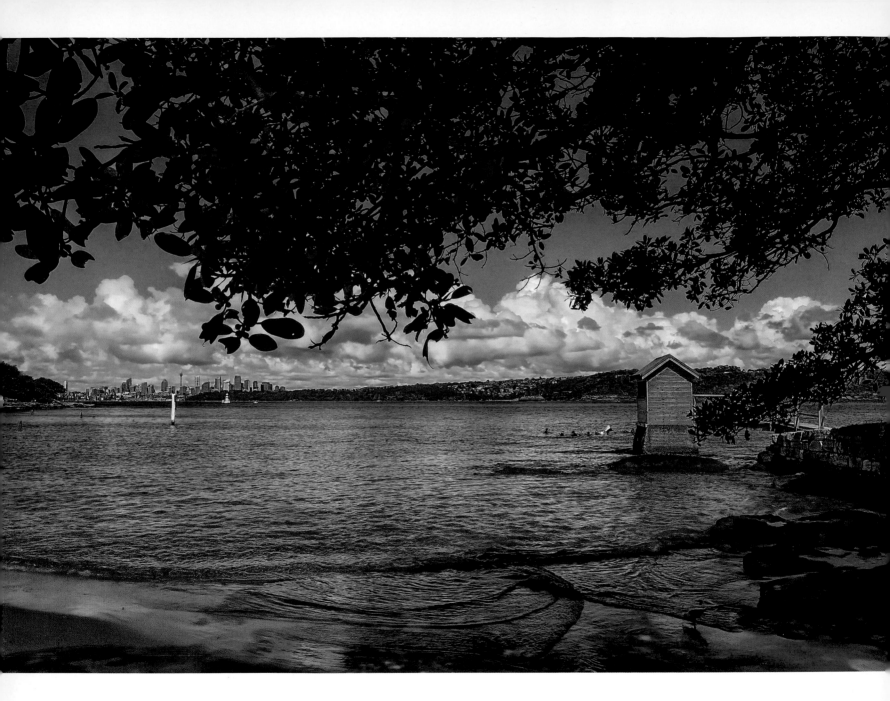

6.4 SCENE SHAPING

Camp Cove is one of hundreds of small inlets that hug the harbour foreshore. When we visit, we rest and enjoy the sights that the area offers.

The challenge for this shot was to have the entire scene exposed correctly including the shaded overhanging tree directly overhead.

6.4A
CAMERA: Canon EOS-5D Mark I
LENS: Canon EF17-40 f/4 USM
SETTINGS: f/22, ISO 1000, 1/400th of a second
exposure manual mode
FLASH: no flash
METERING FOCAL MODE: evaluative
FOCAL LENGTH: 24mm

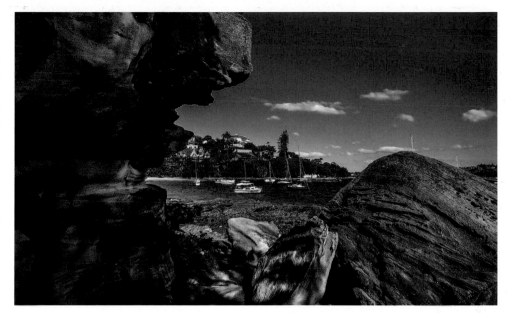

6.4B – f13, 1/320 sec, ISO 400

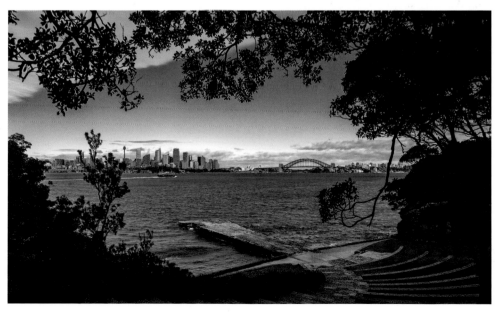

6.4C – f9, 1/200 sec, ISO 100

6.5 FROM A HELICOPTER

Landscape shots don't get much better than an aerial photo. The added height allows you to capture the total area and also provides a point of view that is rarely seen nor appreciated. The helicopter ride over the entire Sydney harbour was triggered specifically as I had photographed most of the harbour foreshore on the ground but never on a much grander or broader scale.

The challenge of such shots is to ensure that the vibration and constant movement that is felt in the helicopter does not affecting the quality and clarity of your photos. The glare that can also occur on sunny days can wreck a good shot with details of the cockpit instrumentation panel mirroring itself in your photo scope. Awareness of this is sometimes lost when you are admiring the scenes that unfold before you.

6.5A
CAMERA: Canon EOS-5D Mark I
LENS: Canon EF17-40 f/4 USM
SETTINGS: f/9, ISO 400, 1/160th of a second exposure
 manual mode
FLASH: no flash
METERING FOCAL MODE: evaluative
FOCAL LENGTH: 24mm

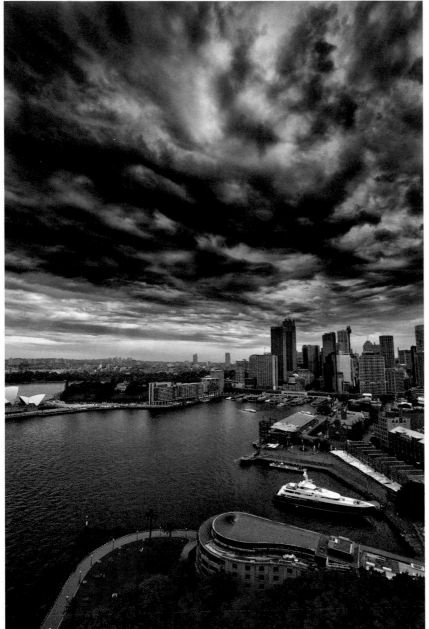

6.5B – f7.1, 1/500 sec, ISO 100

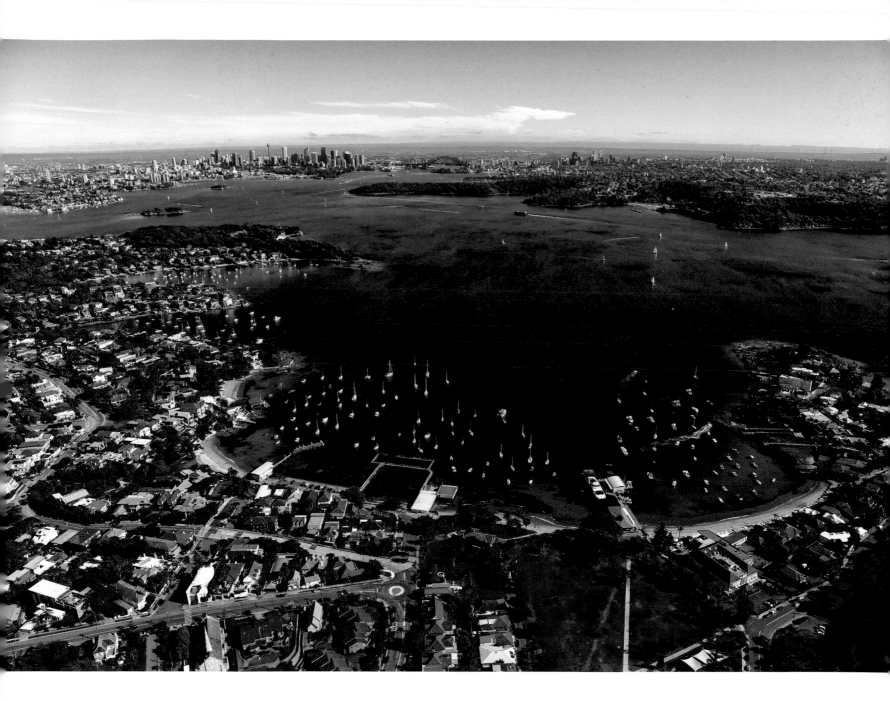

6.6 TOWNSCAPES

As you cross the US/Canadian border near Niagara Falls, the township of Niagara on the Lake (adjacent to Lake Ontario) can be found. The town is nicknamed 'The Loveliest Town in Canada'. We visited this place and during the short time there, the nickname certainly had some relevance. The entire surrounding area is covered with postcard-style scenery.

While some might say that most landscape shots should capture hills, valleys, coastlines, etc., I read that the perfect landscape image is one that completely communicates everything that the photographer is trying to say without the need to say it. I can personally align myself with that approach and it is the basis of almost my entire scope of work. Hopefully the viewer of my images can also unearth the message that I am trying to convey.

This photo, of a small section of the main street in Niagara on the Lake, was shot in manual mode.

6.6A
CAMERA: Canon EOS-5D Mark II
LENS: Canon EF16-35mm f/2.8L II USM
SETTINGS: f/6.3, ISO 100, 1/160th of a second
 exposure manual mode
FLASH: no flash
METERING FOCAL MODE: evaluative
FOCAL LENGTH: 35mm

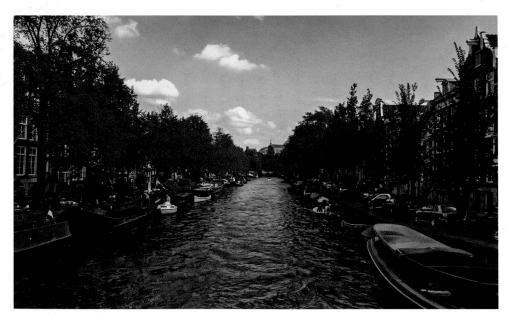

6.6B – f11, 1/200 sec, ISO 100

6.6C – f10, 1/200 sec, ISO 200

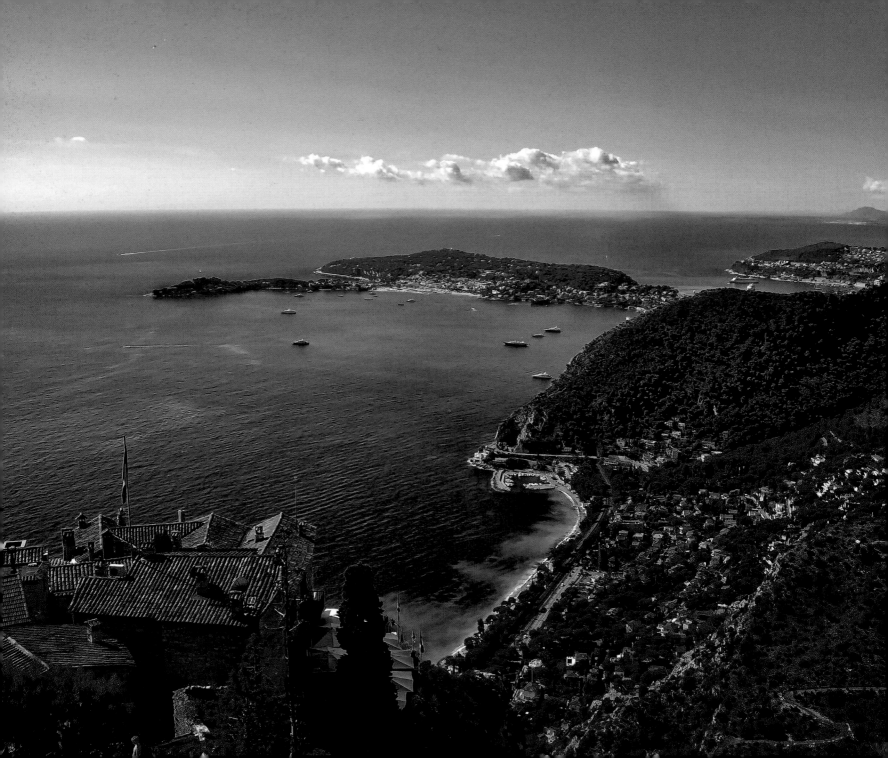

6.7 COASTAL LANDSCAPES

On the way to Monaco from Nice, you will travel through a series of coastal towns that are breathtaking. It pays to stop and look up, as some of the most striking places are actually perched on one of the top Riviera Corniche roads. Such a place can be found at a very small township called Èze. A tip for any photographer—make sure you have a spare memory card in your kit. You will need it as the panoramic views are spectacular. The challenge I faced in this treasured area was where to start and stop photographing this place.

Èze has been described as an 'eagle's nest' because of its location on top of a high cliff almost half a kilometre (about 545 yards) above sea level on the French Mediterranean. The artistic nature and background of this place is bound to rub off on any photographer and there will be plenty of amateur and professionals taking photos here.

6.7A
CAMERA: Canon EOS-20D
LENS: Canon EF17-85mm
SETTINGS: f/5.6, ISO 100, 1/800th of a second exposure manual mode
FLASH: no flash
METERING FOCAL MODE: evaluative
FOCAL LENGTH: 55mm

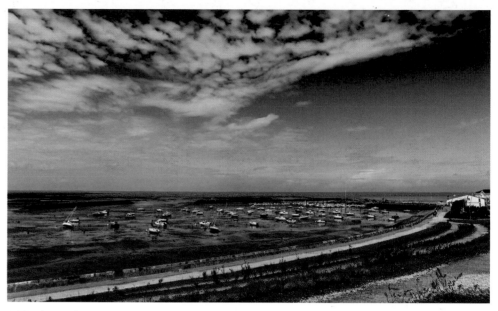

6.7B – f11, 1/250 sec, ISO 100

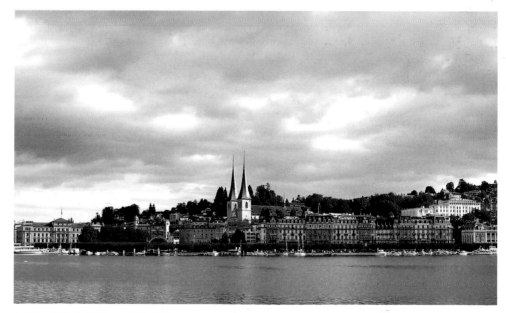

6.7C – f4.5, 1.500 sec, ISO 100

6.8 FROM THE WATER

Some family members gave us the opportunity to visit Newport Rhode Island where the America's Cup has taken place. I had heard that part of this seacoast area was a great spot for photography—there's a great diversity of subject and almost everywhere you look, all parts of the coastline offer some very attractive scenes to capture. I would highly recommend taking a cruise along the inner bay and take your camera with you.

Shooting from the water presents its own challenges such as movement of the boat and sea spray, if prevailing winds are around. We had the good fortune to see and be in the middle of all past America's Cup yachts sailing in their own private regatta as they were heading back to shore. Sports photography is not something I have dabbled in much and the challenge was to also make these shots come alive.

6.8A CAMERA: Canon EOS 550D
LENS: Canon 70–200 f/4 USM
SETTINGS: f/7.1, ISO 100, 1/400th of a second exposure manual mode
FLASH: no flash
METERING FOCAL MODE: evaluative
FOCAL LENGTH: 89mm

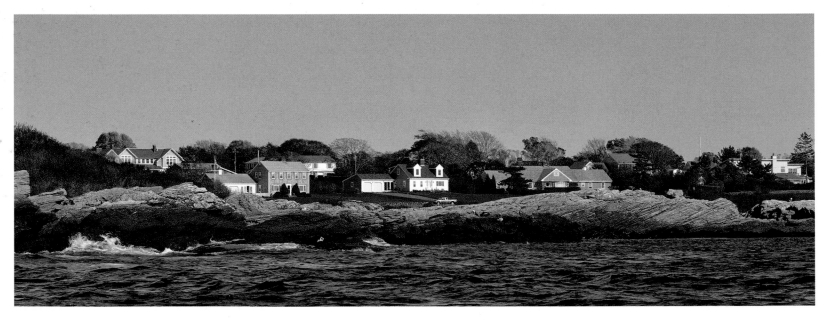

6.8B – f8, 1/400 sec, ISO 100

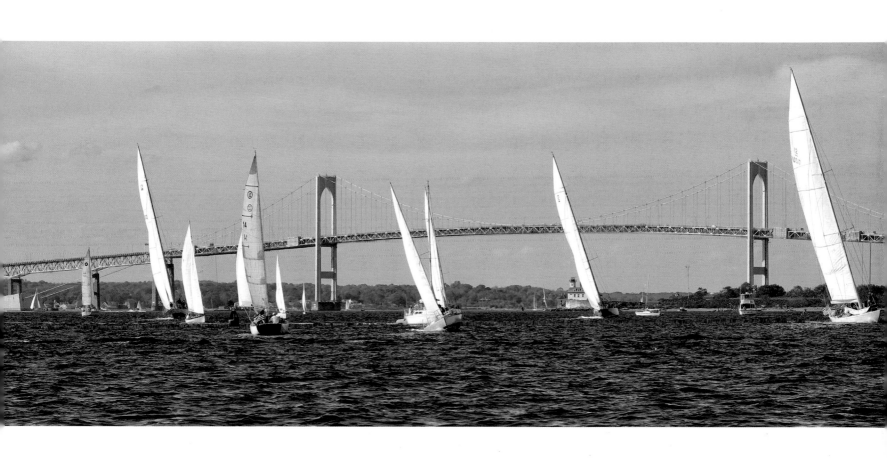

6.9 ICONIC STRUCTURES

Capturing landscapes takes on an entirely new meaning for me when old architectural buildings form part of the landscape. It should be easier as they will not be moving and you have the luxury of positioning yourself at the best angles that work for you. Having said that, you are faced with the challenge of using the available light and working out if the surrounding features around the architecture complement the photo.

The Louvre presents its own difficulties—it is impossible to capture all of it and still be very close to it. For me, the symmetry of the buildings that form part of the structure was the more interesting component so the challenge was to make sure all lines were in sync and that visitors were away from the key focal point.

This photo took several attempts until I was happy with it. The photo was subsequently cropped in Adobe Camera Raw to provide a more panoramic feel.

6.9A
CAMERA: Canon EOS-5D
LENS: Canon EF17 40mm f/4L USM
SETTINGS: f/14, ISO 400, 1/400th of a second
 exposure manual mode
FLASH: no flash
METERING FOCAL MODE: evaluative
FOCAL LENGTH: 17mm

6.9B – f13, 1/400 sec, ISO 400

6.9C – f7.1, 1/100 sec, ISO 100

6.10. OCEAN VIEWS

A large family reunion in France in 2009 provided me with a great opportunity to see the Île de Ré (Island) near La Rochelle on the west coast of France. I was very grateful to spend some quality time with the family but also to experience some great scenery on this exquisite quiet isle. The island has large sections of man-made shallow salt ponds. The geometric patterns formed by these salts ponds reflect the colour of the sky blending together with the clayey bottom producing unusual colours—slate grey, mauve blue, or sometimes pink. These colours change again with the different seasons with more vibrant colours present, from mustard yellows to whites and mauve in summer to reds in autumn.

As it was my first trip to this island, it left me with no plans as to what to see and shoot. But this was resolved fairly quickly when I visited the island's furthest point and climbed up one of the lighthouse posts. The vista at the top was amazing with the large expanse of clear water and coloured shallows.

Prior to taking this photo, I mounted a polarising filter on the EF16-35mm f/2.8 IS USM lens. I will be heading back to this island soon.

6.10A
CAMERA: Canon EOS-5D MkII
LENS: Canon EF16-35mm f/2.8 IS USM
SETTINGS: f/10, ISO 100, 1/250th of a second exposure manual mode
FLASH: no flash
METERING FOCAL MODE: evaluative
FOCAL LENGTH: 16mm

6.10B – f11, 1/250 sec, ISO 100

6.10C – f11, 1/320 sec, ISO 100

6.11 PANORAMA

Here is the best tip I can give you if you are going to Paris. With millions of tourists that visit Paris every year, a very large percentage will go up the Eiffel Tower. Wouldn't it be nice to get a very elevated shot looking down at Paris and also have the Eiffel Tower in your shot? You can—and it will be cheaper that the Eiffel Tower and the visitor's queues will be only about a 5 minute wait.

Make your way to Montparnasse-Bienvenüe Paris Métro station, where you will find the Montparnasse Tower. The tower has 59 floors, which are mainly occupied by offices. The terrace, located on the very top floor, is open to the public for viewing the entire city—once up there you will have an uninterrupted 360 degree view, covering a radius of 40 km (25 miles). The cost is 13 euros per adult and the terrace is open from 9:30am till 11:30pm from 1 April till 30 September. Closing time for the rest of the year is around the 10:30pm mark.

If you have access to a zoom lens, take it with you as you will be able to focus in tight of some great buildings and parts of the city. If shooting at night, take your tripod for some magical shots.

6.11A
CAMERA: Canon EOS-5D MkII
LENS: Canon EF16-35mm f/2.8 IS USM
SETTINGS: f/11, ISO 100, 1/250th of a second
 exposure manual mode
FLASH: no flash
METERING FOCAL MODE: evaluative
FOCAL LENGTH: 16mm

6.11B – f14, 1/400 sec, ISO 400

6.11C – f10, 1/200 sec , ISO 100

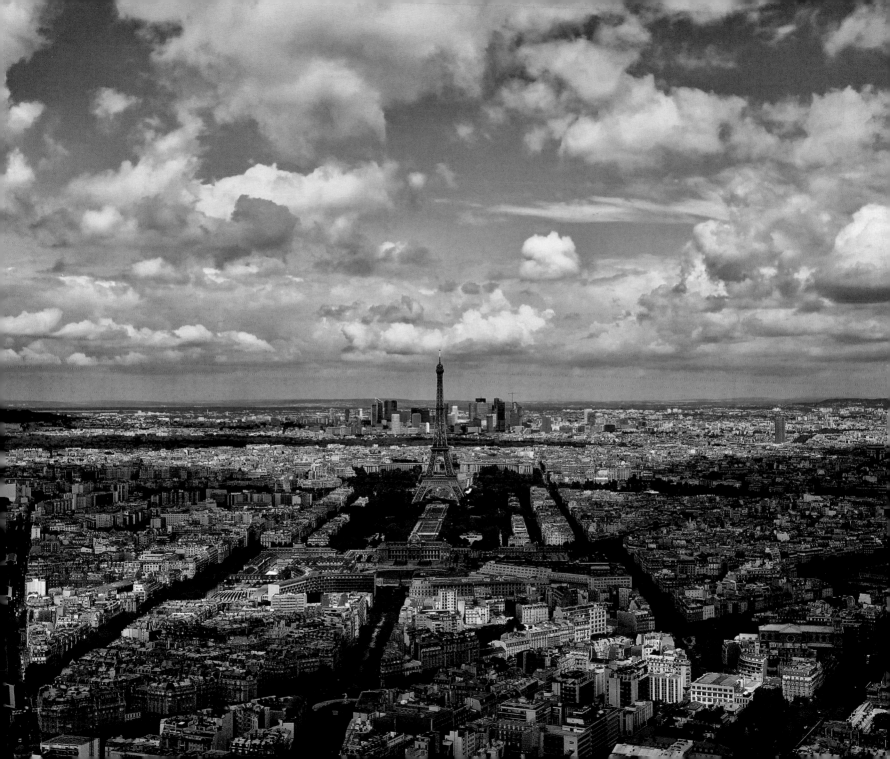

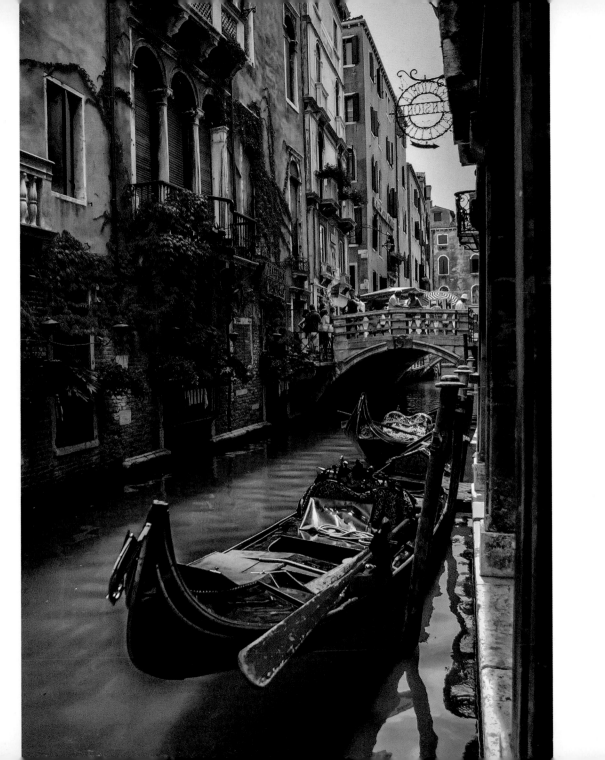

6.12 CANALS AND WATERWAYS

Landscape shooting will be in switched into overdrive in Venice. Don't be fooled or concerned that you need a huge expanse of land in front of you to capture a great landscape shot. A tight narrow view of something special is just as emotive or effective. As mentioned earlier the perfect landscape image is one that completely communicates everything that the photographer is trying to say without the need to say it. So the real challenge for me, in such situations, is to compose a photo that will fit this criterion. I think I have achieved this with this photo. I purposely went out to find quiet areas of Venice where the crowds were absent. While peering down alleyways and covered corridors I stumbled onto a dead end and found this vista unfold in front of me. I did crop the photo slightly on the left-hand side to give a tighter and narrower feel to the overall scene.

6.12A
CAMERA: Canon EOS-5D MkII
LENS: Canon EF16-35mm f/2.8 IS USM
SETTINGS: f/2.8, ISO 100, 1/320th of a second
 exposure manual mode
FLASH: no flash
METERING FOCAL MODE: evaluative
FOCAL LENGTH: 16mm

6.12B – f8, 1/640 sec, ISO 100

6.12C – f16, 1/500 sec, ISO 400

6.13 LAKES

Lake Ontario, and its surrounding shoreline, has many beautiful areas that lend themselves well to landscape photography. The narrow entry to a small, protected jetty and marina caught my eye in terms of its shape and defining lines. I found it odd that two lighthouses were in such close proximity to each other especially with one being set back further inland.

6.13A
CAMERA: Canon EOS-5D MkII
LENS: Canon EF16-35mm f/2.8 IS USM
SETTINGS: f/8, ISO 100, 1/500th of a second exposure—manual mode
FLASH: no flash
METERING FOCAL MODE: evaluative
FOCAL LENGTH: 16mm

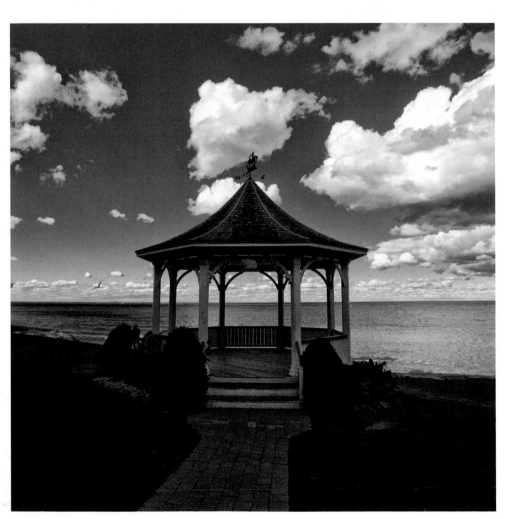

6.13B – f6.3, 1/160 sec/ ISO 100

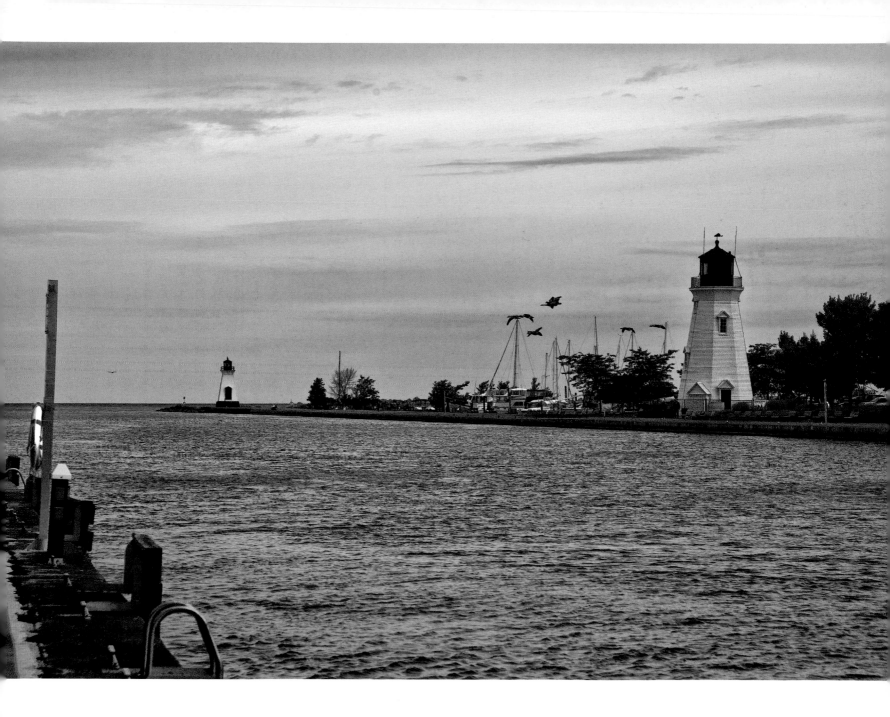

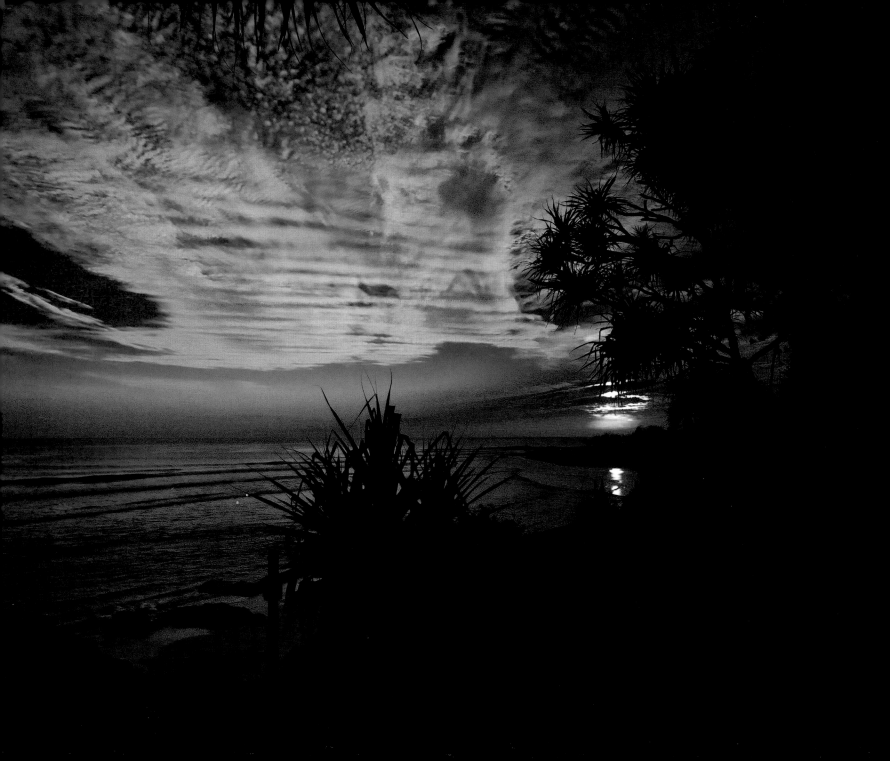

6.14 HEADLANDS AT SUNRISE

Any opportunity to shoot a sunrise landscape shot near the water is always enticing. The key attraction for me is the scope of colours associated with such an event—they always have a surprise or wow factor. Visiting my sister, I know several beaches that have tropical surrounds in the area. I had seen in many travel brochures the high contrast effects of tropical vegetation against a burnt orange sunrise and so my mission was to try to create a similar result.

The headland here provided the appropriate land 'props so all that was now missing was the golden sunrise. The first pre-dawn morning that I ventured out, I was lucky enough to have all the key elements available very quickly. The hardest part about setting up the shot was trying to find a nice array of silhouetted vegetation, to give the shot a sufficient level of recognisable detail. The morning was extremely calm, which helped in obtaining tack sharp contrast and the ensuing glow across the entire sky was a bonus. A tripod was used to reduce the potential risk of camera blur. A remote shutter cable was also used.

6.14A
CAMERA: Canon EOS-5D MkII
LENS: Canon EF16-35mm f/2.8 IS USM
SETTINGS: f/22, ISO 400, 1/15th of a second
 exposure manual mode
FLASH: no flash
METERING FOCAL MODE: evaluative
FOCAL LENGTH: 16mm

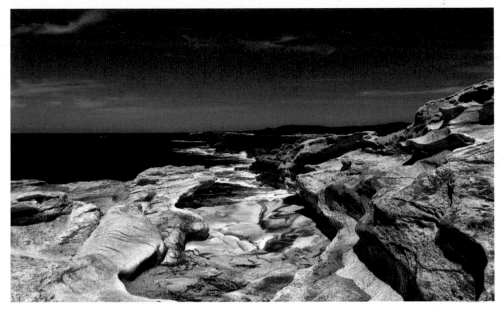

6.14B – f14, 1/160 sec, ISO 100

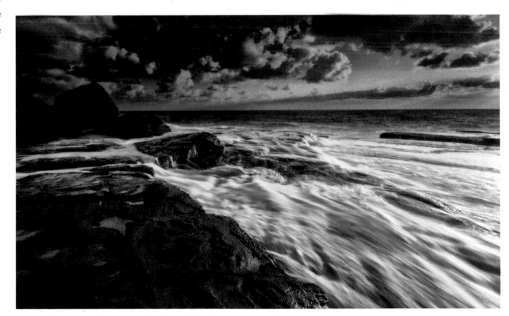

6.14C – f14, 1/8 sec, ISO 100

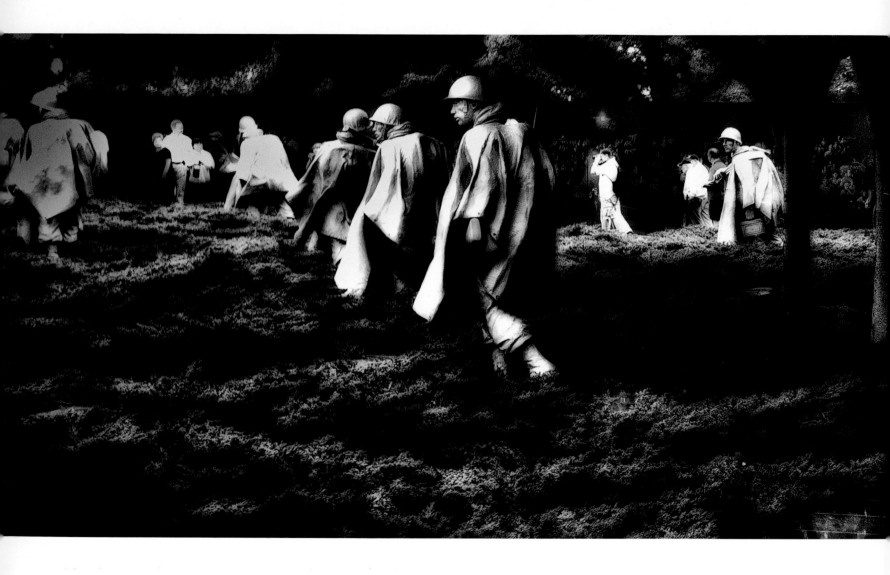

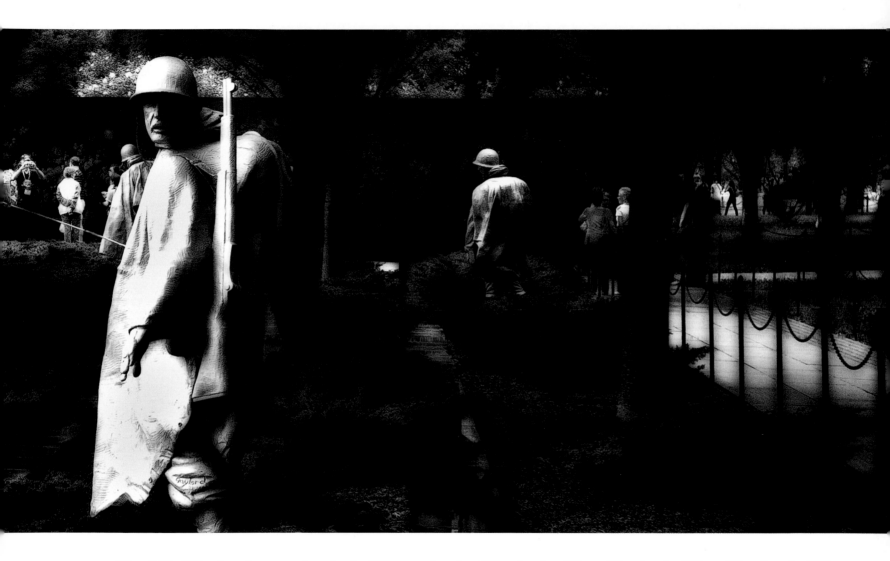

7. SEPIA AND MONOCHROME

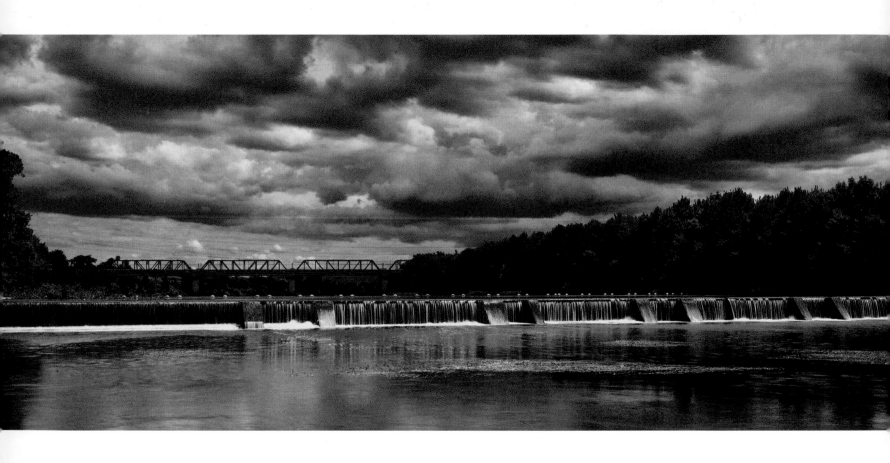

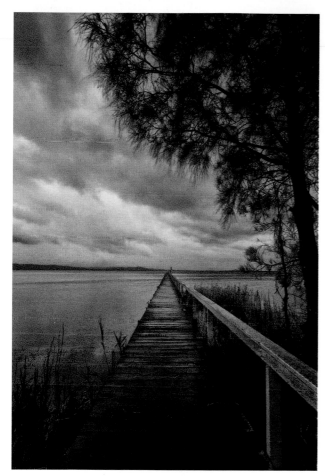

7.1B – f22, .5 sec, ISO 100

7.1 RIVER IN SEPIA

I believe that there is room in the photographic ranks for use of sepia and black and white shots. The term 'sepia tone' refers to a photograph printed in brown-scale, rather than greyscale. The resulting image is considered a monotone in shades of brown. Many old photographs were originally printed with sepia ink extracted from cuttlefish, and photographs printed in this style tend to evoke an older era. Most digital photo editing programs now offer a sepia tone option, along with a greyscale conversion and other photo filters to enhance the look and feel of an image.

When a photograph is treated with a sepia effect, it tends to look softer than it would in greyscale or in its original full colour range. A large array of photographers also use sepia effects purely as a stylistic choice. In the modern era, sepia tends to be used more for landscapes than portraits.

In this example, the river was initially photographed with the view of converting it with a black and white tone as the bridge has been there for a considerable period of time.

The photography technique to be used when the shot was taken was that the photo needed to be correctly balanced in terms of exposure to allow a smoother sepia conversion to be effected. A tripod was used.

The black and white effect was applied in the post editing stage. The NIK Software plug-in application 'Silver Efex Pro 2' was used to obtain the tonal changes. Further cropping of the shot was done in Adobe Camera Raw application to enhance a panoramic feel.

7.1A
CAMERA: Canon EOS-5D MkII
LENS: Canon EF16-35mm f/2.8 IS USM
SETTINGS: f/22, ISO 100, 1.3 second exposure manual mode
FLASH: no flash
METERING FOCAL MODE: evaluative
FOCAL LENGTH: 16mm

Above: 7.2B – f5, 1/200 sec, ISO 100

7.2 ACCENTS OF COLOUR

Perouges is an old medieval town that is situated approximately 25 km (15½ miles) north of the city of Lyon in France. The entire village still has an aura of a time, many centuries ago.

When I was visiting and photographing the village surrounds, a storm had just been through and as the sun was beginning to peer through the clouds, a gold colour washed every surface with this dominating glow. The concept of selective colouring was applied in conjunction with a sepia tonal change (NIK software). This was done purely to create a different artistic feel and at the same time bring back the faded colour of the creeping vine leaves that framed this old window.

7.2A
CAMERA: Canon EOS-5D MkII
LENS: Canon EF16-35mm f/2.8 IS USM
SETTINGS: f/9, ISO 100, 1/125th of a second
 exposure manual mode
FLASH: no flash
METERING FOCAL MODE: evaluative
FOCAL LENGTH: 35mm

7.2C – f6.3, 1/100 sec, ISO 100

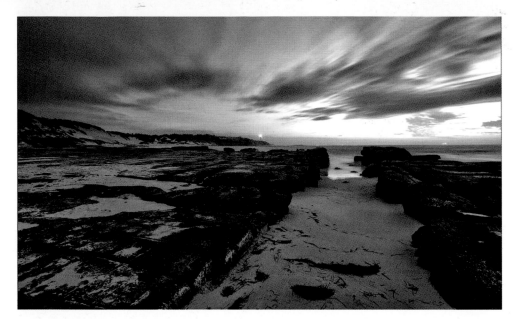

7.3B – f13, 30 sec, ISO 100

7.3 MONOCHROME BEACHES

The beaches and natural surroundings in these shots are simply beautiful with crystal clear waters and an abundance of wildlife. It is a photographer's paradise with numerous locations to be photographed.

Visiting this area to shoot some landscape scenery, I came across a section of the main beach where a form of artistic footprint had been left behind. I was keen to capture the sand etching in its untouched state. The monochrome effect adds another layer of contrast as it was also fairly late in the afternoon with an overcast sky. It was interesting to see that at the time of the photo being taken, many people stood back and tried to relate to its presence. A tripod was also used.

7.3A
CAMERA: Canon EOS-5D MkII
LENS: Canon EF16-35mm f/2.8 IS USM
SETTINGS: f/22, ISO 100, 3.2 seconds exposure
 manual mode
FLASH: no flash
METERING FOCAL MODE: evaluative
FOCAL LENGTH: 16mm

7.3C – f20, 1/100 sec, ISO 800

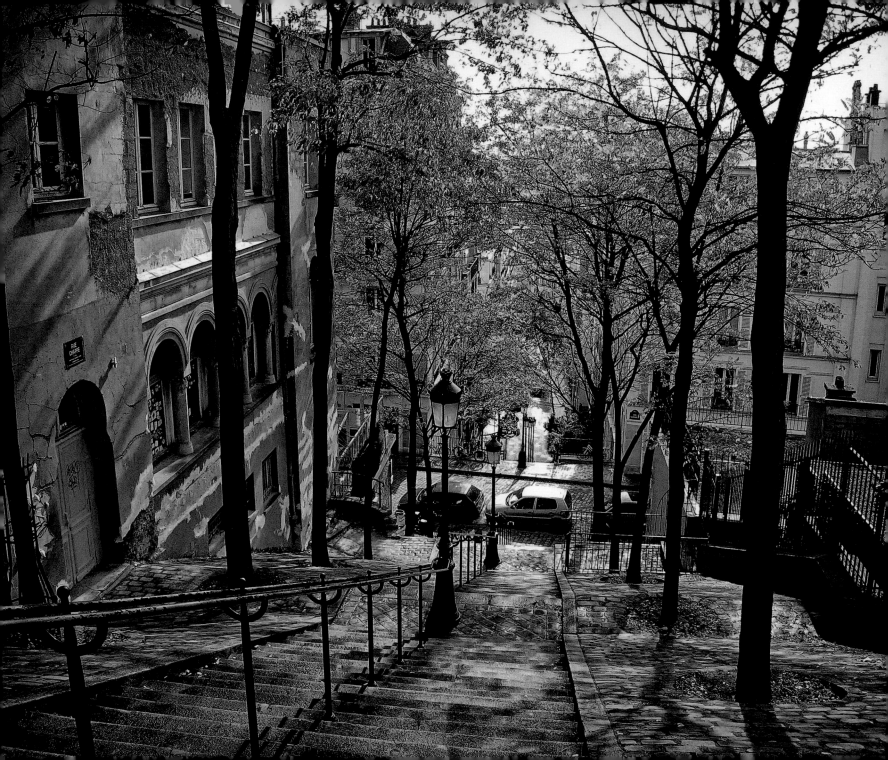

7.4 STAIRS AND LANES

Montmartre district in Paris is renowned as an artist hub and typically this area has not changed very much over the last century. I look at photography as another form of artistic expression and so obtaining inspiration from this part of Paris seemed only natural. The various steep stairs that are found throughout the back streets of this area are well recorded in many artist's paintings and drawings/sketches. I thought I would add my footprint also by taking some fairly iconic photos of such surroundings.

These photos were all taken within the space of 400 metres (437 yards) and are typical of the district. The very essence of adding tonal changes in sepia and black and white recreates the mood of a past historic era. This was my intention when I was trying to locate the various scenes in Montmartre.

The sepia effect was applied in the post editing stage. The NIK Software plug-in application Silver Efex Pro 2 was used to obtain the tonal changes.

7.4A
CAMERA: Canon EOS-5D MkII
LENS: Canon EF16-35mm f/2.8 IS USM
SETTINGS: f.2.8, ISO 100, 1/500th of a second exposure manual mode
FLASH: no flash
METERING FOCAL MODE: evaluative
FOCAL LENGTH: 16mm

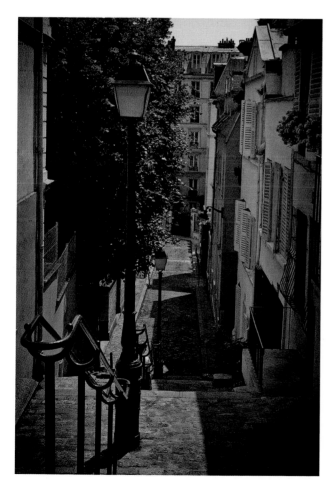

7.4B – f13, 1/250 sec, ISO 400

7.5 RIVER BANKS

The banks of the river Seine are of itself an artistic statement. Just as Montmartre is an iconic spot for artists, the book stores along sections of this river trigger a similar emotion. Known as bouquinistes, the history of these stalls goes back hundreds of years and they have not changed much throughout this time. I was keen to photograph these iconic structures with the intention of later converting the photos with some faded treatment to resurrect a touch of past history.

This handheld photo was shot in manual mode. The sepia effect was applied in the post editing stage. The NIK Software plug-in application Silver Efex Pro 2 was used to obtain the tonal changes.

7.5A
CAMERA: Canon EOS-5D MkII
LENS: Canon 17–40mm f/4 USM
SETTINGS: f/8, ISO 100, 1/125th of a second exposure manual mode
FLASH: no flash
METERING FOCAL MODE: evaluative
FOCAL LENGTH: 40mm

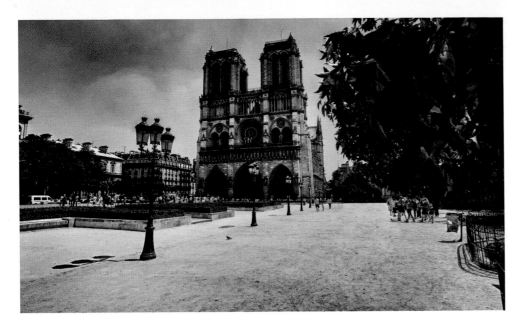

7.5B – fF9, 1/200 sec, ISO 100

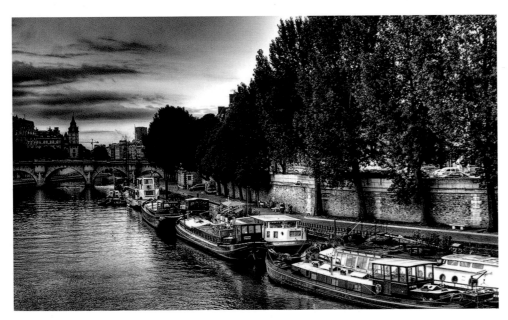

7.5C – f4, 1/500 sec, ISO 800

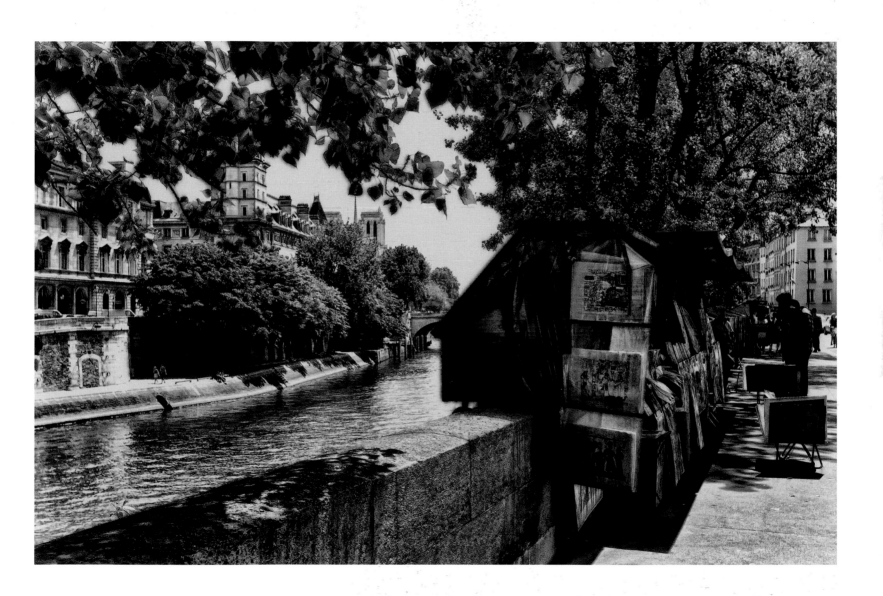

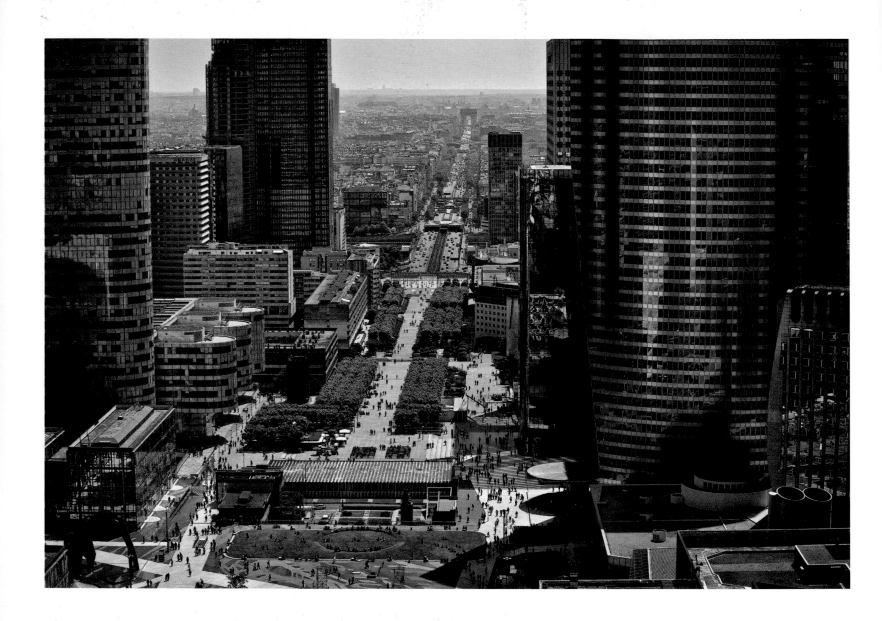

7.6 GLASS AND STEEL

La Défense is Europe's largest purpose-built business district and is made up of 14 high-rise structures. The size of this area is in excess of 31 hectares (77 acres) and has 70 plus glass and steel slick buildings. The architecture and layout is the total opposite of what you would normally find in other parts of Paris. But this form of architecture has its own charms for a photographer. In essence, the sheer size of the district coupled with modern man-made material offers an interesting alternative and challenges.

I wanted to capture this large footprint and somehow link it to the old Paris. I decided the best way to do this was to get to the top of the Grande Arche building and hope that a vantage point would allow me to capture a shot that would mirror my thought process.

This ensuing photo is the result. The shot has a gun-barrel feel to it and at its very end point, one can see the Arc de Triomphe. This handheld photo was shot in manual mode. The black and white effect was applied in the post editing stage. The NIK Software plug-in application Silver Efex Pro 2 was used to obtain the tonal changes.

7.6A
CAMERA: Canon EOS-5D MkII
LENS: Canon 24–70mm f/2.8 IS USM
SETTINGS: f/8, ISO 100, 1/250th of a second exposure manual mode
FLASH: no flash
METERING FOCAL MODE: evaluative
FOCAL LENGTH: 70mm

7.6B – f14, 1/400 sec, ISO 400

7.6C – f11, 1/250 sec, ISO 400

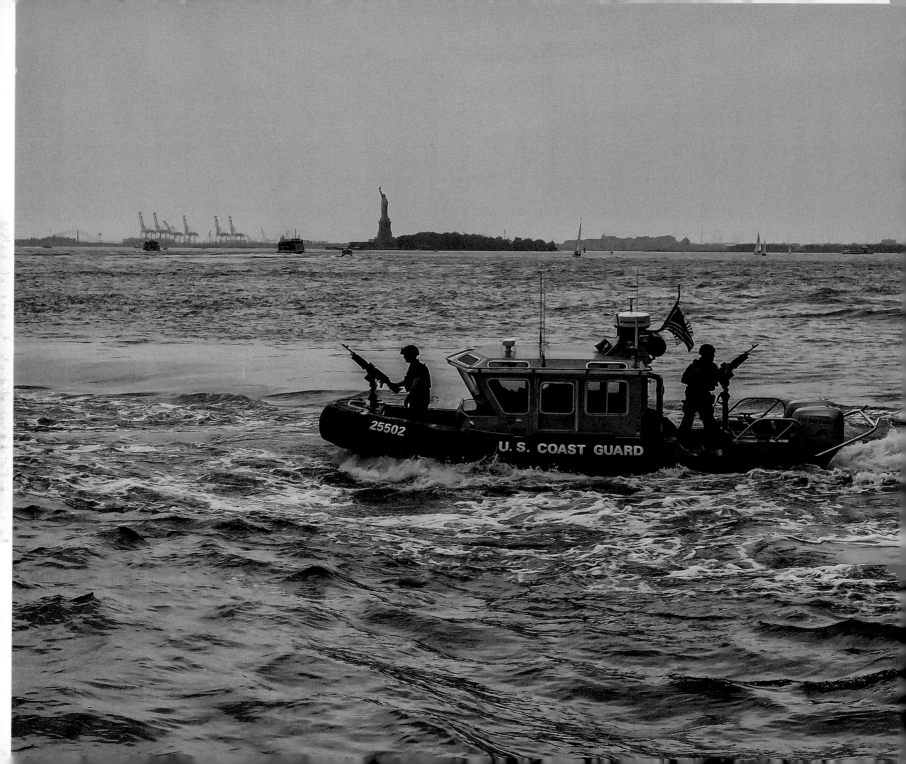

7.8A
CAMERA: Canon EOS-5D MkII
LENS: Canon 16–35mm f/2.8 IS II USM
SETTINGS: f/8, ISO 100, 1/125th of a second
 exposure manual mode
FLASH: no flash
METERING FOCAL MODE: centre weighted
 average
FOCAL LENGTH: 35mm

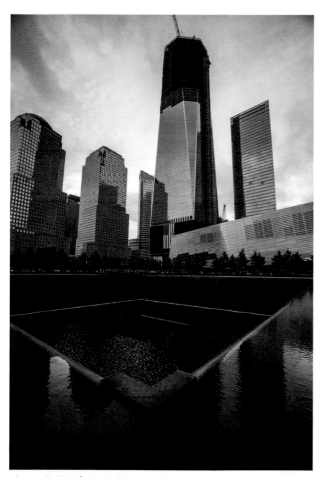

Above: 7.8B – f6.3, 1/30 sec, ISO 100
Above right: 7.8C – f22, 2 sec, ISO 100

7.8 RESPECTFUL IMAGES

My wife, Mary, and I were in New York in the week leading up the 10th anniversary of the 9/11 event. With the upcoming memorial services to be undertaken later that week, security was at a very high level across the entire city.

Upon returning from a ferry ride along the Hudson River, the US Coast Guard made their presence felt. Photography took on another role for me at that particular time. It became a photojournalistic function—one that I am sure photo journalists do when on assignment. I remember that at the time of capturing the shot, I asked myself, am I allowed to do this and have I overstepped a protocol? I don't know why I felt that way!

At the time of taking the photo I hadn't considered the composition nor why I needed to take the photo in the first place. It was just an instinct and it was very much unplanned, yet upon its immediate capture all I could remember was the red sides of the vessel.

This handheld photo was shot in manual mode. The mild sepia effect was applied in the post editing stage with NIK Software plug-in application, Silver Efex Pro 2. That same application was used to carry out the selective colour Isolation.

7.9 SUBJECT SELECTION

On a daily basis, the changing of the guard takes place at the Arlington Cemetery. I was in the vicinity of this event and caught the guard commencing the 'walk' towards the Tomb of the Unknowns. This formal ceremony is quite impressive and anyone witnessing it will be moved. With the context of the Tomb of the Unknown, I thought the focus should shift squarely back on the guard and make all others around fade back as if they were not there. At the time of taking this shot, this was my primary reason to photograph the guard. I specifically used a very shallow field of depth on my lens (f/2.8) and by being some distance away the depth worked well. To emphasise the guard, I introduced the selective colouring effect.

The entire photo was converted to a monochrome effect by using NIK Software plug-in application, Silver Efex Pro 2. That same application was then used to carry out the selective colour isolation.

7.9A
CAMERA: Canon EOS-5D MkII
LENS: Canon 70–200mm f/2.8 IS II USM
SETTINGS: f/2.8, ISO 100, 1/400th of a second exposure manual mode
FLASH: no flash
METERING FOCAL MODE: centre weighted average
FOCAL LENGTH: 200mm

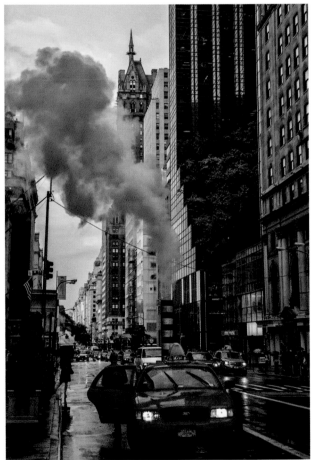

7.9C – f4, 1/500 sec, ISO 800

7.9B – f5.6 , 1/320 sec, ISO 100

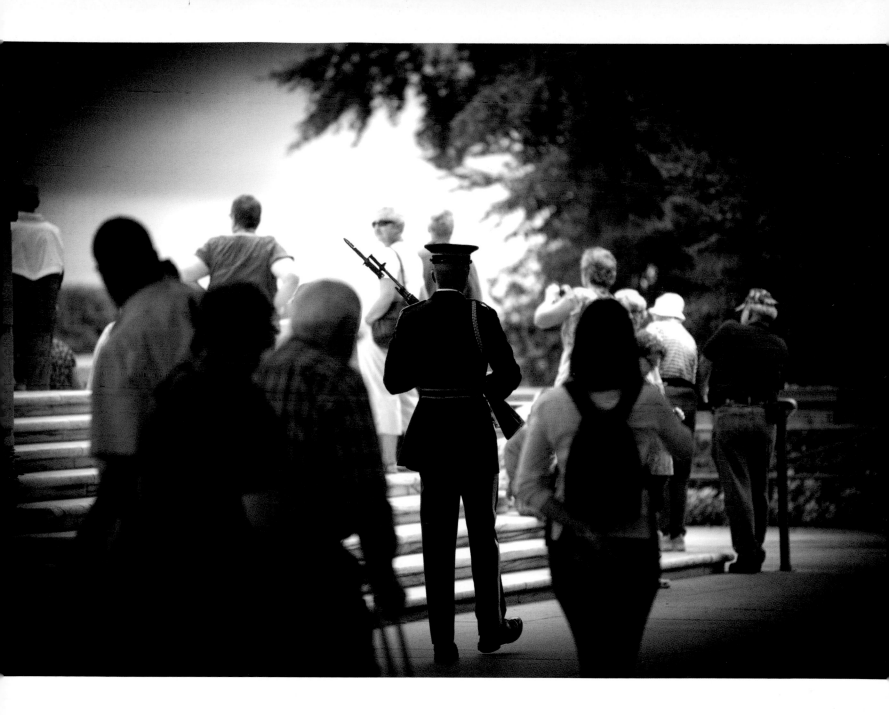

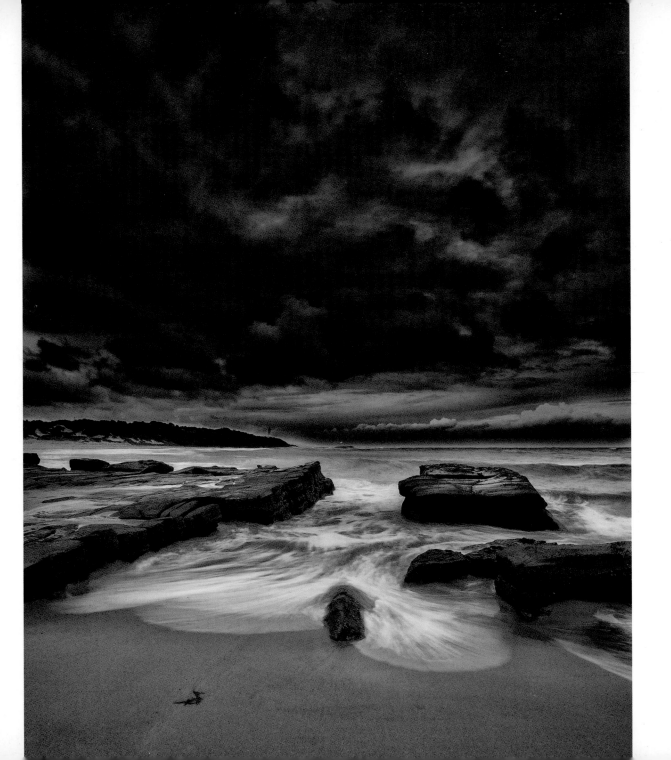

7.10 TONAL ASPECTS

This location is one of my favourite places to shoot landscapes, seascapes and nature shots. The area has some wonderful features and in all my photographic visits there, I have always obtained some dramatic shots.

The expected weather forecast stated that shower activity with lots of cloudy conditions would hit the area mid-morning. For the purposes of capturing interesting and dramatic shots, these prevailing conditions are ideal—especially on coastal areas.

I was present pre-dawn and while no sun was to be seen rising over the horizon, the rolling clouds gave a great show. I remember thinking that the absence of the sunrise colours made the entire seascape scene look very grey and I thought that perhaps I should consider the entire shoot as being in a monochrome format. While my camera has a setting that allows me to do this, I prefer to change the tonal aspects in the post editing stage with software.

A tripod was used during the capture. The entire photo was converted to a monochrome effect by using NIK Software plug-in application, Silver Efex Pro 2.

7.10A
CAMERA: Canon EOS-5D MkII
LENS: Canon 16–35mm f/2.8 IS II USM
SETTINGS: f/2.8, ISO 100, 1 second exposure manual mode
FLASH: no flash
METERING FOCAL MODE: centre weighted average
FOCAL LENGTH: 16mm

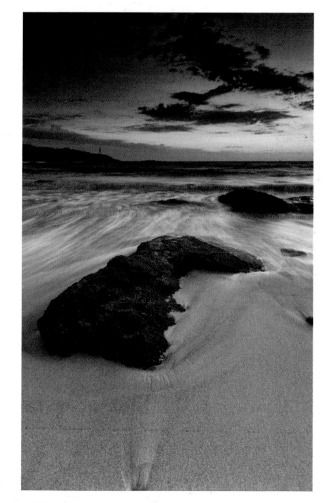

7.10B – f6.3, 1.3 sec, ISO 100

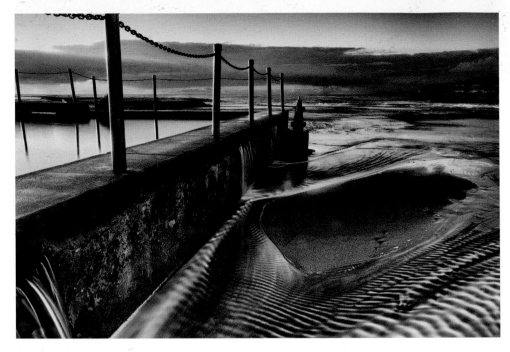

7.11A
CAMERA: Canon EOS-5D MkII
LENS: Canon 16–35mm f/2.8 IS II USM
SETTINGS: f/22, ISO 100, 4 seconds exposure
 manual mode
FLASH: no flash
METERING FOCAL MODE: centre weighted
 average
FOCAL LENGTH: 16mm

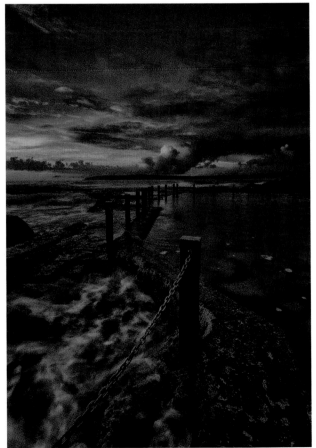

7.11 WATER AND SKY

This ocean pool is fairly small in size but is one of the most photographed pools by professional photographers. The attraction of this pool is its ease of access but also the interesting structure—cube-like blocks jutting on top of the pool edges.

I have shot this pool on numerous occasions and at different times of the day. The best results come from trying to find interesting angles where the wall lines appear to lead you away from your shooting position. On the day that I was there, the weather had turned for the worst and I was able to fire off a series of photos that captured the change in conditions. I wanted to shoot this specific angle with water appearing to fuse itself in and around the structure.

A tripod was used during the capture. The entire photo was converted to a monochrome effect by using NIK Software plug-in application, Silver Efex Pro 2.

Above: 7.11B – f9, 1 sec, ISO 100
Above left: 7.11C – f22, 2 sec, ISO 100

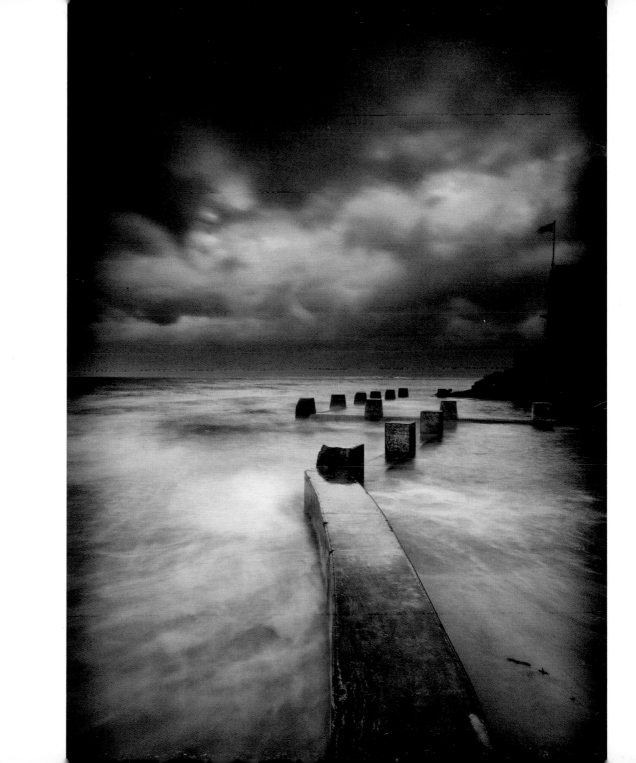

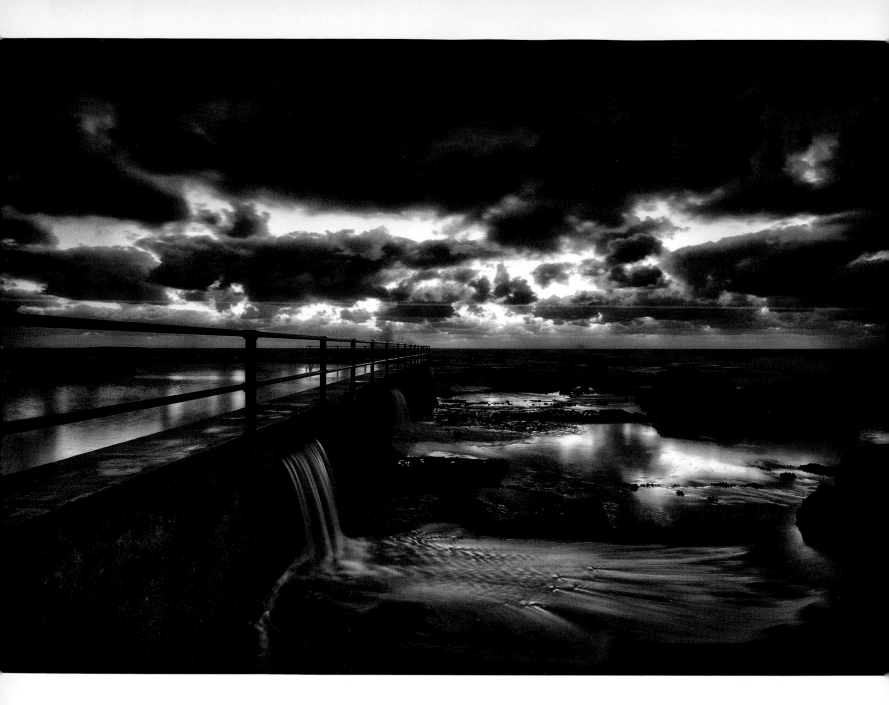

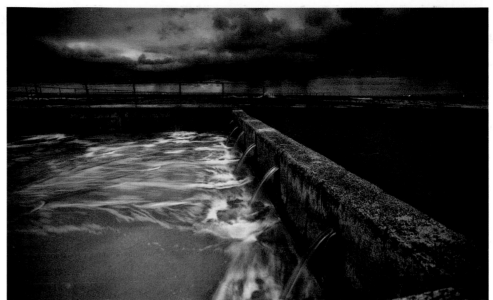

7.12 HARD AND SMOOTH LINES

At times the contrast of hard lines of structures compliments smooth lines caused by flowing water. In this shot, I was immediately drawn to the overflow of water that came out every 20 to 30 seconds in unregulated spurts from the side of the pool. Waves breaking over the far edges of the pool fed in excess water, which in turn would flow out of these three pool openings. The day was drawing to a close and a dull glow came across the entire scene, prompting me to add a harsh sepia tone purely for artistic purposes.

A tripod was used during the capture. The entire photo was converted with a sepia effect by using NIK Software plug-in application, Silver Efex Pro 2.

7.12A
CAMERA: Canon EOS-5D MkII
LENS: Canon 16–35mm f/2.8 IS II USM
SETTINGS: f/7.1, ISO 100, 3.2 seconds exposure manual mode
FLASH: no flash
METERING FOCAL MODE: centre weighted average
FOCAL LENGTH: 16mm

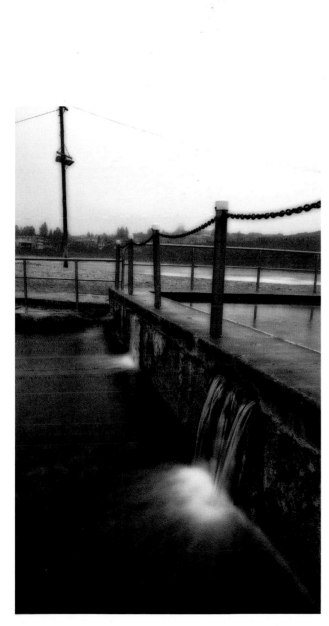

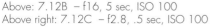

Above: 7.12B – f16, 5 sec, ISO 100
Above right: 7.12C – f2.8, .5 sec, ISO 100

7.13 SEPIA EFFECTS

A group of avid photographers and I rarely get a chance to all go out at the same time in one group given our various weekend commitments. However, when we do cross each other's paths, we compare notes and network our information on various photographic sites that we should go and shoot.

My friend Chris indicated that it might be worthwhile to shoot the north end of this beach where there is a headland with a fairly small rock ocean pool. He had been there before and felt that under the right conditions we could obtain some interesting seascape scenes. That was enough for my mate, Johnny, and me to head out one early morning (pre-dawn) to see for ourselves. As we headed down a narrow natural staircase, it felt odd that the stairs kept going all the way down to a fully submerged area. It was almost as if there was something else to see below the waterline. The stairs heading off to nowhere reminded me very much of the Dutch artist M.C. Escher, known for his often impossible construction graphics.

The entire photo was converted with a sepia effect by using NIK Software plug-in application Silver Efex Pro 2 to typically reflect M.C. Escher's style.

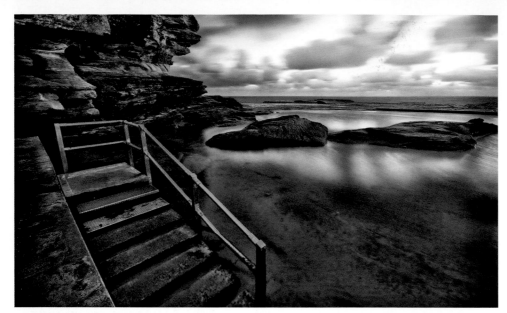

7.13B – f4, 30 sec , ISO 100

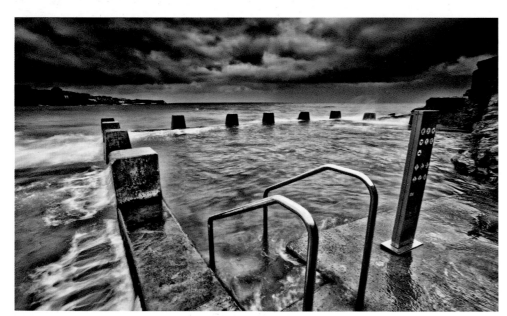

7.13C – f10, .8 sec, ISO 100

7.13A
CAMERA: Canon EOS-5D MkII
LENS: Canon 16–35mm f/2.8 IS II USM
SETTINGS: f/7.1, ISO 100, 3.2 seconds exposure
 manual mode
FLASH: no flash
METERING FOCAL MODE: centre weighted
 average
FOCAL LENGTH: 16mm

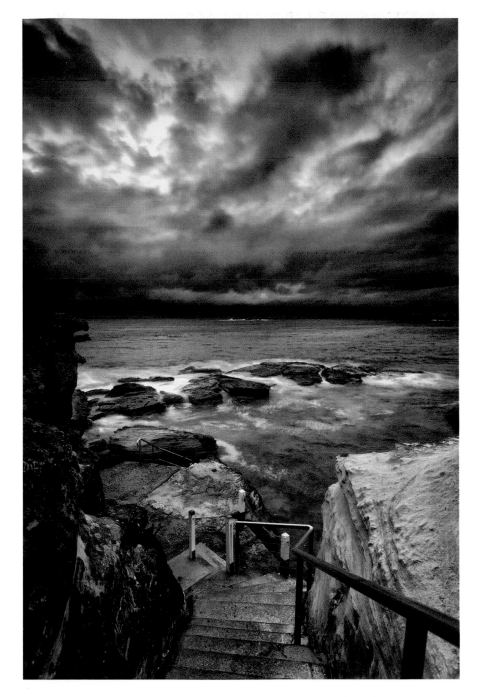

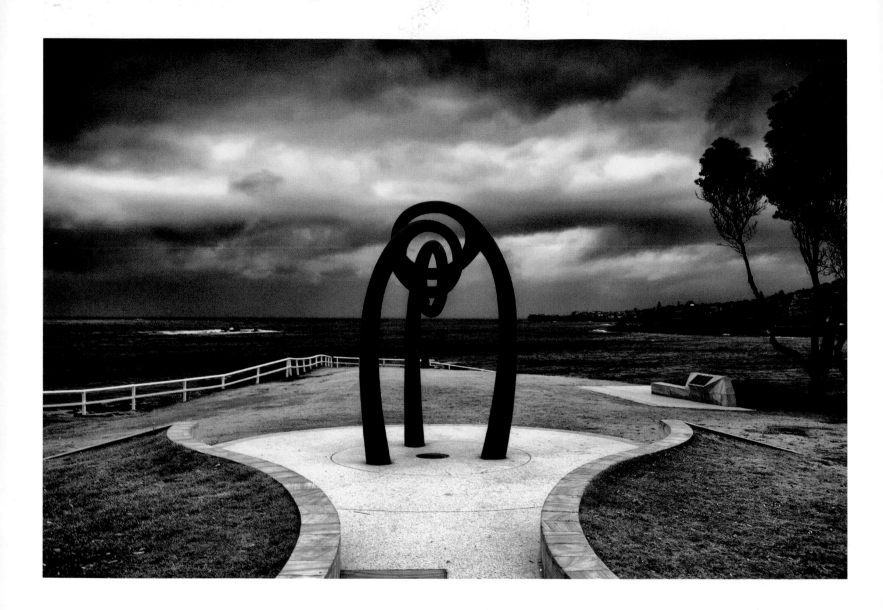

7.14A
CAMERA: Canon EOS 5D MkII
LENS: Canon EF 24-105mm f/4 USM
SETTINGS: f/5, ISO 100, 0.8 second exposure
 manual mode
FLASH: no flash
FOCAL LENGTH: 32mm
Tripod used

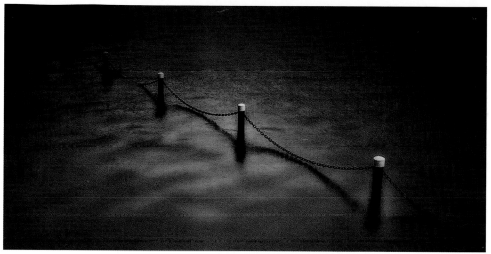

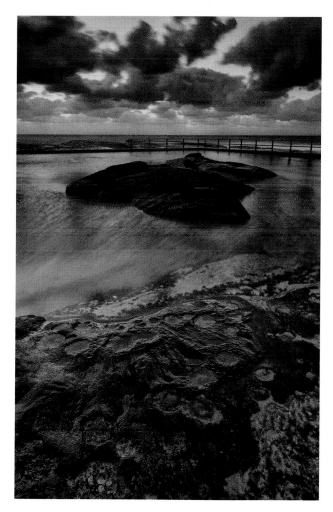

7.14 SCULPTURES AT THE SEA

The memorial to the victims of the Bali bombing is dedicated to those killed and injured in the Bali terrorist attack that took place in 2002. I remember approaching this site and feeling somewhat subdued and wanted to maintain a sense of respect. Unlike any other coastal place that we would normally climb and scamper over, a more measured and reserved introduction was afforded and I wanted to try and capture the beauty of the sculpture against a natural background.

I was aware that the three linked figures in this sculpture signify family, friends and community. Bowed in sorrow and remembrance, they comfort, support and protect each other.

This photo was purposely framed and shot at this angle to work the gentle curved lines of the walkway and the natural curved shapes of the sculpture. I had in mind also that the print would later be converted to monochrome to enhance the solemn mood of the event that had taken place in Bali against the dramatic surrounds of a fast-approaching storm.

The photo was converted with a monochrome effect using NIK Software plug-in application Silver Efex Pro 2.

Above: 7.14C – f2.8, .3 sec, ISO 100
Left: 7.14B – f14, 10 sec, ISO 100

7.15 DRAMA IN THE WAVES

A week before this shot was taken, I had visited this beach for the very first time at a pre-dawn shoot with basically no clouds to speak of. I was keen to revisit this area but when there would be at least some clouds as I felt that the area could be quite dramatic with the right type of overhead cover and the sun rising in the distance. So after vigilantly watching the weather forecast for an entire week, I was eager to get some shots once I heard the news of large bands of clouds rolling in.

The following morning, all my wishes were answered tenfold. A huge cloud ball emerged soon after sunrise and dished out a scene that would normally be associated with an exploding volcano. While there was some calmness at ground level, there were certainly some rapid activity taking place a couple of thousand feet above. I was just glad that I was there and fired off plenty of shots as the cloud mass eventually melted and dissipated to just one thick band of cloud. This particular event was, in essence, the very reason why I will get out of bed and shoot away at 5.30am. You just never know what you will be exposed to and it makes the outing all that worthwhile.

To highlight the drama further, the photo was later converted to a monochrome format using the NIK Software plug-in application Silver Efex Pro 2.

7.15A
CAMERA: Canon EOS 5D MkII
LENS: Canon EF 16-35mm f/2.8L IS USM
SETTINGS: f/22, ISO 400, 1/6th of a second
 exposure manual mode
FLASH: no flash
FOCAL LENGTH: 16mm
tripod used

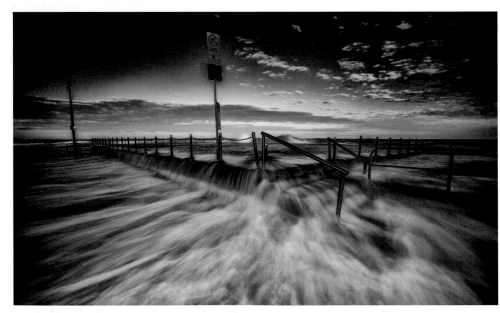

7.15B – f22, 1 sec, ISO 100

7.15C – f13, 1.6 sec , ISO 100

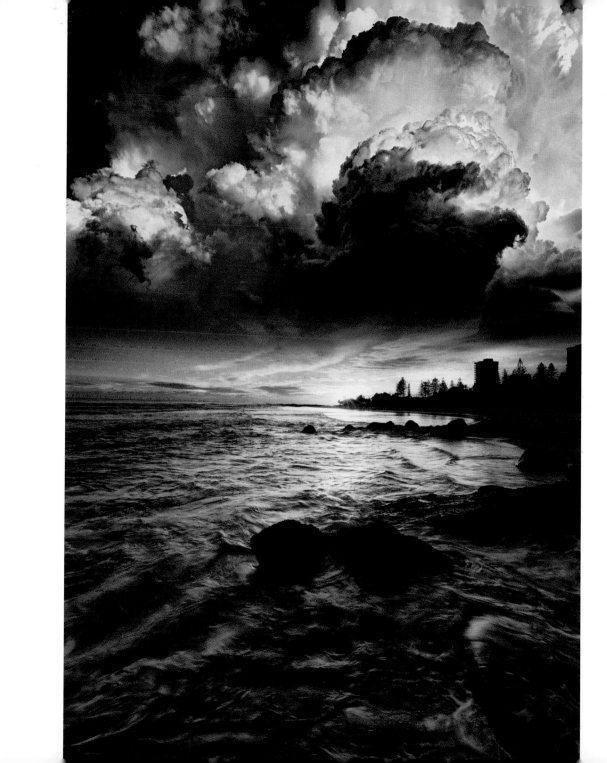

8. SUNSETS AND STORMS

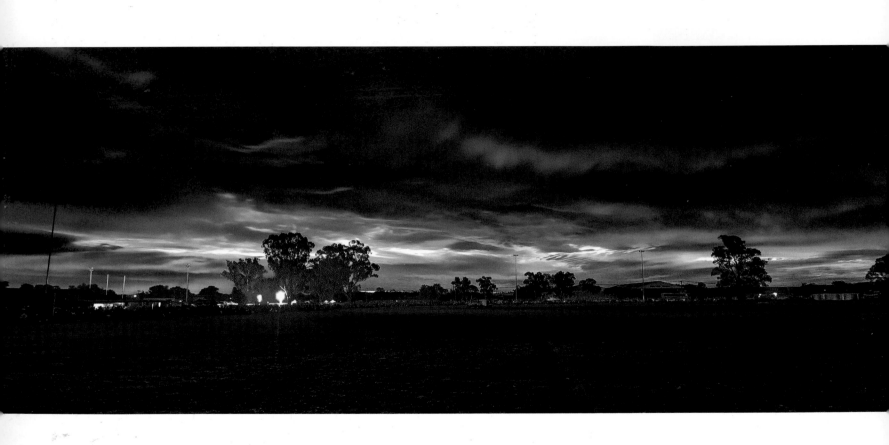

8.1 SUNSETS ON THE FIELD

At the end of every day, if we stop and look, we get the opportunity to take in one of the most beautiful sights that is too often overlooked. Sunsets are one of my favourite events to capture. Unfortunately, they are present for only a very short period of time. Nonetheless, capturing them is very rewarding.

A couple of these photos were taken roughly seven minutes apart at the Canowindra football field where a series of hot air balloons were soon to be positioned and inflated directly before us. The colour tone ranges that were on show was simply amazing. In making our way to this shooting location, we purposely set ourselves up half an hour before to ensure we could capture the sunset. I must admit that at times it can be somewhat more subdued however one needs to think positive and remain optimistic.

For such shots, you will definitely need a tripod mount. Not so much for the fact that the shutter speeds will be excessively long but more so that with limited shooting time, you need to eliminate any risk of fouling up your shot with some form of camera blur. Another recommended tip is that most camera settings can be tweaked to alter the shooting settings. With a canon 5D MkII camera, I can alter the default saturation and contrast settings so that every shot can be somewhat more tonally enhanced. This was done for these particular shots.

8.1A
CAMERA: Canon EOS 5D MkII
LENS: Canon EF 16-35mm f/2.8L IS USM
SETTINGS: f/6.3, ISO 100, 13 seconds exposure
 manual mode
FLASH: no flash
FOCAL LENGTH: 16mm
tripod used

8.1B – f22, 0.6 sec, ISO 100

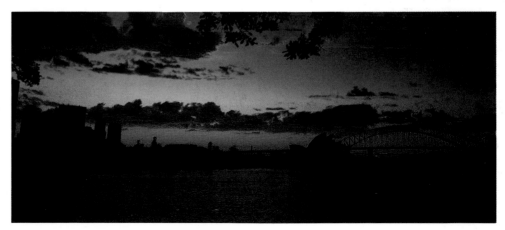

8.1C – f13, 1/10 sec, ISO 100

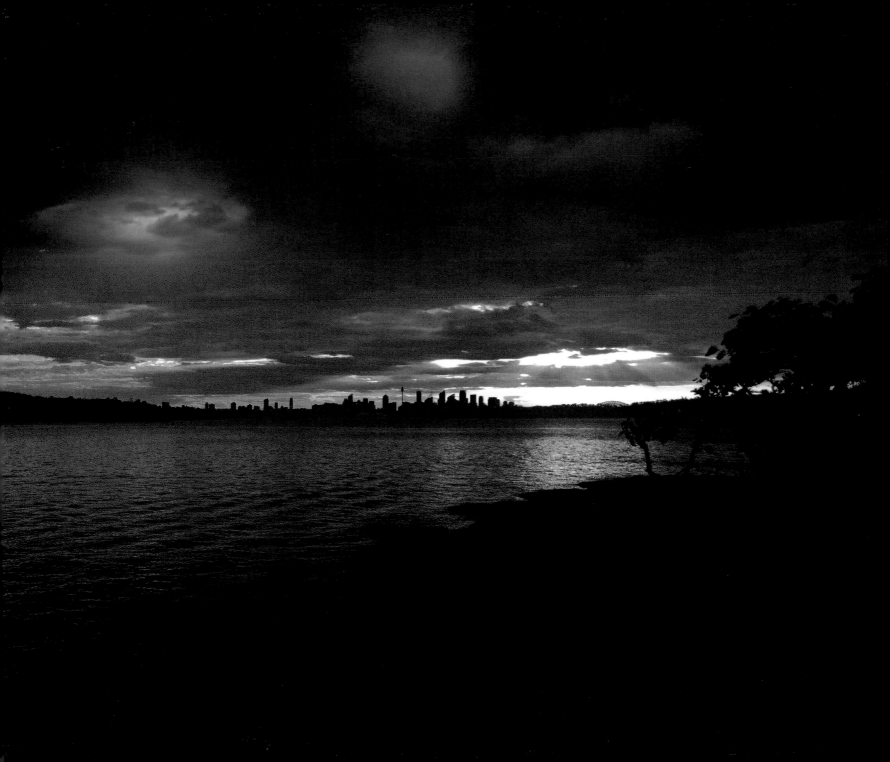

8.2 SUN THROUGH CLOUDS

I came across this spot purely by accident. I thought I would simply turn around and head back home after a quick two-minute stop curbed my curiosity about what could be seen. I quickly took my camera with me and followed the narrow path towards the water. I could see that the sky above me had turned almost dark grey and the sinking sun had little light effect near this area. As I reached the end of the path, I came across this view.

I was surprised by the large expanse of water confronting me, with a total uninterrupted view of the entire harbour and the CBD skyline at the furthest point. While I did not have my full camera kit with neutral density and graduated filters with me, the captured shot was basically taken straight out of the camera with no tweaking what so ever. The camera was rested on a natural rock ledge and while the light tonal range in the area was extreme, the shot was successful.

Once again, this reaffirms that you should always take advantage of any situation that presents itself for photographic opportunities. I have made a strong mental note to go back to this location with my fellow photography buddies for a series of more detailed and prolonged sunset shots.

8.2A
CAMERA: Canon EOS-5D Mark II
LENS: Canon EF 17-40mm f/4L USM
SETTINGS: f/4, ISO 100, 1/200th second
 exposure manual mode
FLASH: no flash
FOCAL LENGTH: 22mm

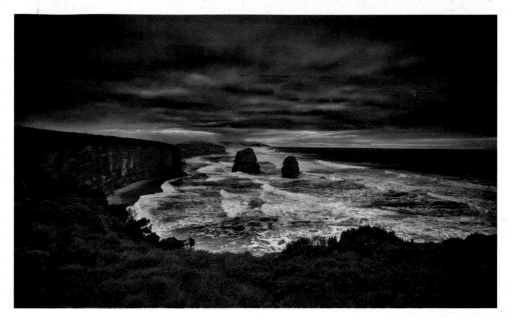

8.2B – f2.8, 1/60 sec, ISO 100

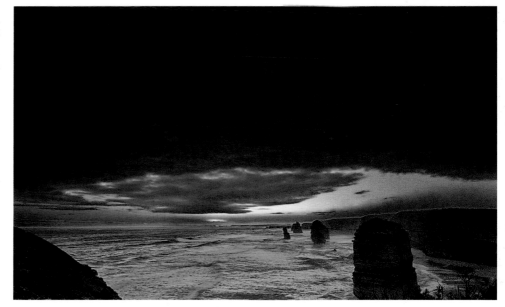

8.2C – f5, .4 sec, ISO 100

8.3A
CAMERA: Canon EOS-5D Mark II
LENS: Canon EF 16-35mm f/2.8L IS USM
SETTINGS: f/5, ISO 100, 20 second exposure
 manual mode
FLASH: no flash
FOCAL LENGTH: 31mm
tripod used

8.3 STILLNESS

I had read somewhere that a tiny triangular rock pool was present with a set of bronze sculptures mounted on the edge of the pool.

I had once visited this area, but none of the shots I'd taken previously were that good. The compositions and exposure in all the shots were very poor and there was nothing to do except work out why the shots didn't work. This place represented unfinished business so when the opportunity presented itself to be in this area again, I was eager to redeem myself.

I got to this location roughly half an hour before sunset and there was a rush to get into a good position to secure some better pictures, taking on board the lessons from the previous shoot. We were lucky enough to have a great sunset with a vast range of colours emanating from the west. The entire scene was extremely calm and that stillness helped me take some fairly good shots especially with some reflections in the water. A (0.6) Neutral Density Graduated filter was attached to the lens.

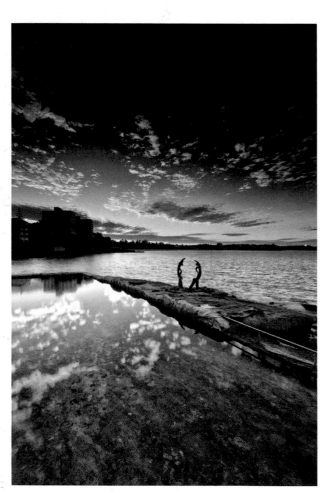

8.3C – f22, .6 sec, ISO 100

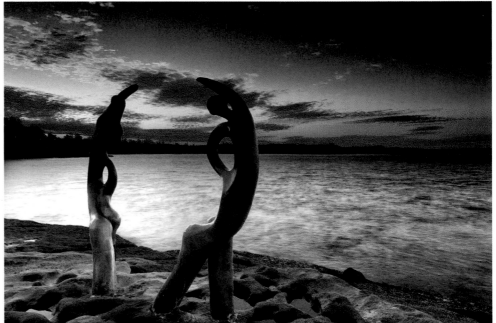

8.3B – f22, 3.2 sec, ISO 100

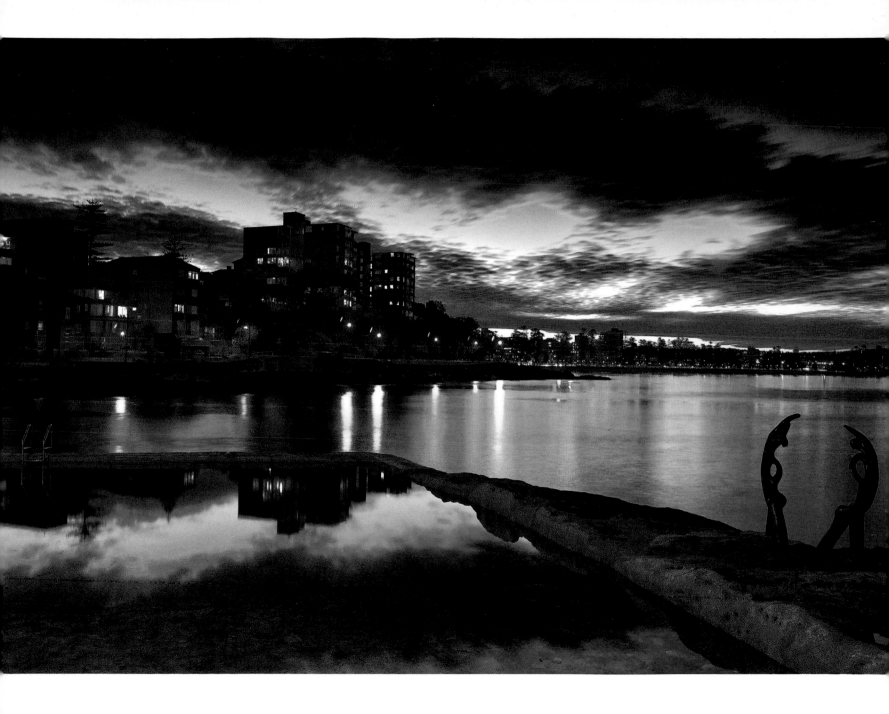

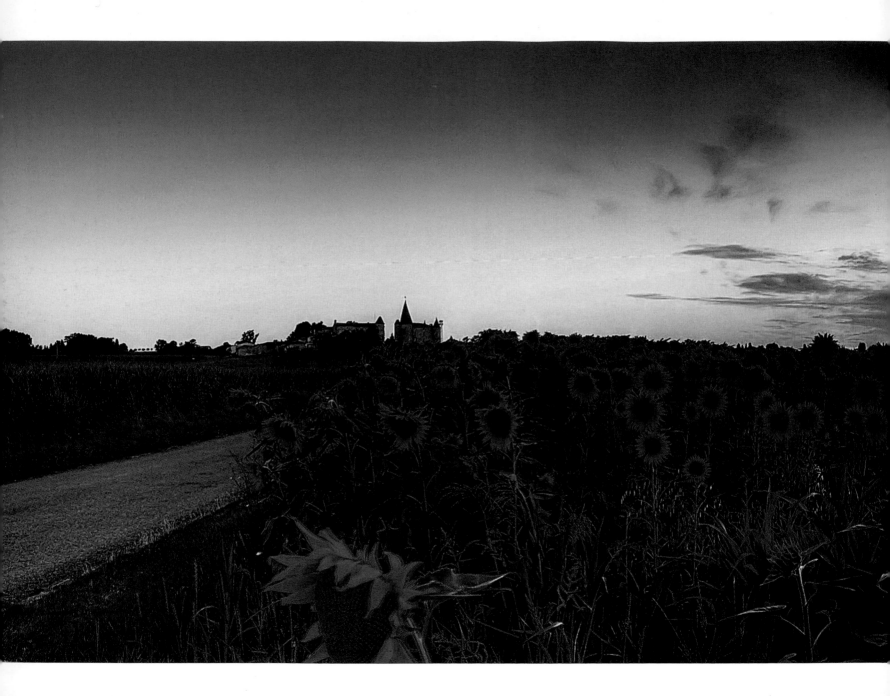

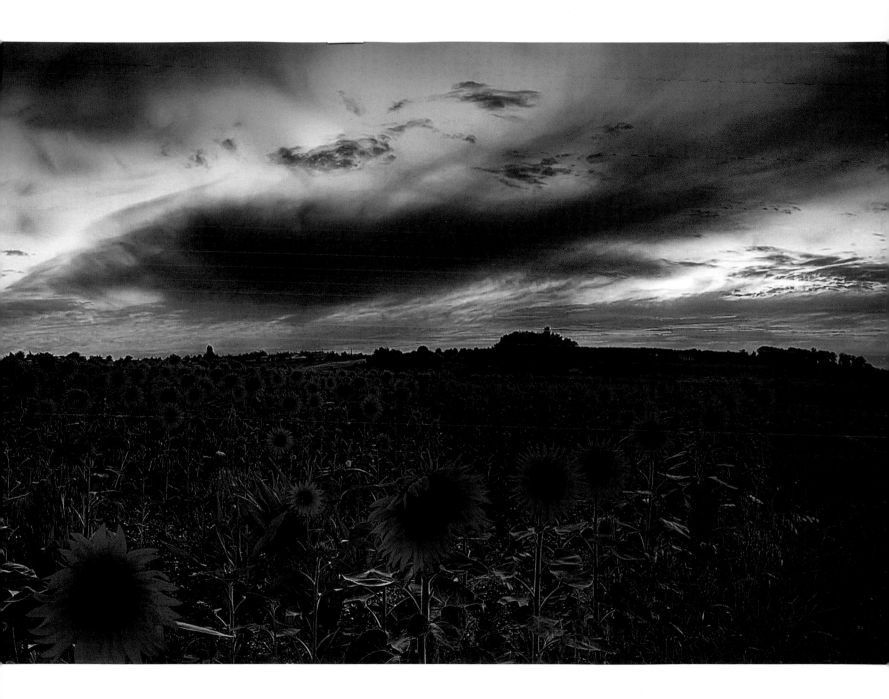

8.4 SUNSETS OVER SUNFLOWERS
(photo on previous page)

In June 2007, my French cousins took me through some great parts of regional France to see another form of lifestyle living. Travelling through the picturesque countryside, sunflower fields were plentiful so I took the opportunity to photograph them.

The back roads in these rural settings are very narrow and the height of these plants tends to create corridor-like channels. The shot was taken fairly late in the day (around 10pm on a summer evening) and yet there was sufficient ambient light to capture the entire scene.

I have found that in all sunset and sunrise instances, when the 'golden hour' appears, the enhanced light tones are something special. I would have loved to take this photo in a more elevated position, as the sun glow could be filtered through all of the fields.

The photo was cropped top and bottom using Adobe Camera Raw to provide a more panoramic effect.

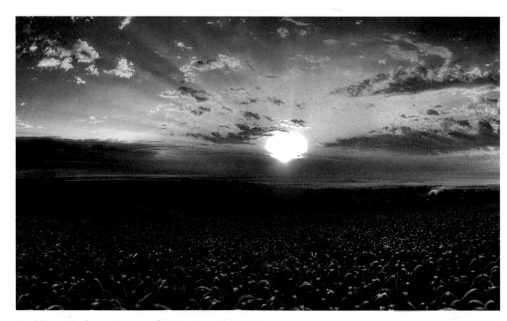

Rural District Toulouse, France – f22, 0.6 sec, ISO 100

8.4A
CAMERA: Canon EOS-5D Mark II
LENS: Canon EF 17-40mm f/4 USM
SETTINGS: f/22, ISO 100, 5 second exposure
 manual mode
FLASH: no flash
FOCAL LENGTH: 20mm

8.4B – f2.8, 1/20 sec, ISO 100

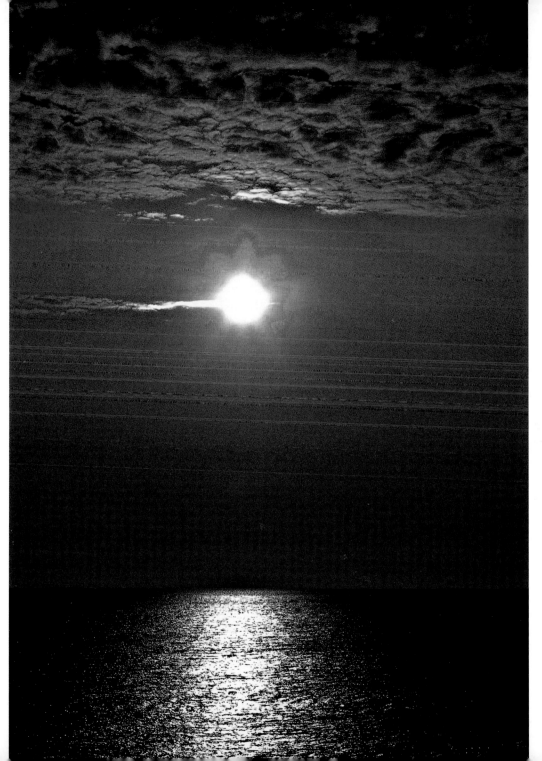

8.6 ISLANDS IN THE STORM

This location is readily accessible to anyone and a high number of amateur and professional photographers often frequent the area as it provides a large array of shooting angles. The footbridge is an interesting part of the scenery and seems to be a focus of most photos taken.

I particularly like this location especially when the weather is turning for the worse. The fort-like structure on the island and its long wooden bridge provide interesting contrasts against a stormy backdrop. I would recommend venturing under the bridge itself as its intricate structure is eye-catching and tightly cropped shots will produce some great-looking artistic photos. Converting photos to monochrome or treating with an HDR effect will also produce some interesting photos.

A ery soft sepia tone was applied with use of NIK Software—Silver Efex Pro application.

8.6A
CAMERA: Canon EOS-5D Mark II
LENS: Canon EF24-105mm f/4L IS USM
SETTINGS: f/22, ISO 100, 1/4th second
 exposure manual mode
FLASH: no flash
FOCAL LENGTH: 24mm
tripod used

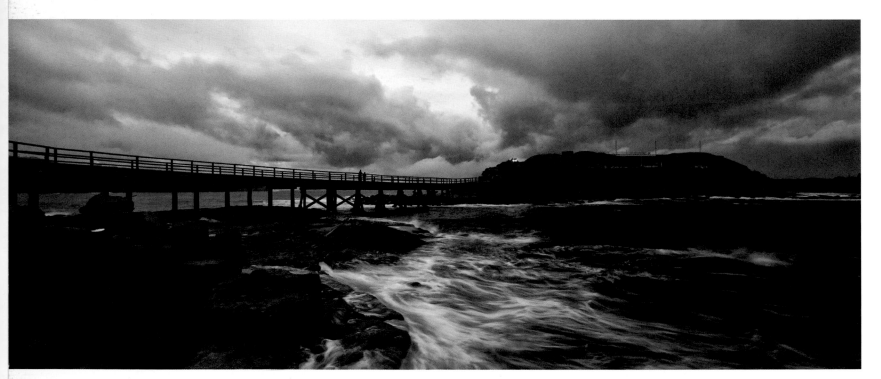

8.6B – f9, 1 sec, ISO 100

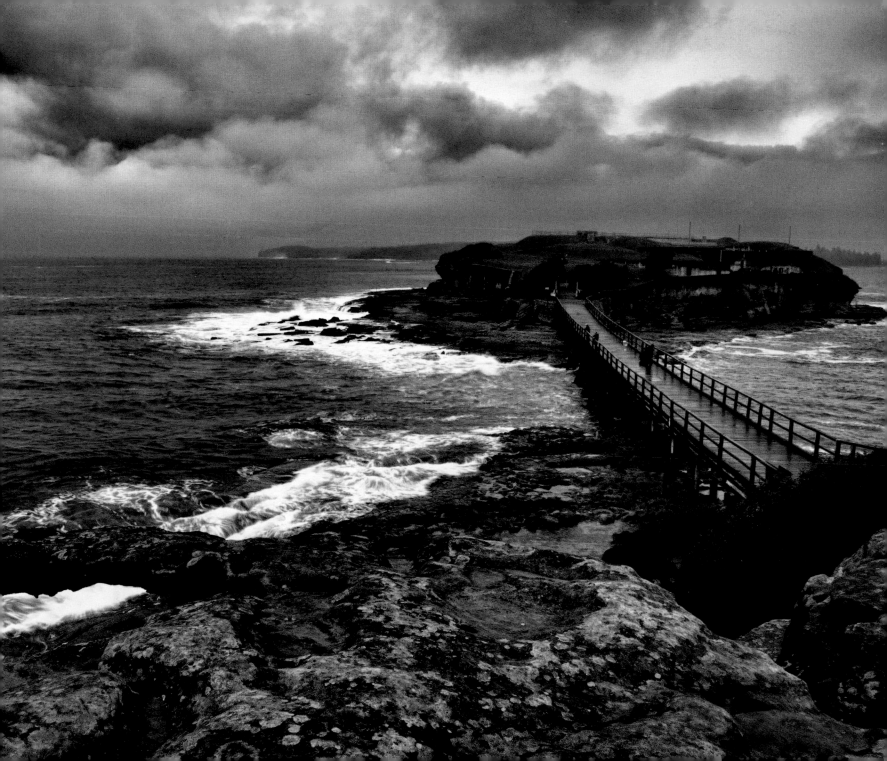

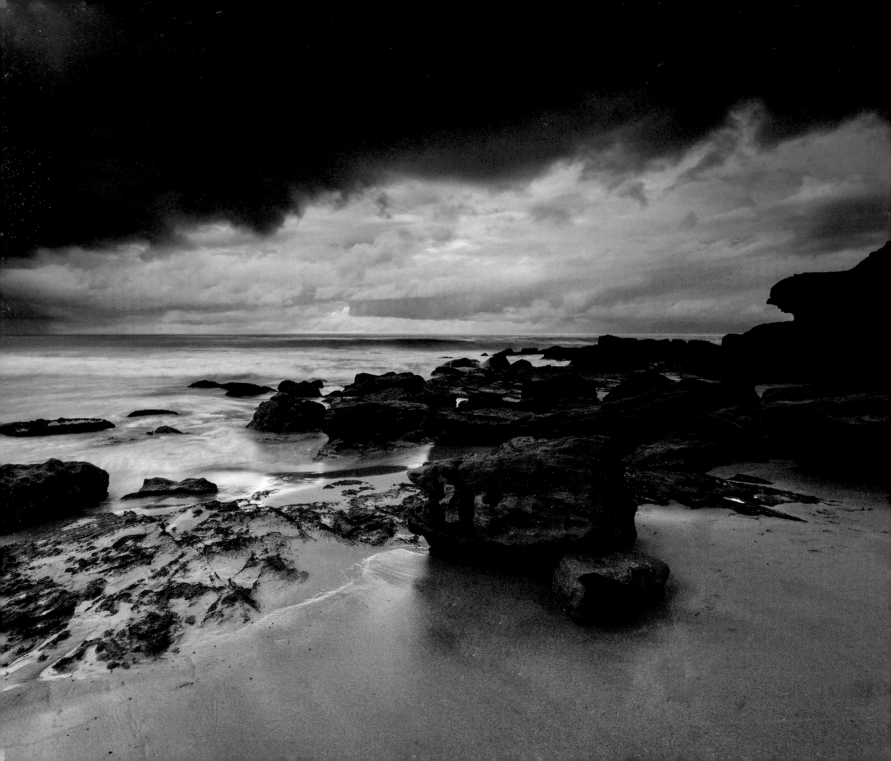

8.7 STORMS ON THE BEACH

I have found that this beach and in particular the headland at the south end are quite a treasure.

The rock structures on the beach are littered with sea grasses and rich colourful moss. The boulders and rock formations also have some intricate shapes that have been caused by wind and sand erosion and these offer some wonderful shots. On my last visit there, two and a half hours were gobbled up because of so many fantastic photographic opportunities.

I would recommend going there at low tide as the additional submerged formations would come into play. If you are interested in doing some portrait work, such as family shots or a model portfolio, this area is a little more secluded but all the backdrops would be exceptional. If you are into surf photography, the rock platforms are directly adjacent to the break of large surf so you could get some close vantage positions.

On the morning that we visited this place, my mate Johnny and I concentrated purely on the seascape action and we are both very keen to head back there again to try a much larger array of photography topics.

8.7A
CAMERA: Canon EOS-5D Mark II
LENS: Canon EF 16-35mm f/2.8L IS USM
SETTINGS: f/22, ISO 100, 1.6 second
 exposure—manual mode
FLASH: no flash
FOCAL LENGTH: 16mm
tripod used

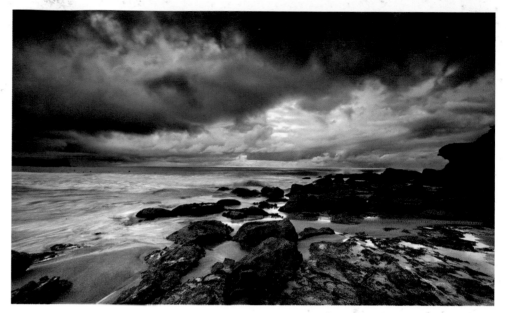

8.7B – f22, 1.3 sec, ISO 100

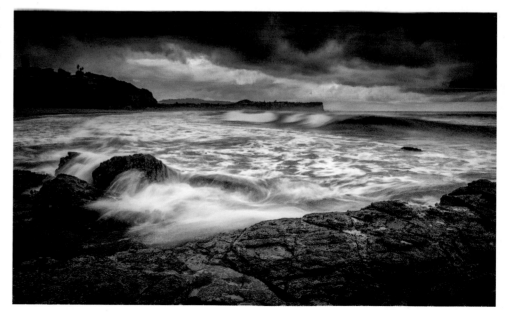

8.7C – f13, .5 sec, ISO 100

8.8 OCEAN SWELLS

This headland adjacent offers some wonderful vantage points to shoot dramatic photos.

First and foremost, there is the comfort level of being able to position yourself far away from any potential danger without jeopardising shooting angles. The added height from these vantage points also gives a three-dimensional aspect to the shot. I would recommend shooting when there are large swell and high tides. These two components will provide some surreal conditions and dramatic photos. Add the potential of a storm and you will not be disappointed. I have photographed this spot on at least a dozen occasions and each time I have been able to obtain some great photos. Also, remember to bring with you an array of clean dry towels to keep your lens nice and clean/dry from the potential sea spray mist.

8.8A CAMERA: Canon EOS-5D Mark II
LENS: Canon EF 16-35mm f/2.8L IS USM
SETTINGS: f/22, ISO 100, 0.8 second exposure manual mode
FLASH: no flash
FOCAL LENGTH: 16mm
tripod used

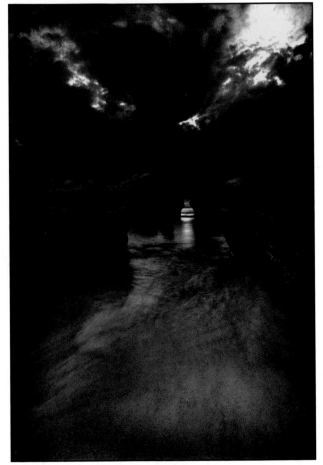

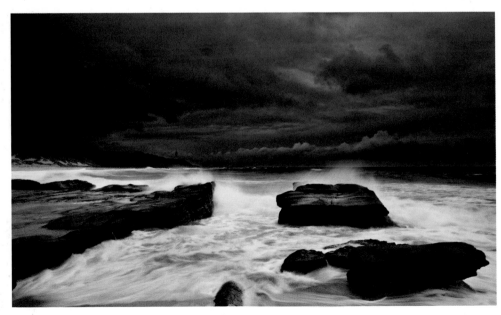

8.8B – f22, .4 sec, ISO 100

8.8C – f8, 2.5 sec, ISO 100

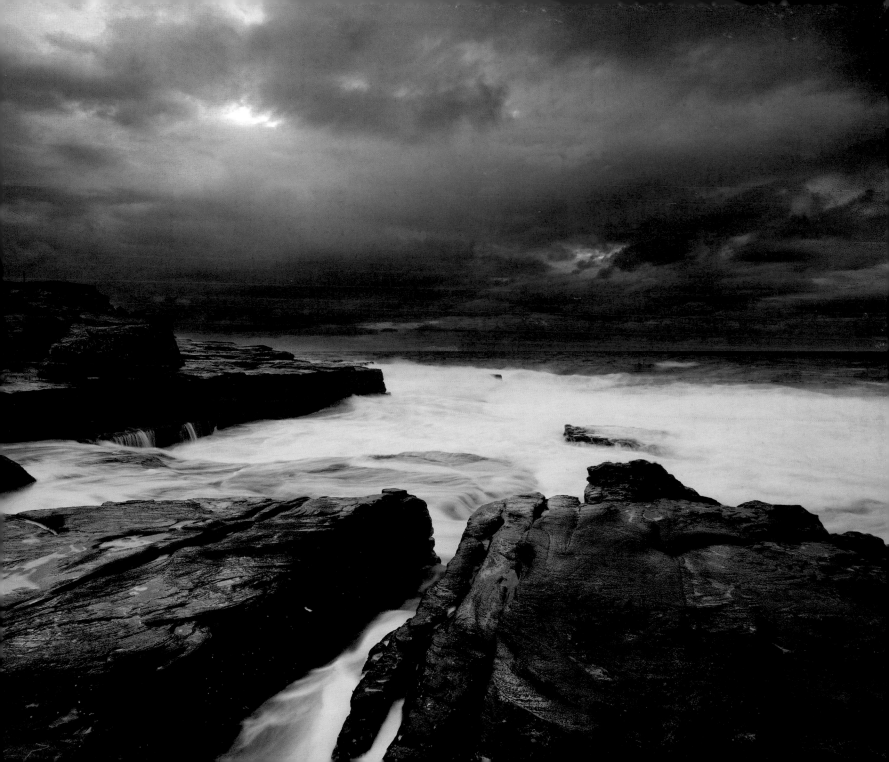

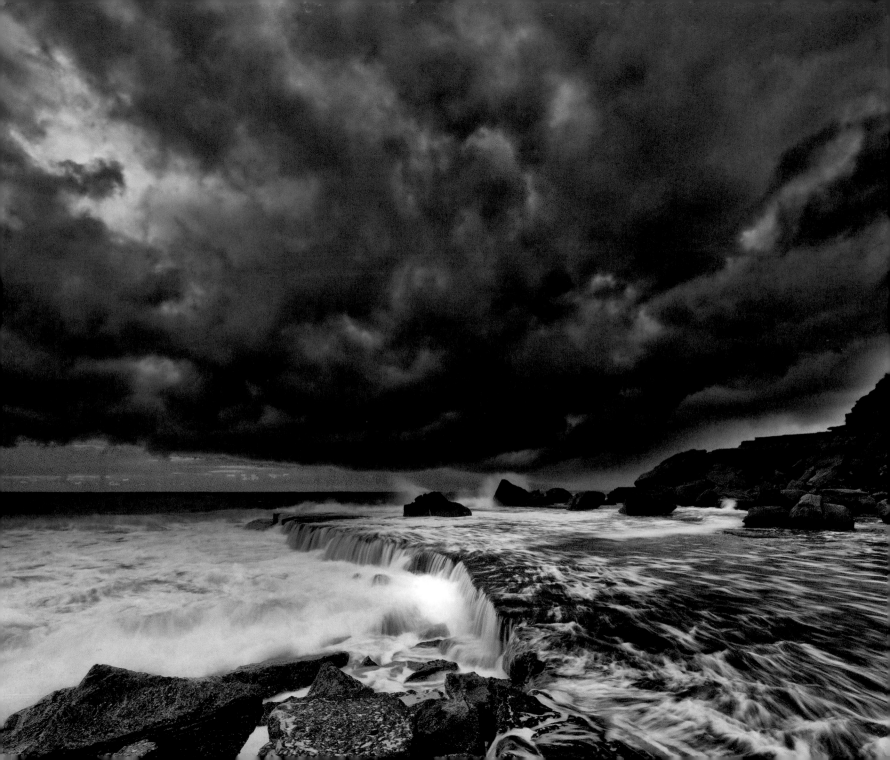

8.9 DISTINCTIVE LANDSCAPES

This spot is the jewel in the crown.

I would go there at a drop of a hat. The location is very distinctive as the changing tidal patterns bring different landscape components into play, all with a high level of photographic appeal.

My favourite is when the tide is at a mid-range level but with some strong swell. The incoming waves wash over a very large rock platform and create a watery curtain effect as the water spills over the long edges of the platform. This photo is a prime example of this. Expect to see a dozen or more photographers there especially at sunrise and sunset. It is a magic spot. At low tide, the exposed rock platform harbours large flat pools of water and this trapped water provides mirror-like conditions for some great reflective shots. Put it on your list to visit.

8.9A
CAMERA: Canon EOS-5D Mark II
LENS: Canon EF 16-35mm f/2.8L IS USM
SETTINGS: f/16, ISO 100, 0.5 second exposure
 manual mode
FLASH: no flash
FOCAL LENGTH: 16mm
tripod used

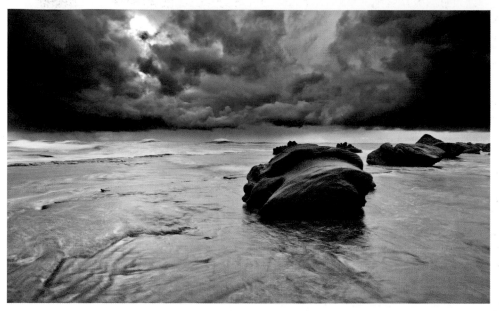

8.9B– f5, .8 sec, ISO 100

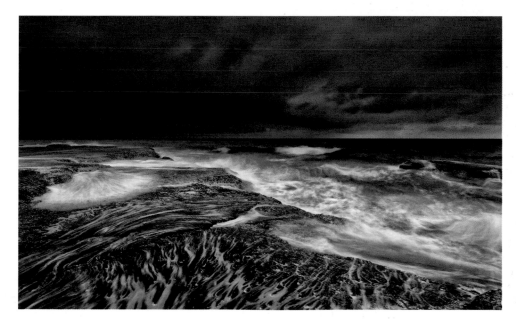

8.9C – f20, 1 sec, ISO 100

8.10 SPECTACULAR SCENERY

Our little gang of five has visited this spot on a dozen or so occasions and we still find some interesting parts to photograph. One of the reasons we head back there on a regular basis is that the location offers at least five key areas where you can capture some awesome storm shots all with a high level of safety. The area is mainly frequented by a large number of surfers. Tourists are almost non-existent due to the distance to travel from the nearest large town.

The area is quite large and has an array of interesting scenery. A pleasurable aspect of taking photos here is that other photographers at the same location are likely to stop and have a chat with you on a series of common themes—the quality of your shots, how you are finding the shooting conditions, what's this piece of equipment like to work with, etc. The social aspect is a bonus and usually the people you meet are likely to point you to some other great locations. We have also found that when we return to a particular place there is a good chance that you will see again some of the photographers that you have met before. Sometimes, it's a bit like catching up with an old friend.

8.10A
CAMERA: Canon EOS-5D Mark II
LENS: Canon EF 16-35mm f/2.8L IS USM
SETTINGS: f/3.2, ISO 100, 1/40th second
 exposure manual mode
FLASH: no flash
FOCAL LENGTH: 16mm
tripod used

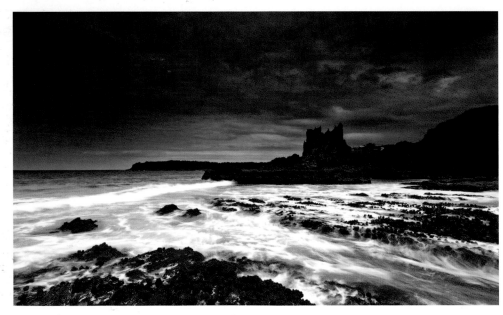

8.10B– f22, .6 sec, ISO 100

8.10C – f22, .6 sec, ISO 100

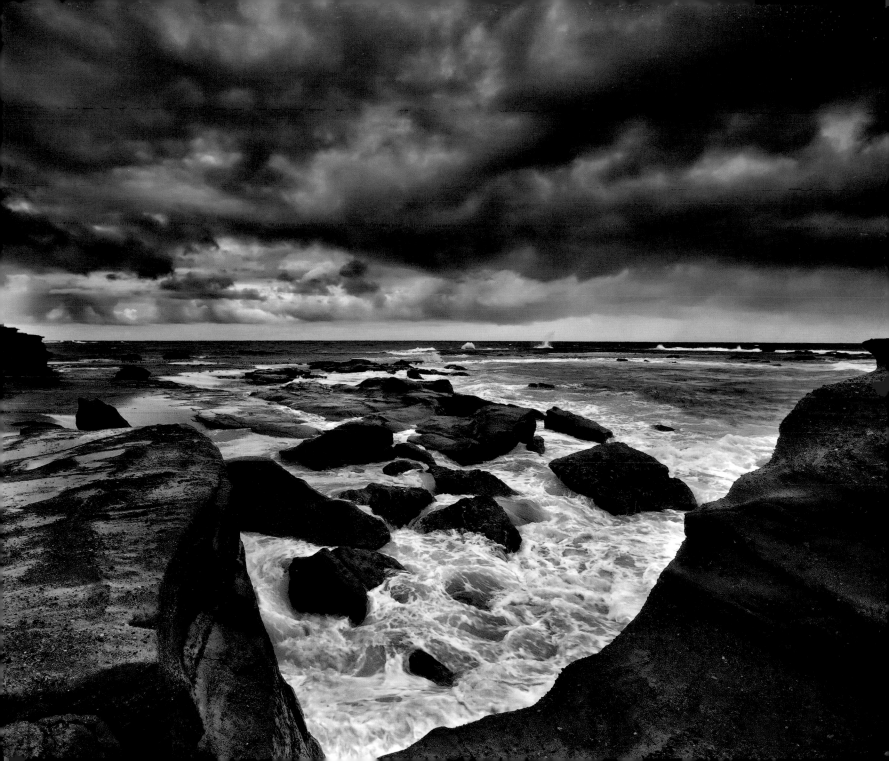

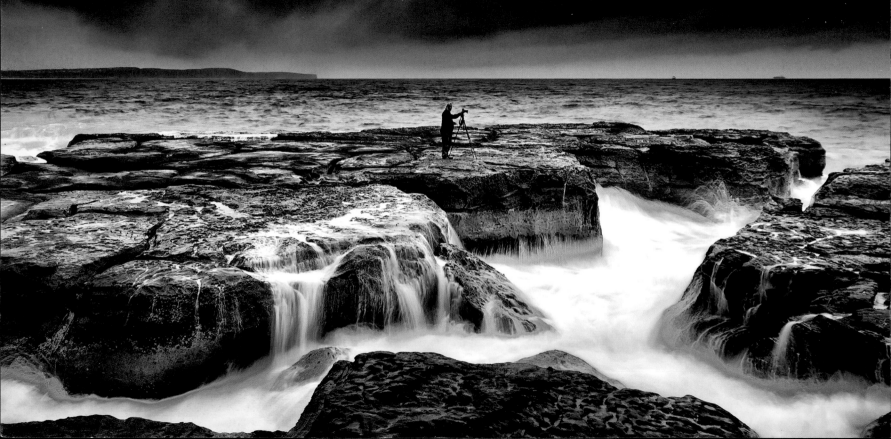

8.11 DEVIL'S IN THE DETAIL

A location commonly known as The Devil's Cauldron would indicate some level of warning and caution. The descriptor is appropriate and this is not a location for beginners. I would not venture there with high tides nor strong swells, as it would be too dangerous. Choose appropriate clothing and footwear for the amount of hiking that is required. It takes a considerable amount of time to climb over large rocks along the base of cliffs just to get to the area. Once you reach the actual spot, it is extremely dramatic, irrespective of the conditions.

This particular place has large open gorges up to 6 m (20 ft) deep. The danger for the uninitiated is that water comes rushing in directly from the open ocean and rises at great speed onto the adjacent platforms where you might be perched. The run-off is then channelled to a section called the Devil's River. The entire area has some intricate rock formations and the constant water flowing from these rising and receding surges provide some fairly special watery effects, especially at shutter speeds between 0.5 to 3 seconds. Professionals who have photographed this area have taken some amazing photos.

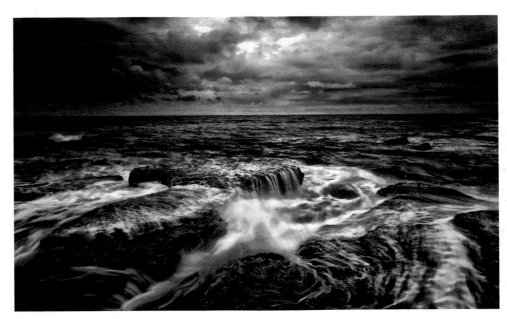

8.11B – f16, .4 sec, ISO 100

8.11A
CAMERA: Canon EOS-5D Mark II
LENS: Canon EF 16-35mm f/2.8L IS USM
SETTINGS: f/9, ISO 100, 0.5 second exposure
manual mode
FLASH: no flash
FOCAL LENGTH: 16mm
tripod used

DEDICATION AND ACKNOWLEDGEMENTS

This book has come about with help and support of some special people. Much of what is contained in these pages is because of some memorable things that have been triggered in my past, that have now brought me great joy and happiness. My immediate family is paramount and they are at the forefront of all that I do.

Special appreciation and thanks go to Mary, Natasha, Jesse and Nathan. Little 'Christopher' is not forgotten also. You shape, and continue to shape, my being in various positive ways.

Inspirations continue to surface from other sources and especially from close friends and family both here and abroad—the Frenchies play a very important part in all of this and to some extent continue to provide me to attain familial quality in living.

On the photography front, a word of recognition also for 'the boys' who go out with me on our weekend treks. Thanks to Nathan, Jonathan, Chris, Andrew and Paul. You guys make the outings special with your wit, banter and companionship.

Additional thanks to Mary, Jonathan and Andrew. Some of the shots in this book with me in them were wonderfully captured by you.

First published 2012 by
New Holland Publishers Pty Ltd
London • Sydney • Cape Town • Auckland

Garfield House 86–88 Edgware Road London W2 2EA United Kingdom
1/66 Gibbes Street Chatswood NSW 2067 Australia
218 Lake Road Northcote Auckland New Zealand
Wembley Square First Floor Solan Road Gardens
Cape Town 8001 South Africa

www.newhollandpublishers.com

A record of this book is held at the National Library of Australia.

ISBN 9781742573410

Publisher: Alan Whiticker
Publishing director: Lliane Clarke
Project editor: Jodi De Vantier
Designer: Kimberley Pearce
Photographs: John Van Put, Mary Van Put and Jonathan Chandramun
Production director: Olga Dementiev
Printer: Toppan Leefung Printing Ltd (China)

10 9 8 7 6 5 4 3 2 1

Keep up with New Holland Publishers on Facebook and Twitter http://www.facebook.com/NewHollandPublishers